IT'S ALL YOUR FAULT!

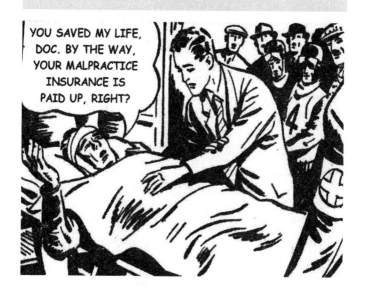

SILVER LAKE PUBLISHING
LOS ANGELES, CALIFORNIA

It's All Your Fault!

A Lay Person's Guide to Personal Liability
and Protecting Yourself in a Litigious World

First edition, 2001
Copyright © 2001 by Silver Lake
Publishing

Silver Lake Publishing
2025 Hyperion Avenue
Los Angeles, California 90027

For a list of other publications or for more
information from Silver Lake Publishing,
please call 1.888.638.3091. Outside the
United States and in Alaska and Hawaii,
please call 1.323.663.3082. Find our Web
site at silverlakepub.com.

Library of Congress Catalogue Number:
Pending

The Silver Lake Editors
It's All Your Fault!
Includes index.
Pages: 291

ISBN: 1-56343-738-4
Printed in the United States of America.

ACKNOWLEDGMENTS

The Silver Lake Editors who have contributed to this book are Kristin Loberg, Christina Schlank, Megan Thorpe and James Walsh.

This is the seventh title in Silver Lake Publishing's series of books dealing with risk and insurance issues that face people living in the United States and other developed countries. Throughout this book, we refer to insurance policy forms and legal decisions from the United States—but the spirit of the discussion about risk and insurance can apply beyond the jurisdiction of the courts cited.

Many of the standard insurance policy forms referenced in this book are developed by and remain the property of the New York-based Insurance Services Office (ISO). Standard policy forms produced by ISO are updated and modified regularly. Our references—either direct or indirect—to the forms are intended solely to illustrate issues and disputes common to liability insurance. Check with your insurance company or an agent or broker if you need currently policy form information.

Because this book is intended to make the concepts and theories of insurance and liability law understandable to consumers, the Silver Lake Editors welcome any feedback. Please call us at 1.888.663.3091 during regular business hours, Pacific time. Or, if you prefer, you can fax us at 1.323.663.3084. Finally, you can e-mail us at TheEditors@silverlakepub.com.

James Walsh, Publisher
Los Angeles, California

CONTENTS

TABLE OF

1

IT'S ALL YOUR FAULT!

A book about personal liability in a litigious world can do one of two things: It can rant about legal excesses or it can offer practical tools for dealing with problems. This book attempts the latter. It's about the hundreds of ways that you can be found liable for some terrible situation. And it's about the dozens of ways you can protect yourself—legally and financially—from the consequences of rotten luck or wicked fate.

An example: You have friends over to watch the Super Bowl. While the Chargers narrowly edge out the Cardinals, something unexpected happens. Your second cousin Jim—in his last year of divinity school—has one too many cocktails, mumbles something about *pagan rituals* and dashes out to his '67 Cougar before anyone can stop him. Ten blocks from your house, he gets into a serious accident. You may find yourself in court arguing that the wreck wasn't your fault.

And any number of people may sue you. You may be liable for the damages your guest caused after you allowed him to consume alcohol—and

engage in various other activities—and then leave. Why? Some states have laws that mandate a host's liability, much like a restaurateur's or a bartender's liability.

If your inebriated cousin veers into a tree on his way home, you could be responsible for his medical bills, vehicle repair costs, lost time from work—and, in the worst case scenario, even damages to the tree. If he goes through the windshield and smashes his skull into paste, his widow Muffy can sue you for everything from negligence (you should have known better than to let a guy who'd been through detox twice tend bar) to lack of consortium (Muffy can't have sex anymore with the recently expired aspiring minister). And the owner of the tree involved in the accident may claim that this particular subspecies of banyan is something he's been cultivating for 30 years...and now all of that effort has been lost because you let your cousin have too many vodka negronis.

Your problems may not stop there. Imagine that your drunken cousin's car kept rolling down hill, passed a stop sign (without stopping) and plowed into the side of the Chrysler minivan that the mayor's idiot brother just bought for $5,000 over MSRP. You may be liable for injuries to the idiot brother—and the minivan he paid too much for.

Local lawyers will be licking their lips. Do you have insurance coverage for this situation? Does such insurance exist? That's what this book is about.

Personal liability is the price that we all pay for being part of a booming economy. It's the price

that have-nots charge haves. It's the mechanism that class-action lawyers cling to. It's an unpredictable factor in any modestly successful person's life. And that modestly is true; you don't have to be rich to be taken in some liability beef. You just have to have a few assets worth enough for someone else to notice.

If you work steadily and save wisely through a long working life, legal or financial crises can still wipe out the money you make. If you own a car, you probably have some liability coverage under you Personal Auto Policy; however, that coverage may not be enough to protect your house. And you may have some liability coverage under your homeowners insurance policy (that's how most people insure themselves against liability claims). But this coverage is limited, too.

In most cases, if you are a middle-class...or wealthier...person, you will need a personal umbrella liability policy to cover the legalistic garbage that infects daily living in the modern world. (Of course, you shouldn't have let your cousin the alcoholic cleric drink and drive...but that's another story.)

A personal umbrella policy can come in handy if you're being sued for physical damages or non-physical damages—like libel or slander—in a non-business situation. An example: Your Chihuahua Spike bites your neighbor Mike square on the Achilles tendon. Mike sues you for medical bills and pain and suffering. Or your Chihuahua Spike writes a guest column in the local newspaper claiming that Mike is a cocaine-addled embezzler who

has forced the bank where he works into receivership. Then Spike goes to a nearby watering hole and swears everything he wrote is true. But Mike hasn't touched drugs since college and his bank is in fine shape. Mike sues you for libel and slander.

STEP RIGHT UP AND SUE

We live in a litigious society. Much of society now believes that an injured party has the right to sue anyone and everyone he or she can and collect as much money as possible—whether or not the payment is justified by the actual damages incurred or by the other party's actual liability for the loss.

For example[1]:

- In early 2000, a surfer filed a lawsuit against another surfer for taking his wave. The case was ultimately dismissed because the court was unable to put a price on the pain and suffering endured by watching someone else ride a wave that was intended for you.

- A California woman sued her fiancé for breaking their seven-week engagement. The jilted bride was awarded $178,000 in damages—$93,000 for pain and suffering, $60,000 for loss of income and $25,000 for psychiatric counseling expenses. There's no record of what it gave her for the wedding gown she had to convert into a cocktail dress.

[1] Source of examples: Citizens Against Lawsuit Abuse (CALA), a non-profit organization dedicated to ending lawsuit abuse. (www.cala.com and www.calahouston.org)

- Another California woman driving a car collided with a man on a snowmobile. The man died in the accident. However, since his snowmobile had suddenly cut in front of her, police said the woman was free from liability. But that wasn't the end of the case. The woman sued the man's widow for the psychological injuries she suffered from watching the man die.

- Recently, a Canadian tourist sued the Starbucks coffee chain for $1.5 million, alleging that a highly personal part of his anatomy was crushed when it got caught between the toilet seat and bowl at a Manhattan Starbucks outlet. He was reportedly in a seated position on the commode. When he turned to retrieve the toilet paper, the seat shifted, and as he leaned forward again the toilet seat clamped his penis. Among other damages, he is asking for $500,000 for his wife who's been deprived of his husbandly services. Imagine owning a small business and having to defend yourself when someone like this decides to use your bathroom.

Even if you're a reasonable, hard-working citizen, life is a risk in this environment. What can you do to protect yourself in the event that some eccentric judge decides that a ludicrous situation is all your fault? Buy insurance.

But all the insurance in the world doesn't protect you from every loss. There are simply more claims than there are coverages.

STANDARD INSURANCE

Personal umbrella policies play a vital role in protecting against liabilities by providing broad coverage and high limits of coverage that most commonly sold personal liability coverages, known as underlying policies, do not provide.

While homeowners or auto policies provide coverage for their respective liability situations, often the limits aren't high enough to cover all the damages that could be awarded in even a moderately severe case. In other words, if you have a $250,000 limit for auto bodily injury and a court enters a judgment of $500,000 against you, you're going to have to come up with the rest yourself.

When a court hands down a liability judgment that exhausts the limits of your homeowners or auto policy, you are responsible for the balance. This means you may have to sell your home, cash out your IRAs or liquidate other assets in order to make the payment on the judgment. And, if your assets are exhausted and the judgment is still not satisfied, you may even have to dip into your future earnings to pay the remainder of the outstanding judgment. One major liability case can wipe out the assets that took a lifetime to create.

Unless you're a minor, legally incompetent or indigent (with no assets at risk), you're probably not exempt from personal liability exposures. Why? If you drive a car, you can never be absolutely positive that you will never be involved in an at-fault accident. If you're a homeowner—or a renter—you can never be certain that no visitor

will ever be injured on the premises. You can never be sure that a personal liability claim will never arise out of something you say or something you do.

The simple answer: You can't be exempt.

Another reason to consider an umbrella liability policy: An umbrella policy can lower your home, car or boat insurance costs; an umbrella policy typically is less expensive than getting additional liability coverage on a homeowners, boatowners or automobile policy.

THE MECHANICS OF COVERAGE

Umbrella liability policies serve two major functions: They provide so-called "high limits of coverage" that protect against catastrophic losses not covered by standard insurance; and they provide broader coverage than underlying policies.

These policies take pressure off of the auto, homeowners and business insurance that most people buy. In this sense, they are as important to insurance companies as they are to consumers.

Umbrellas provide insurance on an excess basis, above any underlying insurance or a self-insured retention (the equivalent of a large deductible). However, they are not standardized forms (like homeowners or auto policies), which means they can differ from one another in significant ways.

Most personal umbrella policies on the market can be organized into two categories:

- Following form excess policies. These provide high limits over the exact same perils, coverages and exclusions found in the underlying policies over which coverage is being provided.

- True umbrella policies. In addition to high limits of liability coverage, these policies provide broader coverage than underlying coverages.

True umbrella coverage protects your present and future income streams most effectively, particularly because it provides three essential things:

- excess limits over underlying policies;

- broader coverage than underlying policies; and

- defense costs in addition to the limit of insurance, and defends a claim even if it is groundless.

An umbrella policy usually defends a claim whether there are grounds for the claim or not. Just ask Bill Clinton, who was issued a pair of umbrella policies for personal liability by two insurance companies—State Farm and Chubb Corp.—that ended up covering *most* of the legal fees he racked up in the Paula Jones case.

The June 9, 1997 issue of *Newsweek* reported that State Farm and Chubb "have paid most of the president's legal fees in the case, already estimated to be in excess of $1.5 million." One small glitch: The insurers refused to compensate Clinton's attorney for the time he spent talking to reporters,

obviously preferring a quick settlement to a drawn-out trial.

In April 1998, however, Clinton fought back, authorizing his attorneys to explore whether he could, by filing a lawsuit, force two insurers to pay his legal bills from the Paula Jones case.

Such a move would have put Clinton in the politically perilous position of suing an industry regulated by the federal government. State Farm and Chubb stopped financing Clinton's defense when the judge threw out some counts of Jones's suit. The companies, who had already picked up a significant amount of Clinton's legal tab, maintained that his umbrella liability policies covered only certain counts and that their obligation ended when the judge dismissed those counts.

U.S. District Judge Susan Webber Wright ultimately dismissed the entire lawsuit. But even after the suit was dismissed, Clinton's lead attorney and his colleagues worked behind the scenes to persuade the insurers to restore coverage, arguing that the companies' obligation to defend Clinton extended until the final dismissal of all charges, which would not happen until appeals were exhausted.

A Senate Republican then accused the White House of stockpiling attorneys at taxpayer expense to handle the president's personal legal matters. And, following this accusation, Clinton's umbrella liability coverage was under scrutiny by Washington-based Judicial Watch—a group which described itself as a non-partisan legal organization

but which was characterized as "conservative" by various media outlets—which took measures into their own hands and sued him on behalf of State Farm policyholders in Illinois.

A derivative lawsuit—similar to a class-action suit, with one plaintiff representing many—was previously filed in May 1997 by the group in the District of Columbia Superior Court on behalf of Thomas Flocco, a State Farm policyholder from Philadelphia who represented a group of policyholders, according to Judicial Watch (an aggressively anti-Clinton group that supported the suit).

The suit demanded that Clinton repay the money that State Farm had provided toward legal bills for Paula Jones's sexual harassment lawsuit. But the suit was thrown out later that year when State Farm and Chubb ceased making payments.

However, in December 1997, Judicial Watch pointed out that the District of Columbia court:

> sustained the underlying bases of the lawsuit, which involved allegations by State Farm policyholders that the payments of legal fees and costs (which will likely increase premiums) for sexual harassment and defamation claims were not covered by the policy, that untimely notice (13 months after the suit was filed) preclude[d] coverage, and that it [was] not the insurance carrier's role to defend a lawsuit merely to delay its resolution, as Bob Bennett, the president's lawyer, plainly admitted was his strategy.

Judicial Watch is a political partisan. But—in this case—it raised some legitimate liability issues.

Steve Vogel, a State Farm representative, insisted that Clinton's policy was not in effect when the alleged *sexual harassment* occurred but during the alleged *defamation* of character. Defamation is covered by most umbrella policies.

"State Farm is defending on alleged defamation, not alleged sexual harassment," Vogel emphasized. "When the Arkansas court dismissed the defamation count, we believe that ended our participation in the defense."

Clinton didn't have to wait years to get the lump sum, as regular citizens often do when they find themselves battling over money with insurance giants. Clinton even selected his own attorney, Robert Bennett, at $495 an hour—a far cry from the $225 most insurance companies are willing to put up for legal defense. Bennett earned his fee by calling the inquiry into the alleged insurance policies "inside-the-Beltway silliness."

A CASE-BY-CASE BASIS

The decision to represent a policyholder is made on a case-by-case basis. But most personal liability policies do not cover sexual harassment claims.

According to State Farm spokeswoman Mary Moore, State Farm was responsible for paying Clinton's legal fees under the single defamation count. That meant State Farm spent $1 million to defend a $75,000 claim. "The president is entitled

to a defense just like any other citizen," Moore asserted. Somewhat unbelievably.

Of course most liability issues involve people much less glamorous than the president. But, even if it's the regional human resources manager who's caught in a sexually harassing relationship with an intern, he's likely to call on every policy he can for protection.

Under most states' laws and standard umbrella policies, there is no duty to provide a defense for sexual harassment or civil rights violations—since those offenses involve *intentional misconduct.*

Even granting State Farm's argument, insurance experts noted that the company still should not have paid for the litigation of collateral issues, such as the fight in the Supreme Court about the president's immunity to a civil action. Those funds are only supposed to be used to stage a defense.

The decision to pony up for these issues, combined with the decision to pay the bills of one of the most expensive attorneys in the country, made more than one insurance lawyer wonder: "Is State Farm in control of the defense?"

Normally, it would be.

THE MECHANICS OF LIABILITY

For losses that are covered under primary insurance, umbrella coverage applies only after the primary coverage has reached its limit. For losses that are covered by the umbrella policy and not by

primary policies, the umbrella coverage applies after a loss exceeds the deductible.

There are no standard umbrella policies. Early umbrella policies were extremely broad and contained few exclusions. However, insurance companies soon realized that they would need to narrow the coverage by creating more specific insuring agreements and exclusions.

The intent: To provide affordable and comprehensive coverage for catastrophic losses, incidental exposures and modest insurance gaps, but not to provide blanket all-risk coverage in multiple areas with no primary insurance. For this reason, insurance companies usually require you to maintain an adequate range of underlying coverages before they sell you umbrella liability coverage.

When you break a law, you have committed a crime. When you violate the rights of another person, you have committed a tort. The person committing a tort is known as the tortfeasor. It is important to note that liability insurance applies only to the financial consequences of *torts*; you cannot buy liability insurance to protect against the consequences of *crimes*.

If your cousin gets angry at his friend and intentionally sets his car on fire, he has committed the crime of arson—and liability insurance won't cover the damages. However, if he is having a barbecue and accidentally starts a fire that burns his friend's car, liability insurance may cover the damages.

Most personal liability cases involve unintentional torts. The basis for unintentional torts is usually

negligence. In order for negligence to exist, the following must be present:

- Duty to act. The duty to act in a reasonably prudent manner toward another (such as driving safely down the street in a manner that avoids hitting other cars or pedestrians).

- Breach of the duty to act. The tortfeasor does not act in the prudent manner described above.

- Occurrence of injury or damage. Another party actually must suffer an injury or damage.

- Negligence is the proximate cause of the injury or damage. The tortfeasor's breach of duty is actually what caused the injury or damage.

If any one of the above elements is absent, negligence does not exist. But if the required elements are present, the injured party usually has a valid claim for damages.

In any discussion of liability, it is important to understand the term *damages*. When someone is held liable for injury or property damage to another, that person can be required to pay compensation to the injured parties. For these types of claims, two broad types of damages apply:

- Compensatory damages—which simply means compensation for the loss incurred. These may include specific damages (the documentable, actual expenses incurred by the injured party,

such as medical bills, wages lost and property replacement costs) and general damages (monetary awards for more subjective, less quantifiable aspects of the loss, such as pain and suffering, or loss of consortium).

- Punitive damages—these are damages that the court can compel the tortfeasor to pay in addition to the compensatory damages awarded. Punitive damages represent a fine, or punishment, for outrageous, severe or intentional conduct.

KEY LIABILITY POINTS

Vehicle-related liability is the greatest single source of personal liability. The act of using a car generally causes you to be in the proximity of others, while operating a several thousand pound machine moving in and around other such machine operators. All in all, you—and others around you—are more likely to be involved in an accident.

Vehicle liability can arise from property damage to other people's cars, injury to people occupying other cars, injury to pedestrians and damage to property other than cars (such as a fence).

Injuries and damages related to vehicle use also may be caused or aggravated by many factors, such as excessive speed, driver inexperience, disobedience of traffic laws (such as running a stop sign), use of intoxicants (drugs or alcohol) or simple carelessness brought on by inattention.

We'll go into greater detail on vehicle liability issues in Chapter 4.

The second largest source of personal liability is *residence-related liability*. Whether you own or rent your home, you may be personally liable for injury or damage to others, including:

- trip and fall incidents due to ice and snow, debris, etc.;

- accidents related to swimming pools or other attractive nuisances, such as jungle gyms and trampolines;

- property damage scenarios (for example, a renter causing damage to the premises by careless smoking);

- injuries sustained by, or injuries to others caused by, domestic workers, such as maids, gardeners, etc.; and

- injury caused by an overly protective dog (if Spike bites your neighbor's toy poodle, you'll pay the vet's bills—and a lawyer's; and watch out if Spike bites your neighbor's kid, no matter how much Junior was asking for it).

In most cases, a personal umbrella policy will not cover *business liability*. However, some business exposures may be covered by personal liability policies. For example, an umbrella policy may cover certain home office exposures.

So far, we've discussed unintentional torts. What about intentional torts? Intentional torts can involve infringement of property and privacy rights

(for example, trespassing). Property rights also can be violated by nuisance-type activities that interrupt a property owner's ability to use the property (for example, when you test the volume limit on your new 2500-watt CD player while your neighbor is trying to relax on a Sunday afternoon). Other intentional torts involve personal injury, which includes bodily injury and damage to reputation through untrue statements, libel (in print) or slander (spoken).

These are by no means the only examples of personal liability exposures. Your children, your pets, your premises, your hobbies, your car and many of your daily activities create exposures.

Take, for example, the 1999 federal appeals court case *Allstate Insurance Company v. Martin E. Raynor,* which considered a bizarre case of homeowners liability. The case tackled the issue of intent when it comes to the negligence of the criminally insane.

David and Candy Johnson and Candy's two daughters, Cheryl and Kathryn Raynor, lived in Longview—next door to Milton and Margie King. Milton was a troubled man with a history of violence. In 1990, he was arrested and convicted for assaulting his wife, police officers and others with a .22 caliber handgun, which the police confiscated.

One week after being sentenced, Milton asked his attorney to get his gun back from the police.

By July 2, 1992, Milton, who had completed all conditions of his sentence, went to his attorney's

office and requested his handgun. His attorney refused to give him the gun and instead gave it to Margie.

> The attorney also warned that, as a convicted felon, Milton was not permitted to possess guns, and advised Margie not to take the gun into their home. Despite the warning, Margie gave the gun to Milton.

On the morning of July 10, 1992, Milton told the police that his neighbors had been illegally keeping rabbits and dumping rabbit excrement near a fence between the two properties.

Later that day, Candy Johnson, her daughters and one of the girls' friends, Shannon Connors, were stacking wood on their side of the fence. As a result, the Kings began cursing over the fence at them. Candy called 911.

A police officer stopped by, examined the woodpile and assured Candy that they had the right to stack wood by the fence. The officer also spoke with the Kings, who renewed their complaint regarding the rabbits. The officer noted that Milton was "acting real strange, 10-22, the whole works."

When Candy and the children resumed stacking wood, Margie called 911 and the operator contacted the police, who informed her that an officer had already been on the scene earlier. As instructed, she told Margie that this was a civil matter and that the police would not be taking action.

After ending her call with the operator, Margie told Milton that the police would not be responding, which made him even angrier than he had been before. Margie went back outside, had more words with Candy and the children, stuck a stick through the fence in an attempt to knock down the wood pile and then went back inside her home.

Moments later, Margie saw Milton in their yard, armed with the .22 caliber handgun and a .38 caliber revolver. He was watching Candy and the children. Margie told Milton not to do anything because "it wasn't worth it," and Milton went back into the house, put the guns in a drawer in his bedroom and lay down on the bed.

Margie then turned on a sprinkler, which sprayed water over the fence. The children called Margie a name and she turned down the water. Minutes later, Margie heard some "pops," went inside and noticed that Milton was no longer in the house.

Milton had entered the Johnson property and begun shooting. He shot Cheryl twice in the chest and Candy once in the mouth. Shannon fled to her home across the street.

Kathryn and Candy ran inside and called 911. Because she had been shot in the mouth, Candy had trouble speaking and the operator could not understand the address. The operator then heard a high-pitched scream and more gunshots in the background. Milton shot Candy in the chest.

The operator told police that shots had been fired at 2950 but that they did not yet know the street

name. The officer who had been on the scene earlier suggested that it might be 2915 Fir, which he believed to be the Kings' address and he immediately headed for 2915 Fir.

Meanwhile, Candy and Kathryn fled to the bathroom, with Milton in pursuit. Candy wedged her body against the door in an effort to keep him out and Kathryn hid in the bathtub and watched her mom die. Exhausted and unable to enter the bathroom, Milton left and shot himself in the head. Officers found Candy and Milton dead and Cheryl bleeding in the yard; she died later that day.

Martin Raynor, Cheryl's ex-husband, and David Johnson filed an action for wrongful death and personal injuries against the Kings, alleging negligence.

The trial court ruled that the Kings' homeowners policy did not cover Milton's criminal acts of shooting to death Raynor's ex-wife and daughter.

As provider of the Kings' homeowners policy, Allstate brought a declaratory judgment action, seeking to avoid liability for the deaths of Candy and Cheryl. Allstate alleged that the deaths and injuries had been caused by Milton's intentional and criminal acts, not by either of the Kings' negligence, and that the Kings' policy did not provide coverage for his "intentional" and "criminal" acts. The trial court granted summary judgment to Allstate as to liability for the actions of both Milton and Margie. Raynor and Johnson appealed.

Raynor argued that: 1) Allstate's policy exclusions for criminal or intentional acts did not apply when

the insured lacked the mental capacity to form the requisite intent; 2) the "criminal acts" exclusion did not apply when the insured had been neither convicted of, nor charged with, a crime arising from the incident for which coverage was sought; 3) a material issue of fact remained as to whether Margie King's negligence was the "efficient proximate cause" of the deaths of Martin Raynor's ex-wife and daughter; 4) the trial court improperly denied coverage to Margie King based on the policy's "joint obligations" clause; and 5) the "joint obligations" clause violated public policy.

Allstate responded that multiple provisions of the policy precluded coverage because the homicides were intentional, not accidental.

INTENTIONAL ACTS

According to the Kings' Allstate homeowners policy, coverage was excluded for any bodily injury or property damage which could reasonably be expected to result from "the intentional or criminal acts of an insured person or which are in fact intended by an insured person."

Raynor argued that Milton's mental disturbance, falling short of criminal insanity, was such that the shootings could not be termed intentional or criminal acts for purposes of the policy's exclusion. The traditional rule had been that, when a person is insane at the same time of his or her act, a liability policy's "intended or expected" exclusion was ineffective. This remained true, even when the policy would have precluded recovery had the slayer been sane.

The appeals court noted that when an insured person "was not insane at the time he committed the offenses, [he] is presumed to be sane and able to form the general intent to commit the acts in question." There was no evidence that Milton was criminally insane when he shot Candy and Cheryl.

> As the court noted, the criminal insanity defense "is available only to those persons who have lost contact with reality so completely that they are beyond any of the influences of the criminal law."

There was no evidence that Milton met either of the insanity tests. Raynor's expert witness, Dr. G. Christian Harris, said that he "would not go so far as to say that [Milton] didn't understand the general nature of his acts" and that nothing in the record indicated that Milton wouldn't have a basic idea of what was right and what was wrong.

Furthermore, there was no evidence suggesting "delusional thinking, hallucinatory deficits that would ordinarily be necessary to sustain a feeling that the person was disturbed to the extent that he couldn't understand the wrongfulness of his actions" or that Milton suffered from "a psychotic illness that would remove him from understanding the nature of his act or its wrongfulness."

This lack of evidence meant that Raynor could not avoid, on grounds of insanity, the policy's exclusion of coverage for Milton's intentional or criminal acts. Raynor then argued that this exclu-

sion applied only when a criminal conviction had been obtained against the insured for the acts giving rise to the claim of liability.

He also argued that the definition of *criminal acts* under the Kings' policy was ambiguous because other Allstate policies excluded coverage for: criminal acts not resulting in criminal charges; and acts committed while the insured lacked the capacity to form the intent to commit the act.

Allstate countered, stating that the criminal acts exclusion unambiguously absolved Allstate from all liability for any actions that could be construed as *criminal* under any statute. The court agreed, contending that coverage for Milton's acts was precluded. These actions clearly violated criminal statutes, and the average purchaser of insurance would have understood such actions to be excluded criminal acts, the court ruled.

ACCIDENTAL LOSS LIMITATION

Allstate also argued that, even if the intentional or criminal acts exclusion did not apply, coverage was still not available because the Kings' policy covered only "accidental loss" and this was clearly not an accidental loss.

In response, Raynor argued that the acts were presumed accidental, unless Allstate could show that they were deliberate.

Under the Kings' policy, Allstate agreed to "pay all sums arising from an accidental loss which an insured person becomes legally obligated to pay

as damages because of bodily injury or property damage covered by this part of the policy."

The appeals court cited an earlier federal court ruling that stated:

> An accident is never present when a deliberate act is performed unless some additional unexpected, independent and unforeseen happening occurs which produces or brings about...injury or death.

Regardless of any mental instability Milton may have been suffering, he clearly engaged in deliberate acts when, after being told by his wife to come back into their house, he shot his neighbors, chased them into their home and continued firing.

Raynor could not reasonably claim that the manner in which the neighbors were harmed was unexpected, independent and unforeseen—when Milton next turned the gun on himself, pulled the trigger and fired a fatal shot.

Because Milton was not criminally insane, he was presumed to have intended his acts. Consequently, the shooting was no accident; and the policy provided no coverage for Milton's actions.

JOINT OBLIGATIONS

Allstate also argued that the policy's "joint obligations" clause precluded coverage for Margie's acts, even negligent acts, because Milton's actions were binding on her. Thus, Allstate denied coverage. And the appeals court agreed.

The joint obligations clause provides:

> The terms of this policy impose joint obligations on the person named on the declarations page as the insured and that person's resident spouse. These persons are defined as *you* or *your*. This means that the responsibilities, acts and failures to act of a person defined as *you* or *your* will be binding upon another person defined as *you* or *your*.

Most federal courts have found these exclusions valid, permitting the excluded acts of *one* insured person to absolve the insurer of liability for claims against *any* insured person. In these cases upholding joint obligations clauses, the acts of an insured had already been determined as exclusions under the policy. Milton's intentional, criminal acts were excluded from liability coverage under the Kings' policy. Accordingly, the appeals court held that the joint obligations clause likewise applied.

The court concluded that coverage for Margie was precluded because—as a matter of law—Milton's acts were intentional and criminal, and therefore excluded from coverage.

CONCLUSION

Everyone from the President of the United States to the widow of a murderous convicted felon can face liability claims that breed lawsuits and insurance disputes.

The cases and examples we've considered in this chapter are just a taste of the complexities and con-

fusion that define personal liability issues in the modern, litigious world. In the chapters that follow, we will examine specific kinds of risks and the mechanics of how they work in greater detail.

In all, the purpose of this book is to give you—a generally well-informed consumer who's not a lawyer or insurance expert—a working understanding of the liability exposures you face in daily life. This understanding should help you make informed decisions about how to handle these liabilities, whether through insurance policies, personal and business choices or various legal tactics.

Our hope, ultimately, is that this information and the better choices it allows will help reduce the personal liability lawsuits that clog our court systems and cloud our collective judgment.

2

IMPORTANT
DEFINITIONS

Before you can find the right kind of insurance to protect you—and your assets—and file a claim for coverage, you must first understand the language of your policy. And because liability insurance is complicated and different companies offer slightly—or radically—different policies, it is important to understand how the language and basic concepts pertain to your specific policy.

Of course, this is true whether your policy protects your boat, home, car or personal assets. This chapter defines terms, describes coverage and exclusions and addresses some of the conditions that affect your personal liability coverage.

AGREEMENT

An insurance policy is an agreement between you and your insurer. The agreement simply states that your insurance company agrees to provide coverage in exchange for payment of the premium and compliance with the provisions of the policy.

For example, the policy may state:

> We will pay damages for "bodily injury" or "property damage" for which any "insured" becomes legally responsible because of an auto accident. Damages include prejudgment interest awarded against the "insured." We will settle or defend, as we consider appropriate, any claim or suit asking for these damages. In addition to our limit of liability, we will pay all defense costs we incur. Our duty to settle or defend ends when our limit of liability for this coverage has been exhausted. We have no duty to defend any suit or settle any claim for "bodily injury" or "property damage" not covered under this policy.

APPEALS

The insurance company is entitled to appeal any judgment which could result in a claim payment being made under an umbrella liability policy. This is true even if you or the insurance company providing underlying insurance elects not to appeal the judgment. If it appeals, the insurance company pays all costs related to the appeal.

ASSIGNMENT

A transfer or making over to another of the whole of any property, real or personal, in possession or in action or of any estate or right therein. This usually refers to intangible property such as rights in a lease, mortgage, agreement of sale or a part-

nership. When dealing with insurance, this may include certain rights in a policy.

In a lawsuit, one party (i.e. the person who caused a said injury or loss) may assign its rights to liability coverage over to the other party (i.e. the victim of the said injury or loss).

An example: You host a book club meeting in your library, but you stack too many books on top of one another in a high shelving unit. A friend of a friend happens to get in the way when the stack falls down; she suffers neck, back and head injuries. When all is said and done, the court finds you liable for $100,000 in damages. Of course, you can't possibly afford this judgment. So what do you do?

You assign your claim of liability coverage (from your insurance company) over to the victim. Thus, she effectively obtains the right to go after, i.e. sue, your insurance company for indemnification.

AUTO-RELATED LIABILITY

In an umbrella policy, the definition of *auto* is broader than it is in a standard auto policy. Under an umbrella, the definition of *auto* includes a motorcycle or moped (the typical definition found in a standard auto policy does not; motorcycles are covered only by attaching an endorsement).

BANKRUPTCY

If you become bankrupt, an umbrella policy still applies on an excess basis over the applicable

deductibles. The umbrella does not become primary coverage due to a lack of underlying insurance or your inability to pay the deductible.

BODILY INJURY

Bodily injury means bodily harm, sickness or disease and includes the costs of required care, loss of services or death resulting from the injury. This is one of the main kinds of loss that constitute a civil liability.

If you are liable for the accidental injury or death of another person, the typical underlying homeowners policy provides coverage. So, if your neighbor slips, falls and breaks both his legs on the sheet of ice on the sidewalk in front of your house, and then slides into the street where he is run over by a passing SUV because you decided to sleep in after a late night at The Tavern up the street, chances are your homeowners policy provides liability coverage. However, in order to be covered for events involving libel, slander, false arrest and the like, you probably need a personal umbrella policy. The personal umbrella policy covers you for liability arising out of these events.

BUSINESS ACTIVITIES

Business means any trade, profession or occupation. *Business activity* is any agreement, contract, transaction or other interaction that advances your occupation. These terms are important because, in most cases, homeowners policies limit coverage for businesses and business activities—even if

you're starting your own business from the comforts of home.

Business-related liability (e.g. your FedEx delivery person slipping and falling while in your living room, which has been turned into a home-based office for manufacturing this year's hottest Christmas toy) is a more complicated issue and such activities are strictly limited.

> Any significant business exposure should be covered under a separate policy, such as an in-house business policy or a business owners package policy (BOP).

CLAIMS-MADE POLICY

A *claims-made* policy responds to claims filed during the policy period. This differs from an occurrence policy, which pays for injury or damage that happens during the policy period.

Several insurance companies issued occurrence policies for asbestos manufacturers in the 1940s and 1950s. Forty years later, these insurers are still paying millions of dollars in claims and legal defense costs for policies under which they collected only a few thousand dollars in premiums. Because the delay between the occurrence and filing of a claim resulted in difficulty in developing premiums adequate to anticipate claims that had been incurred but not reported (IBNRs), insurance companies developed claims-made coverage for risks

with a long delay—sometimes called long-tail exposures.

Claims-made forms create a precise claim trigger that prevents the stacking of limits. In contrast to occurrence forms, the claims-made forms usually have an additional section and a few necessary differences in their conditions.

COMPENSATORY DAMAGES

Compensatory damages are damages recoverable or awarded for injury or loss sustained. In addition to actual loss or injury, these damages may include amounts for expenses, loss of time, bodily suffering and mental suffering, but not punitive damages.

COVERAGE

The scope of protection provided by an insurance policy is called *coverage*. The policy spells out many agreements, but perhaps most important, it specifies the type of losses for which the insured will be reimbursed by the insurance company. When the policy states that the insurance company will pay for a certain type of loss, then it is common to say that the insured person has coverage for that loss.

DECLARATIONS PAGE

In this section—typically the first page of an insurance application—your insurance company includes specific details relating to coverage. These details include everything from policy limits and

premiums due to any specific additions or exclusions based on your personal circumstances.

Any specific kinds of coverage added or dropped from a standard policy are called endorsements.

Remember: There are no standard umbrella policies, so it isn't easy to generalize about them. Early umbrella policies were extremely broad and contained few exclusions. However, insurance companies soon learned that they would need to narrow coverage by creating more specific insuring agreements and exclusions.

The Declarations includes the names of the people covered by the policy, the dates it's in effect and the vehicles, boats, etc. covered.

A policy is in effect beginning on the effective date listed in the Declarations. In some policies, this may be a retroactive date. When coverage under a policy stops, the policy has expired—thus, the date on which the coverage ends is the expiration date.

DEDUCTIBLES

As with any insurance policy, the *deductible* is the portion of an insured loss borne by you before you recover anything from your insurance company.

The deductible amounts for various exposures are shown in the Declarations. Deductibles are mini-

mum requirements for underlying insurance for declared exposures. Deductibles apply even if the underlying insurer becomes bankrupt or insolvent.

Under a personal liability policy, a deductible amount of $1,000, or *self-insured retention*, applies to each loss that arises out of a declared exposure, which is covered by the umbrella but for some reason is not covered by the underlying policy (a good example is a loss occurring out of the underlying insurance coverage territory).

DUTY TO DEFEND

The insurance company has the right and the option to investigate and settle any lawsuit and claim. In the same process, it also accepts a *duty to defend* an insured person in any related lawsuit or claim. But, once it pays the limit of its liability to settle a suit or claim, it is no longer obligated to provide any further defense.

ENDORSEMENTS

Most insurance policies are printed in great quantities as standard forms. Since there are many variations in the protection needed by individual consumers, a method for adding or deleting coverages is necessary. Whenever a basic policy form is changed in any way (to amend, limit or expand coverages), this change is put into effect by an *endorsement*—a page added to a standard policy. Endorsements often involve premium changes. If you add liquor liability to your standard BOP, this is will end up costing you more each month in premiums.

INDEMNIFICATION

Indemnities are securities against hurt, loss or damage. Indemnification for hurt, loss or damage may be payment in money or replacement of the property. An home and fire insurance company indemnifies a policyholder, for example, when it pays for restoring the victim's house after a fire. Indemnities for losses don't always have to be for material goods—they can be for things like bodily injury and pain and suffering. In most cases, the indemnity is monetary.

INSURED

In a liability policy, "you" and "your" refer to the *named insured* listed on the Declarations Page and the spouse if a resident of the same household.

However, an *insured* can also refer to any residents of your household who are:

- your relatives;

- other persons under the age of 21 and in the care of you or your relatives;

- with respect to animals or watercraft to which the policy applies, any person or organization legally responsible for these animals or watercraft that are owned by you or any person included above (except used in business or without permission); and

- with respect to any vehicle to which the policy applies, any persons while

engaged in your employ or that of any person included above, or other persons using the vehicle on an insured location with the consent of you or your spouse.

An example: This year's dreaded family reunion is at a summer cabin on a lake. Your sister's kids invite several of their friends to come along. Your snotty-nosed niece tells her friend that she can ride your mini-bike without your consent. Her friend, attempting an Evil Kanevil-maneuver over a picnic table, a line of trashcans and the twins, loses control, hitting and injuring a visiting neighbor. Because you didn't give your niece's friend permission to use your bike, your niece is not an insured if she is sued for the injury. You, however, are still covered if you are sued as the owner of the mini-bike.

The term "insured" is defined in different ways for various situations and exposures.

If injuries and damages are related to the use of a non-owned auto, the umbrella policy covers you on an excess basis only if the use of that auto is covered by the required underlying insurance.

An example: Your employer furnishes a car for use in your sales work. As long as your employer's policy provides at least $300,000 of coverage for your use of the company-owned car, your umbrella policy provides additional coverage.

Family members are insured for their use of owned autos, or autos furnished for their regular use, only

if their use of such autos is covered by the required underlying insurance.

An example: Mr. and Mrs. Lewinsky have a personal umbrella policy and their daughter Monica lives with them. Monica has her own car. The umbrella policy covers Monica's use of the car if she has personal auto coverage with a limit of at least $300,000.

With respect to an auto or covered watercraft in your care, any other person using such items, or any person or organization responsible for the acts of someone using such items, is insured. So, if your son lets his friend Dave drive the family speedboat, Dave is considered an insured person. Likewise, if Dave uses your boat to teach members of his son's Boy Scout troop to water ski, the Boy Scout troop is considered an insured organization.

For animals owned by any family member, any other person or organization responsible for the animals is an insured person.

An example: While on vacation, you leave your dog with a neighbor who has agreed to take care of it. If the dog breaks loose and bites the two-year-old across the street, the umbrella policy covers the neighbor as an insured person if the neighbor is sued for the injury.

INSURED LOCATION

As is the case with the definition of insured, *insured location* is a sweeping definition that includes a variety of specified locations:

- the dwelling where you live, including the grounds and other structures;

- other premises that you use as a residence that is named in the Declarations or acquired during the policy period;

- any premises you use in connection with one of the premises in 1 or 2 above;

- non-owned premises where you are temporarily residing;

- vacant land owned or rented to you (other than farm land);

- owned land on which a one- or two-family residence is being built;

- cemetery plots; and

- premises occasionally rented to you (and not used for business).

The first three definitions of insured location apply to the named insured (meaning the person named on the Declarations and spouse), while the others apply to an insured (anyone named in the definition of insured, as reviewed above).

INTEREST (FINANCIAL)

Prejudgment interest means an additional amount of damages awarded to a plaintiff to compensate for the delay between the time of injury or damage and the time a judgment is made. Because liability claims may take months or years until an award is made, this amount is designated to replace the amount of interest the plaintiff would

have earned had the damages been awarded at the time of injury or damage.

Postjudgment interest applies when a decision is made in favor of the plaintiff, but an appeal delays payment of damages. Postjudgment interest is money the plaintiff would have earned if the judgment had been paid at the time of the first judgment, before the appeal.

LIMIT OF LIABILITY

The liability limit on a policy is the maximum amount the insurer pays for any one occurrence. This limit is the same regardless of the number of insureds, claims made or persons injured. In other words, the limit is not increased simply because there is more than one injured person or more than one claim filed as a result of a single event.

Most insurers provide medical payments with a per person limit, which is the maximum amount payable to one person arising out of one occurrence. However, there is no limit on the number of claims arising out of an occurrence, nor is there an aggregate limit on the amount payable.

Should you and another family member both be sued, the policy provides a defense for both. However, the limit of liability for all damages arising out of one occurrence remains unchanged.

MINIMUM RETAINED LIMIT

Umbrella coverage applies above a *minimum retained limit*, which is the greater of the deductible

shown in the Declarations or the actual amount of underlying insurance available to you.

For example: You're required to have at least $300,000 of underlying automobile insurance. If you actually have $500,000 of automobile insurance, the umbrella coverage for auto exposures applies as excess over that amount.

OCCURRENCE

An *occurrence* is usually defined as an accident (including continuous or repeated exposure to substantially the same general harmful conditions) in bodily injury or property damage neither expected nor intended by an insured. A situation must be deemed an occurrence before insurance applies.

If water leaking from your outside pipes softens the ground under your neighbor's garage, eventually causing its partial collapse and irreparable water damage to his precious collection of vintage Chatty Cathy dolls, it is a single occurrence.

The definition of occurrence is typically included in a policy in order to specifically clarify that coverage is limited to damages arising out of an occurrence *during* the policy period.

Notice the way in which occurrence is defined in any policy—before you sign on the dotted line. Insurance companies that don't want to pay claims will sometimes make tortuous arguments that whatever went wrong doesn't qualify as an occurrence.

POLICY LIMITS

Your insurer's total liability under your umbrella policy for all damages and loss assessments resulting from any one occurrence are not more than the limit of liability as shown in the Declarations. The limit is the same regardless of the number of insureds, claims made, loss assessments, persons injured, vehicles involved in an accident or exposures or premiums shown in the Declarations.

Should two or more insureds, such as you and another family member, be sued, the policy provides a defense for each insured. However, the limit of liability for all damages arising out of one occurrence remains unchanged.

An insurance company is entitled to appeal any judgment that could result in a claim payment being made under the umbrella policy. This is true even if you or your insurance company providing underlying insurance elects not to appeal the judgment. If it appeals, the insurance company pays all costs related to the appeal.

If you become bankrupt, your umbrella policy still applies on an excess basis over the applicable deductibles. The umbrella does not become primary coverage due to a lack of underlying insurance or your inability to pay the deductible.

PROFESSIONAL LIABILITY

In many small businesses, the business owner provides advice or professional services for which customers pay a fee. However, if these services

are in some way unsatisfactory, the customer may sue the service provider for professional negligence. Professional liability coverage protects you against legal liability resulting from negligence, errors and omissions, and other aspects of rendering or failing to render professional services.

Accountants, attorneys, doctors and financial planners—or anyone who provides professional services—are increasingly finding this kind of insurance very important, especially if they work out of the home. In a broad sense, it's a form of malpractice insurance. It does not, however, cover fraudulent, dishonest or criminal acts.

PROPERTY DAMAGE

Property damage means injury to or destruction of tangible property and includes loss of use of the property. This is another of the main kinds of loss that constitute a civil liability.

Keep in mind that property damage also includes loss of use. If you accidentally set fire to your neighbor's home and it burns to the ground, he might have to shack up somewhere else for a few days or even weeks while the home is being repaired or rebuilt. The extra expenses he has to pay as a result of the loss of use (rent, meals, transportation, etc.) could be claimed in addition to the actual damages to the home.

If you are liable for damage to the property of others left in your care, custody or control, including loss of the use of the property, your homeowners policy probably won't cover you.

Most homeowners policies exclude coverage for damage to such property. However, a personal umbrella does not exclude coverage for damage.

RESIDENCE EMPLOYEES AND PREMISES

Residence employee means an employee of an insured whose duties are related to the maintenance or use of the residence premises, including household or domestic services; or someone who performs similar duties—not related to a business— elsewhere.

Residence premises means the dwelling, other structures and grounds, or that part of any other building where you—or any other named insureds— reside, and which is identified as the residence premises in the Declarations.

It may be a single family home, part of a duplex or triplex where you live, a condominium unit or a rented apartment. (This differs from the definition of residence premises in homeowners forms.) For one- to four-family dwellings, the term includes other structures on the property and the surrounding grounds.

For a condominium or cooperative unit-owner, residence premises means the unit where you reside, and which is shown as the residence premises in the Declarations.

RIGHT TO SUE

Since an insurance policy is a legal contract, an insurance company may be sued if it fails to per-

form its contractual obligations. If it fails to defend you or fulfill other obligations, you may sue. If it fails to pay a valid claim after entry of a judgment against you, the injured party may sue.

However, no one has a right to sue the insurance company until after there has been complete compliance with policy terms and your liability and the amount of damages have been established by final judgment or agreement. For example, you have failed to give the insurance company notice of a loss and legal papers related to the suit that are required of you after a loss. You have no right to sue the company if it fails to defend and investigate the claim.

Another example: An injured party files a suit for damages directly against the insurance company, but the motion is rejected by the court because there are no legal grounds for action. There is no contract between the claimant and the insurance company, and the company has no obligation to the claimant at this point.

A claimant has no right to sue the insurance company before two issues are fully resolved—liability and the amount of damages. The insurance company may voluntarily settle a loss by agreement without going to court, but it has no obligation to do so or to step in and pay on your behalf until damages have been awarded.

The claimant's initial legal right of action is only against you, not the insurance company. So no one has a right to "join" (draw in) the insurance company to any legal action against you.

A third example: A claimant files an initial suit against both you and the insurance company, because it is known that you have insurance coverage. The motion is rejected because the only course of action is against you. The insurance company cannot be drawn into an action to determine liability against you.

SEVERABILITY OF INSURANCE

Liability insurance, like any other form of insurance, applies separately to each insured listed in the Declarations. *Severability of insurance* means that each insured, as defined in the policy Declarations, has the same rights and obligations that would exist had a separate policy been issued to each insured. However, this severability does not increase the limits of liability under the policy.

SUBROGATION

Simply explained, *subrogation* means that, once the insurance company has paid for a loss sustained, it has all the rights in or to that claim. An example: Your neighbor loses control of his car and crashes into your living room. Your insurance company, after paying you, has the right to sue your neighbor for the damages he caused. However, if before any loss occurs you waive in writing all rights of recovery against any person, then the company no longer has the right of subrogation. However, if you did not do this, and the company does subrogate the loss, you must sign and deliver all necessary papers and cooperate with them in any reasonable way they might request to collect from your neighbor.

Subrogation does not apply to medical payments to others or damage to property of others.

So, if your coworker's new Mustang was parked out front when the crash occurred, your insurance company can't sue your neighbor for the cost of the damage to the Mustang. And, if your coworker happened to be checking the air on his tires when the crash occurred, sustaining a severe head injury, your insurance company can't sue your neighbor for your coworker's hospital costs either.

In umbrella coverage disputes, subrogation isn't a technicality—it's a big deal. The 1991 Minnesota Appeals Court decision *American Family Mutual Insurance Co. v. Continental Insurance Co.* illustrates this point.

Franklin Robbins was killed in 1989 when he fell out of a friend's car. Robbins's estate sued the driver, who had an auto policy with Continental, and the owner, who had auto *and* umbrella policies with American Family.

In 1990, the trial court approved a settlement of Robbins's suit in exchange for a $200,000 payment from American Family.

American Family then sued Continental to recover $100,000 of the settlement. There was no dispute that American Family was obligated to pay $100,000 under its auto coverage.

The trial court ordered that the remaining $100,000 be paid by Continental under its auto coverage

rather than by American Family under its additional umbrella coverage. Continental appealed.

Both insurance companies assumed that American Family's auto policy was first in line and therefore liable to pay up to its $100,000 limit. Each of the remaining policies, Continental's auto policy and American Family's umbrella policy, contained an "other insurance" clause that made the other policy second in line to pay the balance of the settlement.

The appeals court wrote:

> When it is clear that a loss cannot be apportioned without violating the other insurance clause of at least one policy, the deadlock must be broken by determining which coverage was effected for the primary purpose of insuring the risk at issue, and which coverage only incidentally insured the risk.

Courts also consider whether the policy insuring intent, as determined by the primary policy risks and the function of each policy, indicate that one policy preceded another. The existence of other insurance exclusions can not change the character and intent of the policies.

TERMINATION AND NON-RENEWAL

If you want to cancel your policy, you must return it or mail a notice specifying the cancellation date to insurance company. The insurance company may cancel the policy for nonpayment of

premium, or for any other reason during the first 60 days that coverage is in effect, by mailing a notice of cancellation to you at least 10 days in advance.

After the policy has been in effect for at least 60 days, or after it has been renewed, the insurance company may cancel for any reason other than nonpayment of premium by mailing a notice of cancellation to you at least 10 days in advance.

An insurance company may elect not to renew your policy. If the insurance company decides not to renew the policy, it is required to give notice of non-renewal at least 30 days in advance.

If the policy is canceled, any unearned premium is refunded to you on a pro rata (proportional) basis. For example, if the policy was issued for a full year (365 days) and it is canceled 73 days prior to the expiration date (20 percent of 365 days), 20 percent of the premium is returned to you.

TRANSFER OF INTEREST

You may not assign any rights or duties under the policy to anyone else without the written consent of the insurance company. However, if you die, the insurance company covers your legal representative, while acting within the scope of his or her duties, for the remainder of the policy period.

UMBRELLA COVERAGE

The term *umbrella* is based on the fact that an umbrella policy is a separate policy over and above any other liability policies that you may have.

So, with respect to personal liability coverage, an umbrella policy is designed to provide liability insurance on an excess basis, over any other valid and collectible insurance (underlying primary coverages), as well additional liability coverages.

The practical application of this clause varies, depending on the other insurance, since duplication of coverage often ends up with both companies contributing to payment of a loss.

UNDERLYING POLICY

Underlying policy or *underlying insurance* means any insurance policy that provides the initial or primary liability insurance covering one or more of the types of liability listed in the deductible section of the Declarations Page.

> Your auto policy and homeowners policy are underlying policies to your umbrella policy.

A consistent problem with umbrella coverage is that policyholders try to use it as a cure-all to insurance problems. Umbrella coverage doesn't protect your from every risk in the world—it's excess insurance for whatever primary, or underlying liability policies you have.

VICARIOUS LIABILITY

Vicarious liability is created by a minor or other dependent for whom an insured person acts as

guardian. In most cases, the guardian can be held liable for the minor's behavior—even though the guardian played no direct role in the loss.

CONCLUSION

More definitions will be provided throughout the book to help you understand the ins and outs of insurance and the tricky subject of liability in common and obscure situations. The object of this chapter was to tackle a few of the most basic definitions that apply to insurance and that you'll encounter when it's all your fault!

3

OWNING A HOME IS A TARGET ON YOUR BACK

The first time that most people realize they have assets worth protecting from lawsuits—spurious or not—is when they buy their first house. It's one of the bracing lessons of financial maturity; saving enough money to put everything you have down on the best old Victorian in a marginal neighborhood exposes you to the potential of a writ of attachment from the unemployed neighbor who slips and cracks his head on your porch while leaving a complaint about your barking dog.

Welcome to home ownership.

If you own a house, the odds are that your homeowners insurance policy is your main protection from personal liability claims. You may not have thought about this when you were pricing homeowners policies—most people don't. But mortgage lenders do. That's why they want to have insurance in place before you close on that shabby chic Victorian. The lenders know that homes are the main mechanism by which people build financial net worth. And this net worth needs to be protected.

The liability portion of the homeowners policy is designed to protect assets if you are sued by someone who is injured—physically, mentally or otherwise—while on your property. But this coverage is a mixed bag. Insurance companies will usually pay out losses for property damage...but they can turn stingy about paying for liability claims.

Two cases in point, each with very different outcomes:

- In the 2000 federal appeals court case *Nikki David v. Tanksley, et al.*, a family sued its homeowners insurance company, seeking coverage for burn injuries sustained by a bystander when they attempted to start a Chevy Impala that had been in storage. The court determined that the car was not in "dead storage"—as it had to be in order to be covered by the policy (instead of a separate auto policy). So, the insurance company did not need to defend the Tanksleys or indemnify the bystander. For the injuries suffered by the bystander, the Tanksleys had to pay $500,000—out of pocket. Goodbye home equity.

- The same year, in the Missouri Court of Appeals case *American Family Mutual Insurance Company v. Bramlett*, the insurance company argued that the business pursuits exclusion negated liability coverage for a lawnmower accident that injured a child being cared for in the policyholder's home. (The

idea was that the family that owned the house was running a childcare business there.) At trial, the court determined that mowing the lawn constituted a "non-business pursuit." So, the insurance company had to provide liability coverage for the injury.

These two cases deal with disparate elements to a homeowners policy.

In the first case, the Tanksleys' policy would normally have covered liability for bystanders injured on or near their property. However, the trial court noted: "The Tanksleys' homeowners policy excludes from coverage any 'bodily injury or property damage arising out of the ownership, maintenance, use, loading or unloading of motor vehicles.'" A homeowners policy only covers injuries caused by a car in dead storage. It will cover damages caused by the garaged '63 Spitfire you've been restoring (but not driving) for 15 years...but it doesn't cover damages caused by the temperamental '69 GTO that you are jump-starting so you can get to the Black Crows concert in style. You're supposed to have an auto policy for that.

In the second case, a more common question comes up. Namely, what constitutes business versus non-business pursuits? If you work at home—even part-time—you should pay attention to this.

The standard homeowners policy excludes coverage for anything related to business pursuits at home. In the Bramlett case, the wife was watching kids part-time for money. One of these kids was hurt when the husband was mowing the lawn.

The court concluded that, even though the wife was running a childcare business out of the house, mowing the lawn was not a business activity. The child was not injured because he was there as a client...he was injured in a way that might have happened in the normal course of hanging out with the neighbors.

A legalism: There was no allegation of negligence on the policyholder's part. If there had been, things might have been different. That might have dragged the part-time childcare business into the dispute. As it stood, even though the caregiver provided a service out of her home, these pursuits and the circumstances whereby the child injured himself did not meet the exclusionary rules of the homeowners policy.

ORIGIN OF HOMEOWNERS' RISKS

A hundred years ago, U.S. government regulations prevented property insurance companies from selling liability insurance. (By the same token, liability insurance companies couldn't sell property insurance.) So, a homeowner had to purchase two or more policies, often from different companies, to obtain total insurance protection.

In the 1940s, these regulations changed. These days, standard homeowners policies (there are several, designed for single-family houses, condos and other kinds of residences) provide liability automatically in addition to the property coverages. The combination of two or more types of coverage into one policy is called a *package policy*.

By combining property and liability coverages, the insurer reduces processing costs, determines losses more accurately, and passes these savings on to the consumer in the form of lower premiums.

If an accident occurs on your property, anyone who is hurt can hold you financially liable for his injuries. In the above cases, both families were named as defendants in cases that involved unintentional accidents to guests on their respective properties. The liability coverage in most homeowners policies applies to the injured person's claim and the cost of defending you—the homeowner—if you are sued.

And the injury doesn't have to occur on your property. The standard homeowners policy's liability protection applies to injuries that an insured person causes anywhere in the world.

Who's an insured person?

An *insured* includes the named insured, a spouse and relatives resident in the household, as defined on the policy. So, if your mother-in-law lives with you, an upside is that your standard homeowners policy covers any damages she causes. Other than the intentional psychological wounds to you.

In addition, an insured includes any person or organization legally responsible for animals or watercraft owned by an insured household member. What does this mean? If your son's Boy Scout troop takes your pet wolverine or your boat on a camp-out and the animal or watercraft causes harm to someone, you're covered.

MECHANICS OF COVERAGE

There are two kinds of coverage provided under the liability section of a homeowners policy. The first is *personal liability* coverage. This pays an injured third party for losses which are due to the negligence of the insured, and for which the insured is liable. The second is *medical payments* to others. This covers necessary medical bills incurred within three years of an accident causing bodily harm—including reasonable charges for surgical, x-ray, dental, ambulance, hospital, professional nursing, prosthetic devices and funeral services.

Medical payments coverage does not apply to medical expenses related to injuries of the named insured or any regular resident of the household, except residence employees (maids, gardeners, etc.).

At the *insured location*, coverage applies only to people who are on the insured location with the permission of an insured. Away from the insured location, coverage applies only to people who suffer bodily injury caused by:

- an insured person;
- an animal owned by or in the care of an insured;
- a residence employee in the course of employment by an insured; or
- a condition in the insured location or the ways immediately adjoining.

In some cases, these costs are simply determined; in other cases, the facts may be unclear—and the

insured may or may not be legally liable. In these cases, the insurer will often pay medical costs as a goodwill gesture to avoid any legal action.

Example: A visitor to Melvin's home slips and falls on the front steps. The slip results in a lightly sprained ankle and medical expenses in the amount of $475. Later, the visitor sues Melvin for $10,000, claiming damages for negligence. The insurance company will pay the $475 quickly, in hopes of preventing the larger lawsuit; but it's going to investigate the negligence claim thoroughly—and will probably take some time doing so.

The insurance company has plenty of incentive to avoid lawsuits. Under the standard homeowners policy, it will provide a legal defense against claims—even if the claims are groundless, false or fraudulent. So, its adjusters and investigators are trained to pay simple claims quickly and hammer questionable claims hard.

Both personal liability and medical payments coverage have limits; medical payments coverage is usually much lower than personal liability. Unless you ask otherwise, you'll get the basic limits of these coverages, which are the minimum amounts available. (Of course, higher limits of liability can be purchased for additional premiums.)

Remember: **Personal liability insurance applies separately to each insured person, but total liability coverage resulting from any one occurrence may not exceed a limit stated in the policy.**

Example: Melvin and his sister are both walking the dog when it bites Ethel; they both are named in the resulting lawsuit. However, their homeowners policy only covers them up to the single limit. If Melvin had been involved in one dog bite and his sister another, the policy covers each separately, up to the limit.

PREMISES LIABILITY

As a homeowner, you carry heavy liability burdens related to things as simple as a slippery staircase or a serious pitfall to things less obvious: airborne contaminants, water temperatures, etc..

Example: A January 2000 Georgia state court decision pitted two friends against each other when one visited the other's home, sustained second-degree burns in the shower and accused the owner—her friend—of negligence. The case, *Waldo v. Moore*, provides an interesting look at how state laws come into play in some liability cases, and how, as a homeowner, there's really nothing you *can't* be held liable for.

Alice Waldo, who had visited Margaree Moore's home previously and bathed without incident, took a shower one morning after staying over. When she turned on the hot water, she failed to test the flow before immersing herself in the water—which was approximately 130 degrees Fahrenheit. Waldo (in her sixties) slipped and fell—and remained there until others heard her cries.

Moore, who had raised the thermostat on her water earlier in order to wash clothes, did not in-

form Waldo of the temperature change. Waldo claimed that Moore's "intentional conduct in increasing the water temperature combined with [her] negligent omission in failing to mention this fact when [Waldo] announced the intention to bath...amounted to willful and wanton negligence for which [Moore was] liable."

According to Georgia premises liability law, a homeowner owes a social guest protection to the extent that he or she refrains from inflicting "willful or wanton injury." There is no duty of keeping the premises up to any standard of safety, except for pitfalls, mantraps and things of that type. Thus, the court entertained two questions:

1) Does scalding water in the shower constitute a hidden peril?

2) Does the defendant's action amount to willful and wanton negligence?

The appeals court said yes to these two questions. Although other judges filed dissenting opinions, Moore—and her insurance company—became liable for her guest's unfortunate accident.

Even when it comes to friends and happy sleepovers, there are situations that can occur for which a policy can cover—and save—you from the expensive consequences. This particular case was no exception.

DUTY TO DEFEND

The first key issue in liability coverage is the insurance company's duty to defend a policyholder.

This means that if you are sued by a third party, the insurance company must cover the cost of a defense—even though there's been no determination about whether you are guilty or liable.

As we have seen—and will see again, throughout this book—this duty to defend is a critical matter in liability cases, which are often determined in the early stages of litigation. (Personal injury lawyers taking cases on contingency will often scram if they don't score a strong legal victory in the early stages of a suit.)

Of course, an insurance company's duty to defend has some limitations. The 1996 Missouri Court of Appeals decision *Loretta McDonough v. Liberty Mutual Insurance* considered a few of these.

McDonough was a trustee of the Terrace Gardens Subdivision in suburban St. Louis. Terrace Gardens refused the request of a Michael and Teresa Schiff to build a hockey rink on land within the subdivision that they—the Schiffs—owned.

The Schiffs sued the Terrace Gardens Subdivision trustees, including McDonough. The trustees didn't have insurance through the subdivision, so each had to rely on his or her personal insurance to respond to the Schiff's claims.

McDonough had two relevant policies from Liberty Mutual—a homeowners policy and a personal catastrophe liability or umbrella policy (we consider umbrella insurance separately later in this book). She notified Liberty Mutual and asked the company to defend her against the Schiff's claims.

Liberty Mutual refused to provide McDonough's defense, claiming the policies she had purchased didn't provide coverage for the type of claims asserted by the Schiffs. It argued that she needed separate insurance for her actions as a trustee.

McDonough didn't have time to bicker with Liberty Mutual. She hired an attorney and financed her own defense to the Schiff suit. (The case was tried by a Missouri state court, which found in favor of McDonough and the other trustees.)

Between Liberty Mutual's refusal to cover her expenses and the court ruling in her favor, McDonough sued Liberty Mutual for breach of contract and "vexatious refusal to pay."

In that separate lawsuit, the state trial court issued a summary judgment for McDonough. Liberty Mutual appealed.

The insurance company argued that the trial court had made a mistake in its interpretation of the policies. It insisted the Schiffs' suit wasn't covered.

Before making its decision, the appeals court reiterated how it handles these sorts of disputes:

> When determining an insurer's duty to defend, we look to the insurance policy provisions and the allegations of the petition charging liability to the insured. Unless the facts alleged in the petition come within the coverage of the insurance policy, the insurer has no duty to defend the insured.

Liberty Mutual argued that its policies provided "coverage only when a claim or lawsuit alleged money damages as a result of an occurrence producing bodily injury or property damage or personal injury." The insurance company based its denial of coverage on three grounds:

1) the Schiffs' petition did not request monetary damages;

2) no "occurrence," as defined by the homeowners policy, took place; and

3) the Schiffs sustained no direct bodily injury or property damage as a result of McDonough's actions.

McDonough argued that neither policy explicitly stated that damages meant monetary damages and that the term "occurrence" was ambiguous.

Again, the court was careful to reiterate its role:

> In construing insurance policies we are to give the language of the policy its ordinary meaning. Unless an ambiguity exists or statute or public policy require otherwise, the policy must be enforced as written.... Ambiguity exists when the language of an insurance policy reasonably and fairly is open to different constructions. Ambiguity [also] arises when there is duplicity, indistinctness or uncertainty in meaning.

The appeals court cited Black's Law Dictionary, which defines damages as "[a] pecuniary compensation or indemnity...[a] sum of money awarded to a person injured by the tort of another." It also

cited Webster's Collegiate Dictionary, which defined the word as "compensation in money imposed by law for loss or injury."

Using these definitions, the court concluded that the term *damages*, as used in the policy, was limited to monetary damages and did not include the Schiffs' claims. (The Schiffs hadn't sued for money; they'd sued for permission to build a hockey rink.)

Next, the appeals court had to consider whether Liberty Mutual's use of the term *occurrence* was ambiguous. The policy covered "bodily injury or property damage caused by an occurrence." It then defined occurrence as an accident, "including...exposure to...harmful conditions."

In the dispute between McDonough and the Schiffs, there had been no accident or exposure to harmful conditions of any type. So, the court concluded there had been no occurrence.

The court elaborated this point:

> The Schiffs were prevented from installing a hockey rink on their property by the act of a governing body, the [Terrace Gardens] board of trustees. The homeowners policy issued to [McDonough] provides no coverage for acts of governing bodies, and consequently, Liberty Mutual was not obligated under the homeowners policy to defend [her] in the Schiffs' lawsuit.

The court also found there was no coverage under the umbrella policy.

On a separate—and much weaker—point, McDonough argued that Liberty Mutual should have defended her because of representations made by Donald Schweppe, the Liberty Mutual agent who'd sold her the policies. She said that Schweppe had assured her the homeowners and umbrella policies would protect her in her capacity as trustee.

The court didn't give this argument any credence:

> We follow the general rule that an insurer's agent cannot bind an insurer by a construction of a policy which is contrary to the plain meaning of language used in the policy and would vary its terms. Liberty Mutual is not bound by the representations of its agent which contradict the language of the policies....

The policies clearly did not cover McDonough. Liberty Mutual didn't have to defend her. If McDonough had wanted coverage to protect her in her capacity as trustee, she should have purchased directors and officers liability insurance.

ADDITIONAL COVERAGES

The personal liability coverage in a homeowners policy provides three kinds of insurance in addition to the stated limits of liability:

- claim expenses,
- damage to the property of others, and
- first aid to others.

Claim expense coverage includes the costs of defending a claim, court costs charged against an insured and premiums on bonds that are required in a suit defended by the insurance company.

Expenses incurred by the company, such as investigation fees, attorneys' fees, witness fees and any trial costs are covered by the policy.

If any bonds are required of you in the course of lawsuit, such as release of attachment or appeal bonds, the company pays the premium for such bonds but is under no obligation to furnish the bonds. That is your responsibility.

When the insurance company requests your assistance in investigating or defending a claim, reasonable expenses—including loss of earnings up to $50 per day—are usually covered.

Claim expense insurance also covers postjudgment interest, which accrues prior to actual payment. If a judgment is rendered against you, there usually is a time lapse between the rendering of the judgment and the payment of the damages awarded. The company pays any interest charges accruing on the damage award during this time period.

Expenses for first aid to others—an injured third party— are covered when the charges are incurred by an insured person—and when the charges result from bodily injury covered by the policy. So, you're covered for your attempts to be a good Samaritan. However, expenses for first aid to an insured are not covered.

If you damage the property of others, the policy provides replacement costs on a per occurrence limit. This additional coverage won't pay for:

- damage caused intentionally by an insured person who is at least 13 years of age (there has to be some cutoff age, otherwise this would cover the intentional acts of insured adults);

- property owned by you, because this coverage is designed to cover property owned by others; or

- property owned or rented to a tenant or a person who is resident in your household.

Example: Melvin borrows a camera from his neighbor and accidentally drops it in his swimming pool while taking pictures. His policy provides up to $500 to replace the camera. However, if Melvin willfully throws the camera into the pool, screaming "I hate you, you bastard, and I'm going to wreck your camera," there will not be any coverage. Unless Melvin is the 10-year-old son of the guy who owns the house—in that case, the policy will pay. Got it?

COVERAGE CONDITIONS

The liability coverage in a homeowners policy has a number of other conditions, which can limit its applicability. These conditions include:

- The bankruptcy of an insured person does not relieve the insurance company of its obligations under the

policy. (We'll consider this issue in greater detail in Chapter 9.)

- Personal liability coverage is treated as excess over any other valid and collectible insurance—unless the other insurance is written specifically as excess over the personal liability coverage.

- Your duties in the event of a covered occurrence include providing written notice identifying the insured involved, your policy number, names and addresses of claimants/witnesses, and information about the time, place and circumstances of the occurrence.

- You are also required to promptly forward every notice, demand or summons related to the claim and, when requested, to assist in the process of collecting evidence, obtaining the attendance of witnesses and reaching settlement.

- You are not supposed to assume any obligations or make any payments (other than first aid to others following a bodily injury), except at your own expense.

- Payment of medical costs to others is not an admission of liability by you. When medical payments are made, the insured or someone acting on the behalf of the injured person has to provide written proof to support any claim. The injured party must submit to a physical examination, if requested

by the insurance company, and autho-
rize the company to obtain medical
reports and records.

A standard policy will also pay a certain amount—
usually up to $1,000—for your share of any
homeowners association or condominium loss
assessment made because of bodily injury or prop-
erty damage occurring on jointly-owned property.
(But, as McDonough found out, there have to be
real money damages sought for this coverage to
kick in.) Higher limits are available.

However, if a local government makes a charge
against your association, your share of the loss is
not covered. (This coverage would apply if you,
as a volunteer officer of the association, were sued
individually, too.)

Some states allow coverage for domestic employ-
ees under the personal liability coverage—but this
is not usually the case. Usually, a domestic must
work a specified number of hours a week or re-
side on the premises in order for coverage to be
mandatory. So, if your housekeeper is grocery
shopping for your kids and slips in the store,
breaking her arm, there may be coverage under
your homeowners policy. If she's shopping for
personal reasons though, there is no coverage.

COVERAGE EXCLUSIONS

Insurance companies love exclusions—the legal
loopholes under which they don't have to pay
claims. They fill standard policies with exclusions.
In fact, any time you read a standard insurance
policy, one of the best places to start is with the

exclusions (and proceed carefully, there may be more than one exclusion section in a single policy).

In standard homeowners liability coverage, there are three major exclusions. We've seen some elements of each of these already, but they are worth considering in detail.

The first major exclusion is business activities. (We consider the liability risks posed by home-based businesses in greater detail in Chapter 6.)

Liability assumed under a written contract is covered, as long as the contract is personal in nature. There is no coverage for business-related contracts or activities. Personal liability coverage is not a business policy—it only covers personal activities and exposures. The standard policy form itself states:

> Any liability arising purely out of the insured's occupation or business and/or the continual or permanent rental of any premises to tenants by the insured is excluded.

However, there are some activities which can be construed as business activities but are specifically covered under the policy as exceptions to the exclusion. Among these:

> ...the insured may rent out the residence and be covered by the policy under limited circumstances....

> ...A portion of a residence might be used for professional purposes, such

as a beauty parlor or physician's office...[but]there is no coverage for professional liability arising out of these activities.

The second major exclusion: Injury to members of the insured household.

Lawsuits between people covered by the same policy are excluded. Before this exclusion was added to the standard policy, some courts permitted family members to sue other family members and collect damages. The Utah Supreme Court considered exactly this kind of claim in its 1992 decision *Blaketta Allen v. Prudential Property and Casualty Insurance Co.*

In 1981, Allen's husband met with a Prudential agent to discuss homeowners insurance. During the meeting, Mr. Allen completed an application for a policy under which Prudential would insure the Allens' home and provide liability coverage against accidents occurring on the property.

The Allens received the policy in the mail approximately two months later. Attached to the policy was an endorsement excluding members of the Allens' household from liability coverage. Neither Allen nor her husband read the endorsement.

Three years after the agreement went into effect, the Allens' two-year-old son was injured when Mrs. Allen spilled a pot of boiling water on him. After the accident, Mr. Allen contacted the Prudential agent, seeking recovery against the policy for his wife's accidental injury of his son. Based on the household exclusion, Prudential denied coverage.

Mrs. Allen sued, seeking to invalidate the exclusion on the grounds that the existence of the exclusion violated her reasonable expectations of coverage. The district court dismissed the lawsuit.

Mrs. Allen appealed. She argued that the household exclusion should be held unenforceable because it violated her reasonable expectations.

The Utah Supreme Court, considering this argument, classified *reasonable expectations* claims into three groups:

- construction of an ambiguous term in the insurance contract to satisfy the insured's reasonable expectations;

- refusal to enforce the fine print of an insurance contract because it limits more prominent provisions giving rise to the insured's expectations; and

- refusal to enforce an insurance contract provision when it would frustrate the reasonable expectations of coverage created by the insurer outside of the contract.

The court didn't find any of these applicable to the Allens' case. The Prudential policy clearly stated that coverage was excluded for "any Insured under...the definition of Insured." It then defined insured as "residents of the Named Insured's household, his spouse, the relatives of either, and any other person under the age of twenty-one in the care of any Insured." The exception clearly meant no medical payments coverage for Allen's son.

The homeowners policy is not meant to be a substitute for accident and health insurance—and this exclusion makes it clear that there is no coverage for an injury suffered by the named insured or other family members in the same household.

The third major circumstance: intentional acts of an insured person or acts that can be expected to produce bodily injury or property damage.

So, if you mean to hurt someone, your homeowners insurance won't cover the damages.

In early 1991, Ariel Hessing sought coverage under his father's homeowners policies for his former girlfriend's claims for medical costs and other damages. Hessing had pleaded guilty to beating the woman at his father's New Jersey home in 1985. Her civil lawsuit against him was pending.

New Jersey State Superior Court Judge Burton Ironson dismissed Hessing's claim, ruling that the insurers didn't have to provide coverage—even though Hessing *was* a family member living in his father's home—because the act was intentional.

"The decision sends a signal that people who lash out at their wives or girlfriends will have to personally pay and cannot transfer the responsibility to an insurance carrier," said Lawyer James Rothschild, of Pennsylvania-based Harleysville Mutual Insurance, a company involved in the case.

In addition to the above exclusions, there are other circumstances in which homeowners insurance does not cover liabilities, including:

- a loss assessment charged against the named insured as a member of an association or corporation;

- rendering or failure to render professional services;

- transmission of a communicable disease by an insured person;

- sexual molestation, corporal punishment, or physical or mental abuse;

- the use, sale, manufacture, delivery, transfer or possession by any person of controled substances (illegal drugs), other than legitimate use of prescription drugs ordered by a physician; and

- entrustment by an insured person of an excluded vehicle, watercraft or aircraft to any person, or vicarious parental liability for the actions of a minor using any of these items.

The first two are best covered by business or professional liability policies. The others are basically reiterations of the intentional act exclusion.

RISKS POSED BY VEHICLES

One of the most dangerous activities anyone can undertake is driving a motorized vehicle—be it a car, a golf cart or a boat. And the dangers posed aren't just personal—vehicle accidents are the most common cause of liability claims. A reasonably smart person might suppose that vehicle accidents and homeowners insurance come together in a lot of liability claims. They do. And, they do often.

We've already considered the distinction between liabilities caused by your house and your car. That's easy. But what if it's not your car that creates a liability? And what if it's not a car at all?

Homeowners insurance does not apply to any exposure—even liability—created by driving any vehicle that is registered and tagged with a state motor vehicle administration. There is also no coverage for liability arising out of vehicles that you own, operate, rent or borrow. These vehicles should be covered by an auto policy.

However, there is coverage for the *vicarious liability* created when a member of your household drives someone else's vehicle.

Vicarious liability is a nasty proposition. It can make something all your fault...even when it's not—strictly speaking—your fault.

Example: Melvin is sued for damages caused by his 12-year-old daughter, who went joy riding with his car. Sadly for Melvin, there is no coverage under his homeowners policy because of a vicarious liability exclusion for his own cars. However, if his reprobate daughter had borrowed a neighbor's car, Melvin could claim coverage under the policy. Its exclusions only apply to his family and his cars.

Liability involving the following types of unregistered vehicles is covered under a standard homeowners policy:

- a trailer parked on an insured premises;

- an off-road recreational vehicle that you rent, borrow or own—as long as it is used only at an insured location;

- damage or injuries involving golf carts, when used for golfing; and

- motorized lawn mower tractors, electric wheelchairs and similar vehicles in dead storage.

The watercraft exclusion is very similar to the motor vehicle exclusion. Large boats are more appropriately covered by boat or yacht policies. However, liability claims involving the following types of boats are covered:

- motorboats with inboard or inboard-outboard motors that you don't own;

- motorboats with outboard motors of greater than 25-horsepower that you have owned since before inception of the insurance contract—as long as the insurance company is notified of the exposure;

- motorboats with outboard motors of greater than 25-horsepower that you acquire during the policy period;

- sailboats that you own—as long as they are under 26 feet long (a homeowners policy will cover bigger sailboats, as a long as you don't own them); and

- boats in storage, regardless of size.

The standard homeowners policy includes an aircraft exclusion similar to the other vehicle exclu-

sions. A hang glider would be considered an air-craft, and would be excluded since it is designed to carry a person. Of course, if you shake up your passengers while you're flying the Gulfstream V you bought after the big IPO, your homeowners policy isn't going to be of any use.

On the other hand, liability involving model planes, including remote-controled model planes, is covered. And that's a more likely risk for the majority of us who are not executives at Oracle.

CHARGES OF NEGLIGENCE

We've dispensed with most of the technicalities that can jam up liability coverage under a stan-dard homeowners policy. That done, the main issue you need to consider is when someone ac-cuses you of negligence with regard to damages he or she has suffered. Negligence makes the money in question go up. It also makes insurers nervous.

A good example of a case in which negligence played a role was the 1999 Illinois state court deci-sion *Timothy Koonce v. Pacilio*. If you think a backyard is a safe place to play (and to send chil-dren to play), then think again.

On April 10, 1992, 10-year-old Timothy Koonce was playing with nine-year-old Nello Pacilio, in the Pacilio family's backyard. The boys were shak-ing and hanging on a clothesline when it snapped and struck Timothy's left eye, making it bleed.

Although Nello denied seeing any wire hit Timo-thy in the eye, he said there were no rocks nearby

and that they were not playing with pencils or anything sharp at the time. It was later determined that the lines had indeed caused the injury.

Through his parent and natural guardian, Timothy brought a premises liability action against the Pacilios, alleging that he was injured when a clothesline on their property snapped and a wire connected to the clothesline punctured his left eye. An Illinois court entered judgment on jury verdict for the Pacilios. Timothy's lawyers appealed.

On appeal, the court held that:

- the Pacilios' lawyer's improper arguments to the jury, including implying that the Pacilios had no insurance, required a new trial;

- refusal to give missing evidence instruction was an abuse of discretion; and

- exclusion of evidence that one of property owners had previously been a defendant in another premises liability action was not an abuse of discretion.

At trial, Timothy's lawyers argued that the Pacilios carelessly and negligently maintained their premises by permitting a clothesline to exist on the premises in a dangerous condition; by failing to warn of that condition; by failing to properly fix, repair and maintain the clothesline; by permitting minors to play in the area of the clothesline; and by failing to properly supervise the minors. They also contended that Timothy was injured when

the clothesline snapped and a wire punctured his eye causing permanent loss of vision in that eye.

After deliberation, the jury returned a verdict in favor of the Pacilios.

On appeal, Timothy's lawyers argued for a new trial, insisting that the Pacilios' lawyer's closing argument was improper and highly prejudicial— it falsely suggested to the jury that the Pacilios had no insurance and would bear the burden of any judgment entered against them.

The appeals court agreed with Timothy's lawyers' arguments. It stated:

> It is well settled that it is improper to inform the jury, either directly or indirectly, that the defendant is, or is not, insured against...liability on a judgment that might be entered against him in a negligence action.... Likewise, a defendant cannot suggest to the jury that a defendant would be personally responsible for satisfaction of the judgment entered when the defendant has insurance or will be indemnified.

Courts have determined, through various cases, that evidence of insurance or lack of it is irrelevant to the issue of negligence. Such evidence may influence a jury in determining in which party's favor to render a verdict, and in determining the size of the verdict.

The mere mention of insurance or lack thereof does not automatically require reversal and remand

for a new trial. But, if undue emphasis is placed on the irrelevant evidence, or if the jury's verdict is affected by it, then reversal is warranted.

The appeals court concluded that the Pacilios' lawyer's closing remarks improperly attested to their honesty and character and inaccurately summarized the evidence presented at trial. All in all, defense council aimed "to portray the defendants as faultless uninsured homeowners." The court ordered another trial—but the Pacilios' insurance company didn't want to go through the same problem again. It suggested a settlement.

SOCIAL HOST LIABILITY

If you host a New Year's Eve party, serve spiked eggnog and bottles of André Rosé, there may be laws that govern your responsibility as a dispenser of liquor (if not your taste in sparkling wine). Technically, you are considered a *social host* and in some states *social host liability* applies to you. In at least 21 states, statutory liability extends to noncommercial servers. In 10 other states, similar liability has been established by common law.

A social host's responsibility for the actions of drunk guests was first addressed in a 1984 New Jersey State Supreme Court ruling that a private host serving liquor could be held liable for a drunk guest's subsequent motor vehicle accident. The court's decision did not apply, however, to situations when there are parties with many guests, when guests serve each other, or when a host is busy with other responsibilities and is not serving liquor or when the host is drunk.

Subsequent rulings—particularly one in 1988—tempered that law even further, limiting social host liability. However, courts in some states have ruled that social hosts are not liable and that this is a matter of public policy, which should be decided by the legislature. In at least three states—Missouri, Washington and Colorado—courts have decided that social hosts cannot be treated under the law the same way as those who sell drinks for a living.

Most of the liquor liability cases heard in state appeals courts in the 1990s limited social host liability. In Texas, for example, a court ruled in 1993 that the drinker, not the social host, is responsible for the driver's behavior. Supreme Courts in only four states have imposed liability on social hosts and in two of those states—California and Iowa—laws were later passed that abolished court-imposed social host liability. In Michigan, social hosts of a party where minors consume alcohol are not liable for criminal acts of their guests other than alcohol-related auto accidents.

In 1999, the Vermont Supreme Court rejected an appeal in a case that sought to make property owners liable for deaths or injuries resulting from unauthorized drinking on their property. The ruling stated that social host liability would not apply if the land owners are neither present nor furnish the alcohol.

A Massachusetts Appeals Court decision in late 1995 expanded social host liability in that state. The court said that bar patrons who "pick up the tab" can be held liable if the person for whom they buy drinks injures others by negligently op-

erating a motor vehicle. The case concerned an uncle who paid for his nephew's drinks at a bar and then allowed him to drive home. En route, the nephew was stopped by police for speeding and received a warning. Soon after, his car collided head-on with another car after drifting into oncoming traffic. The plaintiff won a $1.2 million verdict against the nephew, uncle, the bar and the Commonwealth of Massachusetts; all but the nephew appealed. The appeals court reversed the judgments against the bar and the Commonwealth, but ruled that the uncle, by paying for the nephew's drinks, made liquor available to him and he therefore could be liable as a social host.

Does a standard homeowners policy cover this kind of liability? The jury—quite literally—is still out. However, there is little doubt that cases of social host liability—especially stretched to the limit of claims against someone who picked up a tab in a bar—would fall within the duty to defend...and probably the general liability coverage...of a standard homeowners policy.

Until Congress enacts a federal law to define and govern social host liability, you must look toward your state's laws for such guidance. And even those laws are individually interpreted on a case-by-case basis.

DOMESTIC EMPLOYEES

If you own a house and have people come and work there—a once-a-week housekeeper, a live-in nanny or a full complement of livery-wearing staff—you face a certain liability risk with these

domestic employees. We've considered a few extreme examples of these risks before; now, we'll take a quick look at the basic risks they pose.

Domestic employees are no longer a staple of the very rich. Many households today, middle and upper-middle class alike, employ one or more people to perform domestic work. These tasks include cleaning the house, shopping for food, preparing meals and washing clothes, and caring for children and elderly relatives.

If you choose to employ people to perform such tasks without obtaining workers' compensation insurance, as required by law in some states, you are not only failing to protect these people, but you are putting yourself at legal and financial risk.

In New York, for example, the Workers' Compensation Board resolves conflicts when a claim for compensation is filed and a worker's right to benefits is contested. The definition of *employer* under New York's Workers' Compensation Law encompasses not just corporations or partnerships, but any person who has one or more persons in employment. Workers' compensation insurance must usually be provided by an employer as soon as she or he employs one person for any length of time, even as short as one hour.

As an exception to this general principle, however, New York law specifically excludes as employees for whom compensation coverage is required domestic servants who are employed by the same employer for less than 40 hours a week. Also excluded from the law's protection are people

engaged by the owner in casual employment consisting of yard work, household chores and making repairs to or painting in and about a one-family owner-occupied residence.

A person whose only job is to clean a house comes within the definition of a domestic servant. A family who hires someone to clean the home once or twice a week employs that worker for less than 40 hours, so that worker is excluded from the protection of the workers' comp insurance. On the other hand, anyone who employs a house cleaner for more than 40 hours a week is required by law to secure compensation insurance for that worker.

It is far more common for families, particularly those with young children, to hire someone for the dual purpose of performing both housekeeping chores and child care. Does a family need comp insurance for that worker (variously referred to as a *caregiver*, a *housekeeper*, a *nanny* or an *au pair*)? If the employee works 40 hours or more a week there is no question that she or he is an employee who comes within the protection of the law, and compensation insurance must be secured.

Compensation coverage for this kind of employee is not provided by a homeowners policy. An employer must secure compensation benefits separate from the endorsement.

As a practical matter, homeowners who intend to hire a firm or individual on an independent contractor basis should ask for a written agreement setting forth the nature and cost of the work and should also ask for, and retain, the business's own

certificate of compensation insurance. Such factors can help convince a court that a worker was either an independent contractor or the employee of an independent contractor, rather than an employee of the homeowner.

Even if it were safe for a homeowner to assume that his or her part-time household worker would be considered a domestic servant, if that worker files a claim for compensation, other uncertainties abound. Since the 40-hour cutoff is what determines both a claimant's entitlement to benefits and the employer's corresponding obligation to provide insurance, it is not surprising that domestic servant cases before the board often involve an employee claiming he or she worked 40 or more hours and an employer asserting the worker worked less than 40 hours.

In the case of live-in workers, for example, employees argue that their services were continually called on, and that they were required to be available 24 hours a day.

The compensation endorsement in a homeowners liability policy is extremely limited to the situations in which it provides benefits—it was designed to cover only the employee who performs minor, quick jobs around certain homes, not a regularly employed domestic servant such as a home health care aide or a nanny.

CONCLUSION

If damage was caused by you, your spouse, children, or pets to another person or persons on the

premises of your home, you can be held liable. We've also seen that "things"—like your lawn mower, your stored (prized) car and even a steaming, hot shower can hurt guests.

There's no safe haven anymore; homes are dangerous places—breeding grounds for seemingly frivolous lawsuits.

If you think a Christmas tree is a fire hazard, consider how, regardless of the fire hazard, each ornament could harm a curious guest. The lights could electrocute an unassuming toddler. The angel could fall from the top and spike your octogenarian aunt.

Or, in the worst case, your mother-in-law goes into anaphylactic shock because she's highly allergic to Douglas Firs and you failed to warn her that indeed, the tree is real. Later, she sues you for her medical bills (she went into cardiac arrest and remained in the hospital for a week), pain and suffering and of course—lost wages.

Liability coverage is one of the distinguishing characteristics of homeowners insurance. It's what separates homeowners coverage from dwelling or fire coverage. But liability insurance has become so important in the modern marketplace that even this distinction is fading.

Increasingly, liability coverage is added to dwelling and fire policies. When liability coverage is not attached to a dwelling policy directly, it's sometimes written as a separate policy.

It is important to know the different definitions of liability and how they apply to you legally. It is also important to know when limits of liability occur in your insurance policy and when the insurance company stops paying.

4

WHY LIABILITY IS SUCH A BIG DEAL WHEN YOU DRIVE

Driving a car is the most risky thing that most people do in the normal course of their daily lives. Knowing this, most people who drive have auto insurance. Most states require drivers to have at least basic coverage. But driving can result in personal liabilities that a basic policy doesn't cover.

Liability means a very specific thing in terms of auto insurance. If you are at fault in an accident, liability insurance pays for the bodily injury, property damage and intangible losses suffered by the other people in the wreck. It also pays your legal bills if they sue you.

Don't underestimate how many legal claims can come out of an auto accident: tangible losses like medical bills, lost wages, property damage (the other cars, a $10,000 custom stereo, the 200 pieces of lead crystal in the trunk); and intangible losses like pain and suffering...even loss of consortium.

Really. It's shocking how much people claim things like loss of consortium after a car wreck. Some insurance experts estimate that three-quar-

ters of all auto liability claims are for intangible losses.

> An important caveat: If you cause an accident, you can't hold yourself liable for your own injuries. You have to buy separate insurance—usually called *comprehensive coverage*—for your own losses.

Damage you do to yourself is also called *first party liability*. In auto liability issues, you'll often see or hear references to *first party* and *third party*. The third party is the other driver (or drivers...or people in their cars) involved in an accident.

First party liabilities are relatively easy for insurance companies to calculate and control. Third party liabilities are far more difficult.

However, the mere fact that injury or damage has occurred does not necessarily mean that you are legally liable—no matter how much an angry driver or his angry lawyer yells at you.

LIABILITY COVERAGE

A standard auto policy is usually written with a *single limit of liability* per accident, sometimes called a *combined single limit*. It is the maximum amount that the insurance company must pay for all damages arising out of a single accident.

If you have a policy with a single limit of liability of $100,000 per accident, your insurance company

will pay up to $100,000 for all bodily injuries, property damage and intangible loss arising out of an accident—if you are at fault—regardless of the number of persons injured, and regardless of what portion of the loss is bodily injury, property damage or intangible loss.

The minimum liability limits required by law vary from state to state. Several states require that automobile owners have liability coverage in the following amounts:

- $15,000 per person and $30,000 per accident for claims stemming from bodily injury, and

- $10,000 per accident for claims stemming from property damage.

Many experts recommend that your bodily injury liability limits be $100,000 per person and $300,000 per accident. (These are common and widely available amounts.) Even higher limits are available from most insurance companies.

> If you own a home and have any sort of liquid net worth, you probably should buy higher limits than state minimums. If a court awards someone more money than your auto insurance limits, you will have to pay the balance from your own pocket.

Usually, if you lease a car, the finance company will require that you carry higher limits. Since—technically—the finance company owns the car, it

might be held liable for any losses from a wreck that your insurance doesn't cover.

Some insurance companies sell auto policies with *split limits* of liability coverage, and many of the companies that usually write single limits provide split limits on request.

Split limits are frequently expressed as three numbers separated by slash marks. The first two numbers represent the bodily injury limits in thousands of dollars. The third number represents the property damage limit in thousands of dollars.

For example, Washington State's minimum liability coverage is 25/50/10, meaning a car owner must have at least $25,000 of coverage for injury to one person, at least $50,000 for injury to two or more people per accident and a minimum of $10,000 for property damage per accident.

For most people, split limits are the most economical way to carry sufficient auto liability coverage.

LIABILITY LIMITS

But even sufficient coverage has its limits. As we've noted, the *limit of liability* on a policy is the most the company will pay as a result of one accident. This maximum is not increased because several cars are insured on the same policy or because of the number of claims made or the number of vehicles involved in a particular accident.

Also, liability insurance payments are reduced by amounts paid for the same accident on behalf of the liable person. These include direct cash payments, payments made by other insurance coverages (including workers' compensation or disability benefits) and payments made under different sections of the same policy.

For example: Running late for a photo shoot, Darva crashes into Monica, who was on her way to lunch. Darva is at fault for the wreck, which caused $10,000 in damage to Monica's car, $1,000 in damage to the berets and presidential memorabilia in Monica's car and $111 in wages lost while Monica recuperates from the trauma of the wreck. Darva's insurer might have to pay $11,111.

But things go differently. Feeling guilty, Darva spends her own money to replace Monica's berets and presidential memorabilia. And, as it turns out, disability insurance from Monica's job covers her lost wages.

Since they are both honest people, Darva and Monica tell Darva's insurance company about the alternative arrangements. So, Darva's insurance company only has to pay $10,000 to repair the damage to Monica's car.

DEFENSE COSTS

Because defending a lawsuit can be expensive, payment of legal costs is an important part of auto liability insurance. In some cases, the cost of defending a lawsuit can be as much as—or more than—the amount ultimately awarded as damages.

Your insurance company pays unlimited defense costs in an automotive liability suit—and these defense costs are paid in addition to the limits of liability. (If defense costs were included *within* the limit of liability, you'd have to purchase much higher limits of insurance to be adequately protected.)

If your insurer defends against a liability suit and you lose, and if the company delays making a payment, the court might require that interest be paid or an offer of payment is made. This *postjudgment interest* is covered but counts toward your policy's overall limit of liability.

In addition, most policies will pay up to $50 per day for *loss of earnings* you incur because of attendance at hearings and legal proceedings at the insurance company's request. But this coverage doesn't impact most liability limits significantly.

Key point: An insurance company is only obligated to defend claims that are—or may be—covered by the policy. It has no duty to defend a legal claim not covered by the policy. So, if you are being charged with drunk driving (a criminal offense and not covered), your insurer won't pay for your defense.

OTHER LIABILITY COVERAGE

The average person usually carries $25,000 per person per accident in liability. But if you live in a high-cost market, such as a big city, and you need

more than minimum amounts of liability insurance—you may be able to slash your auto insurance bill by hundreds of dollars with a personal liability umbrella policy—and increase your coverage amounts.

Personal umbrella liability policies are stand-alone insurance policies that supplement most other liability insurance you have purchased, including auto policies.

For example: Your auto policy offers $100,000 in liability protection. A $1 million umbrella policy would boost your total car-related liability coverage to $1.1 million. If you cause a major accident—five or six other cars damaged and a dozen injuries—you'll probably have enough coverage.

Umbrella liability policies are usually inexpensive and cover more than very high auto liability limits. (Chapter 5 focuses on umbrellas in detail.)

Key point: An umbrella policy only kicks in when you're sued. It doesn't help you if your house or car is destroyed in a fire or flood.

HANDLING MULTIPLE CLAIMS

One issue that comes up often, in the wake of an accident: How does the insurance company divide a certain liability limit between two people making claims against a single at-fault driver in a single accident?

To be more specific: If your liability limit is $100,000 per accident and there are two other cars involved in an accident you caused, how will each of those drivers' claims be settled?

The insurance company will give each claimant a share of the limit of liability proportionate to his or her claim in relation to the total of all claims submitted.

So, if one driver claims $60,000 in liability damages and the other claims $90,000, the insurance company will give each a proportional part of the $100,000 limit—$40,000 and $60,000, respectively. They'll have to sue you directly for the rest of their claims.

A more common conflict affecting coverage limits: set-off provisions that limit one kind of coverage when another has been claimed.

In the 1982 Nevada Supreme Court decision *Sullivan v. Dairyland Insurance Co.*, an insured's passenger sustained physical injuries that were far in excess of the driver's liability coverage. The passenger sought to collect both the liability and the medical payments coverage from the insurer.

Dairyland relied on a set-off clause that allowed it to deduct medical expenses from the uninsured motorist insurance payment. The state supreme court determined that the passenger could recover under both coverages despite the set off clause because "...the set-off clause only operates to prevent double recovery for the same elements of damage...."

The court concluded that although the set-off limitation was in keeping with the reasonable expectations of the policyholder, it was inapplicable when the damages exceeded the coverage limits.

Obviously, liability is the most important reason most people buy auto insurance. If you cause an accident, the damage you can do to another person's car is usually limited. The damage you can do to that person, however, is essentially unlimited. And in many (unfortunate) cases, damages exceed one's coverage and ultimately, one's ability to make payment.

When you're reviewing or comparing auto insurance policies, remember that the word liability has different meanings for different parties. For you, it's a potentially unlimited downside you want to limit. For the insurance company, it's the obligation taken on when issuing an insurance policy.

Remember: The term *limit of liability*, which occurs throughout the standard auto policy, relates to the insurance company's obligations to you—not your protection against civil lawsuits.

WHAT'S IN AN AUTO POLICY

Simply speaking, there are two kinds of car insurance. There's the kind you're required to have, such as medical benefits, bodily injury and property damage liability. And there's the kind you're

probably going to want, even though it isn't mandated by law.

A typical auto policy consists of six types of coverage—three mandatory coverages and three coverages that are not mandated by law. Your auto policy may include all six of the coverages or only some of them; only four apply to liability.

The six types of coverage include the following:

1. Bodily Injury Liability. Coverage for injuries you cause to someone else. As we mentioned earlier, most states require you to buy bodily injury liability coverage of at least $15,000/$30,000 (the $15,000 pays for injuries to one person; the $30,000 is the total available per accident).

2. Medical Payments or Personal Injury Protection (PIP). Coverage for treatment of injuries to the driver and passengers of your car. At its broadest, PIP can cover medical payments, lost wages and the cost of replacing services normally performed by someone injured in an auto accident. In most states, you must buy at least $5,000 worth of coverage. The typical driver buys $10,000. However, if you have health insurance you may not need it.

3. Property Damage Liability. Coverage for damage you cause to someone else's property. In most states, you must buy at least $5,000 worth of coverage.

Many standard policies include a higher limit—often $25,000. (Of course, if you total your neighbor's Jaguar, you'll need a little more. Although, as part of your property damage liability coverage, your insurance company pays for a rental car for your neighbor while he's getting his Jag fixed, it's considered a loss of use expense. However, your insurance company isn't so generous with you. Loss of use is not part of *your* physical damage coverage; but you can add on rental coverage for a small fee.)

4. Collision. Coverage for damage to your car from a collision. The collision could be with another car, a light post, fire hydrant, etc. Like medical benefits, this coverage is a no-fault coverage. (In other words, it pays— regardless of who is at fault. We'll go over this in more detail later.)

5. Comprehensive. Coverage for damage to your car that doesn't involve a collision with another car. Covered risks include fire, theft, falling objects, missiles, explosion, earthquake, flood, riot and civil commotion. If you're financing a car purchase, most lenders require you to purchase collision coverage. Insurance companies usually give you a $500 deductible, unless you request a different amount. As is always the case, the higher your deductible, the lower your premium.

6. Uninsured Motorist Coverage (UM). Coverage for treatment of your injuries as a result of collision with an uninsured driver. Underinsured Motorist coverage (UIM) can also be included in an auto policy. UIM coverage comes into play when an at-fault driver has auto liability insurance, but the limit of insurance is inadequate to pay for your damages. It usually makes sense to purchase the same level of this coverage that you have for bodily injury liability.

As mentioned above, the mandatory auto insurance coverages in most states include bodily injury liability, medical benefits and property damage liability. The others are not required but most people buy them to protect them from common risks.

MEDICAL PAYMENTS

Medical payments coverage is an optional part of auto insurance. This coverage pays reasonable medical expenses if you, members of your family or any other passengers sustain bodily injuries while riding in your car, regardless of who is at fault. Of course, the insurance company gets to decide what is or isn't reasonable. But the coverage also applies to you and your family members when you're riding in another automobile, or if you're injured as pedestrians by an automobile, so it's well worth the purchase.

This coverage allows immediate payment to you or other covered persons, regardless of who is at

fault, but your insurer may seek to recover the loss from the other party if that party is liable for the accident. All reasonable and necessary medical expenses are covered up to the amounts and within the time specified in your policy.

Medical payments coverage is valuable if you do not have health insurance because payment will be made while liability is being determined. If you already have health insurance, you may only need coverage for expenses beyond what is provided by your primary insurance. Excess medical payments coverage pays for eligible medical expenses not covered by your primary insurer—including deductibles and copayments.

Personal injury protection (PIP) and broader no-fault coverages are expanded forms of medical payments protection that may be required in your state. Even if it's not required, such coverage is frequently offered. Expanded features include lost wages and payments for childcare and other services you would normally perform (but are temporarily unable to) due to injuries caused by an accident.

AT-FAULT BUT NOT INSURED

As you have no doubt read or heard, many drivers don't have auto insurance of any sort. If one of them causes an accident and hurts you, all of the legal judgments in the world aren't going to get you paid. UM coverage is designed to protect

you for bodily injuries caused by another driver who doesn't have liability insurance; it also protects you for bodily injury caused by a hit-and-run driver who isn't found.

Even in states that strictly enforce auto insurance rules, uninsured motorists go to great lengths to stay on the road. Some purchase temporary insurance to obtain license and inspection seals, then discontinue their payments; others use counterfeit insurance cards.

The term *uninsured motor vehicle* may vary from state to state.

Several caveats: Vehicles owned or furnished for the regular use of a family member, owned or operated by a self-insurer, or owned by a governmental unit are not considered uninsured motor vehicles (but a vehicle owned or operated by a self-insurer that becomes insolvent is considered an uninsured vehicle). Also, vehicles operated on rails or treads, those designed for use off public roads (but not while being operated on public roads), or vehicles situated for use as residence premises (e.g., motor homes) are not uninsured motor vehicles.

What if the at-fault party isn't another driver? Or even another person? Does UM coverage still apply? The 1995 case *Matthews v. State Farm Mutual Insurance Company* considered the strange issue of liability—when a car collided with a horse.

Brenda and Ashley Matthews were injured when their car, driven by Brenda, smashed into a horse that had gotten loose on the highway. The horse belonged to Phillip and Mary Bolin.

At the time of the accident, the Matthews' car was insured under a policy issued by State Farm. State Farm paid basic and added reparation benefits.

The Matthewses then filed an action against the Bolins alleging their negligence in the use, maintenance, ownership, operation and control of their premises—including the keeping of the horse. This claim was subsequently settled for the maximum amount of the Bolins' homeowners insurance policy: $100,000. The Matthewses then sued their own insurance company under the UM coverage in their policy, claiming that the damages they suffered in excess of $100,000 must be paid by their insurance. The trial court held that the horse was not covered by the UM provision.

The Matthews family appealed. But the Kentucky Appeals Court agreed with the trial court. It held that the insurance policy covered injuries in excess of coverage limits when inflicted by the driver of a motor vehicle—not a horse.

The policy issued by State Farm to the Matthewses applied solely to claims against an underinsured "owner or driver" of a "land motor vehicle."

ARBITRATION

With UM coverage, you and your insurance company usually have to agree to arbitration. *Arbi-*

tration means negotiation by impartial persons when two sides cannot agree on settling an uninsured motorists claim.

Not all disputes are as wacky as hitting a horse on the highway. Disagreements usually center on what you, the policyholder, were doing when the accident took place.

Each party selects an arbitrator. Then, the two arbitrators select a third. Each party pays the cost of its own arbitrator and splits the cost of the third arbitrator. If they cannot agree within 30 days, either party may request a court judge to decide.

Arbitration usually takes place in the county in which you, the insured person, live and the decision is binding as to the entitlement of damages and the amount, unless the amount exceeds that required by financial responsibility laws, in which case either party may demand the right to a trial.

NO-FAULT INSURANCE

A favorite auto insurance topic among consumer advocates and some regulators is the no-fault system. In effect, *no-fault* insurance means that all claims are first party—your insurance pays for damages to you or your car, regardless of who causes an accident in which you are involved. This means if you don't have insurance, you can't make a claim against someone else.

While there are arguments about whether no-fault insurance is a benefit to consumers, it certainly does simplify car-related liability disputes.

There are no-fault elements to all auto insurance policies. The medical payments and property damage sections of the collision coverage pays, no matter who was responsible for an accident. No-fault systems take this element to a more complete degree.

Supporters say that no-fault promises quicker payment of insurance claims, because there's no wait for insurance companies—or courts—to decide who's to blame for an accident. A growing number of insurance companies agree, saying that no-fault systems reduce their costs—and the resulting higher auto insurance premiums—by limiting the number of lawsuits over auto insurance policies.

That's a big plus for an insurance sector in which legal fees account for 12 percent of premium costs (while medical expenses account for 15 percent).

The basic factors that shape no-fault programs include:

- Thresholds. Designers of a no-fault system must decide when injuries are so severe that a person should be allowed to sue the driver responsible. Make the threshold too low, and people will flock to court; too high, and some might not be fairly compensated. Most no-fault proponents favor a verbal threshold that spells out which specific injuries permit a trip to court. The alternative is a monetary threshold, which allows lawsuits for damages above a specified amount. But

detractors are concerned this encourages the padding of medical bills to exceed the threshold.

- Benefit (or liability) limits. What are the maximum benefits an injured motorist can receive under a no-fault policy? While some suggest a limit as high as $250,000, most insurance industry proposals put the cap on benefits at less than $100,000, which insurance companies say covers most auto liability claims.

- Lost coverage allowances. No-fault can mean that drivers pay more to maintain their current level of coverage. For instance, since no-fault only covers insured motorists and their passengers, a driver might have to buy a separate liability policy to cover such things as hitting a parked car.

- Cost containment. Low-cost policies also could require medical treatment from a managed care provider.

One reason proponents defend no-fault so staunchly is that when they say no-fault, they generally mean *pure* no-fault.

Under a pure no-fault system, virtually all lawsuits related to auto accidents are eliminated. The right to sue and a chance for a damage award are replaced with the right to guaranteed benefits. Lawsuits are retained only to punish convicted drunken drivers and others guilty of criminal conduct. Policyholders pay premiums to protect

themselves. If they (or their passengers) are injured, they are compensated by their own insurers—no matter who caused any part of an accident.

That's unlike a liability system, which requires the responsible party's insurer to pay for medical bills and car repairs.

Although there is no pure no-fault system in the U.S., it's had its history of attempts.

In 1995, the Hawaiian state legislature adopted what would have been the first pure no-fault program. The California-based RAND Institute estimated that the Hawaiian pure no-fault initiative would have provided drivers with $1 million in medical and wage loss coverage for an average of 48 percent less than they were paying for less injury coverage under the liability system.

But Governor Ben Cayetano—taking the side of Hawaii's trial lawyers—said the no-fault plan would cost victims their chance to sue for compensation for pain and suffering.

About the same time that the Hawaiian no-fault plan fell into a political bog, a group of high-tech entrepreneurs in California proposed a package of ballot initiatives that included a nearly pure no-fault auto insurance plan. The group called itself the Alliance to Revitalize California (ARC) and positioned its ideas as good for both consumers and businesses. But ARC's plan was also shot down by political interests determined to maintain the status-quo liability system.

The ARC program came pretty close to pure no-fault. But most of the no-fault programs currently in place can best be called *partial* no-fault. They allow you to make a claim up to a certain dollar limit without having to determine who caused an accident.

REFORMING NO-FAULT

Some consumer groups defend the traditional liability system because it allows people to win large awards when they're injured. This argument holds that no-fault systems subsidize the wealthy—relatively—by limiting all claims.

But defenders of no-fault also champion the poor. Not only do many less-wealthy motorists find auto insurance unaffordable, but they also are the ones who most need the guaranteed prompt payments to cover the costs of their accidents.

The experience of states experimenting with no-fault insurance suggests that they haven't been successful in restraining auto-insurance rates. The original concept of waiving the right to sue in return for prompt, guaranteed medical payments often falls victim to the lobbying efforts of trial lawyers (who insist on preserving the right to sue), the medical profession (which pushes for higher medical benefits) and certain consumer groups (which want both).

Jeffrey O'Connell, one of the founding fathers of no-fault insurance, began to criticize the system in the 1990s. He argued that the original concept

had been "bastardized" by state legislators beholden to powerful special interest groups.

O'Connell didn't give up, though. A model he developed in 1994 would give consumers the choice of purchasing no-fault coverage or, for a significantly higher premium, full liability coverage. Those who elect no-fault would waive the right to sue for noneconomic damages such as pain and suffering. A PIP policy would cover their economic damages regardless of fault. In return, they would be insulated from liability claims by other motorists.

Motorists who retain their right to sue for noneconomic damages would remain in the tort liability system. However, such drivers also would have to purchase tort maintenance insurance similar to uninsured motorists coverage.

In addition to lowering the costs of auto insurance, O'Connell claims the proposal offers several other advantages to drivers and insurers. For example, he says, health care fraud and abuse would decrease by cutting the link between medical costs and intangible damages, which—as we have noted before—are usually calculated as multiples of medical costs.

Under O'Connell's plan, there would be no incentive for accident victims to run up unnecessary medical bills to qualify for pain and suffering compensation.

In theory, no-fault insurance is an appealing alternative to the vicious circle of third-party liability

claims, lawsuits and rising premiums that plague traditional insurance programs.

Unfortunately, the no-fault plans that have been tested so far have had mixed results in practice. No-fault supporters argue that this is because the programs that have been tried are only partial efforts. They argue that, in order to work effectively, a no-fault program would have to prohibit most liability lawsuits.

As long as people look at insurance as a means of gaining financial windfalls larger than damages they suffer in auto accidents, no-fault will have trouble being implemented.

RENTAL CAR LIABILITY ISSUES

You rent a car and sideswipe another car on your way out of the rental agency's lot, then you careen across the street and slam into a tree. Not only does the other driver claim massive damages, but the tree-huggers come after you for killing the state's last Dutch Elm. What do you do? How are you covered? Basically, a rental agency will offer you four main coverages before you sign the dotted line. Many of these may be covered with your personal or corporate auto and health insurance coverages.

1) CDW (Collision Damage Waiver), LDW (Loss Damage Waiver). Although technically not collision insurance, in return for a daily fee, CDW or LDW waives the right for a rental car company to recover money from

the renter if the vehicle is damaged or stolen. This does not cover damages made to someone else's car during your rental (third party damages). Your personal or business auto coverage normally covers this when you are renting a car. Check first with your car insurance agent.

Some CDW's can even become void in certain circumstances. This may happen if you drive in a negligent manner or out of the state in which you rented the car if geographical restrictions apply in your rental contract.

2) Personal liability coverages such as LIS (Liability Insurance Supplement). Besides LIS, an agency may offer supplemental or additional liability coverage that pays over and above what your personal or business insurance covers. If you do not already have personal liability coverage you should purchase the rental agency's.

3) PAI (Personal Accident Insurance or Coverage). This provides a one-time payment for you or a passenger in case of death or maiming from a car accident. This is generally covered under your auto or health policies.

4) PEC (Personal Effects Coverage) or Personal Property Insurance. This pays if you have something lost or stolen from your car. Opting for this coverage is obviously something you have

to decide for yourself since your existing coverage probably doesn't include this coverage.

Before you step into a rental agency, it's good to know what your auto policy already covers.

Most standard auto policies used to cover you for liabilities while you were driving a rental car. But state laws and insurance industry trends have carved away at that coverage. Check the part of you auto policy called "non-owned vehicles" to see how much protection your policy offers.

CONCLUSION

Auto insurance is for your protection, providing the financial resources to deal with harm to you and your auto, avoiding catastrophic losses and shielding your assets from liability if you are at fault in an accident.

Buying automobile insurance can be confusing. But one rule of thumb does apply: Get as much liability coverage as you can reasonably afford. Liability coverage is what your insurance company pays to someone else in the event that you are held responsible for an automobile accident.

Obviously, insurance needs vary from person to person, but make sure you purchase enough liability coverage to protect your valuable assets in case you are sued.

Additional liability insurance isn't usually expensive. Buying coverage in the $100,000/$300,000 range is generally a good idea. Higher liability coverage levels are also available—but, at that stage, a separate personal umbrella policy probably makes sense.

Try to buy uninsured/underinsured motorist coverage equal to the amount of your liability coverage. Uninsured motorist coverage is paid to you by your automobile insurance company if you are injured by an uninsured car or if you are a victim in a hit and run accident. Underinsured motorist coverage is paid to you by your insurance company if you are injured by a driver who does not have sufficient coverage to pay for all of your injuries. This coverage is also not usually too expensive.

5

WHEN YOU REACH YOUR LIMIT: THE UMBRELLA POLICY

For the majority of wealthy—or even middle-class—Americans, personal liability represents a potentially catastrophic financial risk. Unless your homeowners coverage has special limits reaching into the multimillion dollar range, losing a personal liability lawsuit can wipe out your assets.

And legal costs alone can cause hardship. That's why insurance coverage of defense costs is so important. As we noted earlier, Bill Clinton's initial defense of the Paula Jones sexual harassment and defamation lawsuit is a memorable example of liability insurance paying legal defense costs. For most of us (even those who stay out of politics and hotel suites with women we've just met), not having to pay legal bills to defend ourselves and not having to risk loss of assets due to a large judgment are clearly key priorities.

If your assets are much greater than the liability limits of your homeowners and auto policy, you may want to purchase an umbrella policy to extend your liability coverage. As we've mentioned briefly already, a personal umbrella policy offers

coverage above and beyond the liability coverage you have on your homeowners or car insurance policy. An umbrella policy starts paying after your regular policies have reached their limits.

In this chapter we will look at the details and mechanics of umbrella liability insurance.

THE BASIC FACTS

A personal umbrella policy is well worth the $200 or $300 a year that it costs—especially if you are at or near retirement and have been fortunate enough to accumulate a decent nest egg. If you do not have liability insurance, your assets could be lost to someone else through a liability lawsuit and judgment. And we've seen some strange ones already—cars hitting horses, neighbors shooting neighbors, bosses hitting on employees.

Another good reason to purchase this coverage: Obtaining an umbrella policy is a good way to lower your auto and homeowners insurance costs, since getting an umbrella typically is less expensive than purchasing additional liability coverage on a homeowners or auto policy.

The umbrella policy sits over other liability coverages and will pay claims in excess of any underlying policies, plus liabilities that existing policies do not cover. Hence, the term umbrella.

Keep in mind that you still will have to have at least the minimum liability limits on your auto policy that are required by law in the state where you reside. And most personal umbrella policies

also require that you have a minimum amount of underlying insurance.

Generally, an umbrella policy is issued by your current homeowners, renters or auto insurance company. If you have these other policies, you need to carry specified liability maximums—often at least $100,000 per person and $300,000 per accident, for auto. Since the minimum liability coverage under a personal umbrella is usually $1 million, you'd have $1.3 million worth of auto and comprehensive personal liability coverage for about $200 more a year than you pay for regular auto coverage.

The price sounds too good to be true? It really isn't. Here's why.

In effect, the liability limits on your auto and homeowners insurance policies serve as a deductible on the umbrella policy. Umbrella liability companies require you to have at least $300,000 insurance on your home and on your car. The umbrella liability company now has a $300,000 deductible on your house and, more important, on your car. Most likely, if there is a claim, it will be paid by your auto policy.

High-deductible insurance policies are cheap for two reasons. The first is that there are few claims. Because there are few claims, there is little administration, which lowers the issuing company's costs. Give an insurance company a product that

provides a stream of premiums, low administration and few claims, and you have an eager issuer.

Because an umbrella policy is designed to provide liability insurance on an *excess basis*, above underlying primary insurance coverages and deductibles, the scope of the coverage is generally broad and the limits of coverage are high.

> If you don't have the usual underlying homeowners or auto insurance, the umbrella company may force you to pay a large amount ($100,000 or more) as a so-called "self-insured retention." This is another way of saying deductible.

There is a great variation in the umbrella liability market—because many insurance companies issue their own policy forms instead of using industry-standard forms. However, the Insurance Services Office (ISO) has designed a standard personal umbrella policy; a growing number of insurance companies use it.

WHAT'S COVERED?

If you have personal liability coverage and a claim is made or a suit is brought against you for damages because of bodily injury or property damage your insurance company will:

1) pay up to the limit of liability for the damages for which you are legally liable. Damages include prejudgment

interest awarded against the insured person; and

2) provide a defense at its expense by counsel of its choice, even if the suit is groundless, false or fraudulent. The insurer may investigate and settle any claim or suit that it decides is appropriate. The insurer's duty to settle or defend ends when the amount for damages resulting from the occurrence equals the limit of liability.

The duty to defend a claim ends when the insurance company has paid damages equal to its limit of liability. And, if laws prevent the insurance company from defending you, it will pay expenses for defense which are incurred with its written consent.

In addition to the limit of liability, your insurance company pays:

- All expenses incurred and costs taxed against an insured person.

- Premiums on required bonds, but not for bond amounts more than the limit of liability. (You need not apply for or furnish any bond.)

- Reasonable expenses (other than loss of earnings) an insured person incurs at the insurance company's request.

- An insured person's loss of earnings, but not other income, up to $100 per day, to attend trials or hearings.

A useful note: If you're an owner or tenant of a condominium unit, the umbrella policy will pay your share of loss assessments charged against you by the condominium association.

> Loss assessments against individual unit owners are often made when the condominium association is held liable for a loss which exceeds the limits of its liability insurance, or is not covered by its policy.

BROADER SCOPE OF COVERAGE

As we've noted, umbrella policies offer broader coverage than underlying policies. In the case of homeowners insurance, this means that in addition to bodily injury and property damage, umbrella policies cover false arrest, wrongful eviction, libel, slander, defamation of character and invasion of privacy.

The term *drop down coverage* is often used to name the coverages provided by a personal umbrella that are not provided by underlying liability policies. Some of these include:

- Personal injury coverage. Most underlying homeowners policies provide liability coverage for accidental bodily injury (meaning physical injury or death), but not for events involving libel, slander, false arrest and the like. The personal umbrella does cover you for liability arising out of these events.

- Regularly furnished autos. The standard auto policy contains language that precludes liability coverage for the use of vehicles made available for your regular use (such as a company car). The personal umbrella does not exclude such situations.

- Contractual liability. The standard homeowners policy limits coverage for liability assumed by contract. The personal umbrella is much broader in its provision of this coverage.

- Damage to property of others that is in your care, custody or control. The standard homeowners policy excludes coverage for damage to property left in your care. The personal umbrella does not exclude coverage for damage to such property.

DUTY TO DEFEND

As we have mentioned before, a major benefit of the personal umbrella policy is that it provides for payment of defense costs. If you are accused of being liable for damages to someone else and are taken to court over it, you will incur legal costs, even if the suit is totally groundless and ends in your favor. Fortunately, most underlying liability policies provide coverage for defense costs, whether or not the suit is groundless. Also, these costs are paid in addition to the available limits of liability (in other words, the entire liability policy limits are available to pay damages).

However, the insurance company's duty to defend ends when it has paid or offered to pay its maximum limit of liability.

Actually, the insurance company does more than pay defense costs when a suit is brought against an insured person. It not only assumes the cost for defending a claim, it also has a legal duty to defend the claim or suit.

This is where a personal umbrella policy comes in handy. The duty to defend, as well as pay defense costs, can be very important in situations where a defense by an underlying insurer may not be provided or may not be available.

An example: You have a homeowners policy providing $100,000 of personal liability coverage, and you also have $1 million of personal umbrella coverage. One day, your normally well-behaved Chihuahua bites and severely injures your cousin's sister-in-law on the finger. And she's a concert pianist. She sues you for $500,000.

If the underlying insurer believes a defense may be successful, it may defend the claim to conclusion, regardless of the outcome. Perhaps there will be no liability. Perhaps any liability awarded will be less than the homeowners policy limit. Perhaps the award will exceed that limit. The umbrella insurer observes but does not participate in the defense. It will, however, pay its share of any award in excess of the $100,000 homeowners limit.

However, the underlying insurer might not provide a defense. If it believes a successful defense is doubtful, and that any settlement is going to exceed its policy limit, it might only offer to pay its $100,000 limit and avoid defense costs (its obligation ends when it exhausts its limit). You no longer have the underlying insurer defending its claim.

The personal umbrella becomes very valuable at this point for two reasons: First, the umbrella company will step in and defend the remainder of the claim; second, the umbrella's liability limit can make up the remaining $400,000 if the pianist wins her entire demand.

An underlying defense might also not be available at all. Generally, this occurs when a loss is not covered by an underlying policy, but is covered by the personal umbrella on a drop down basis. Obviously, if a situation is not covered by an underlying policy, there is no underlying insurer to provide a defense of the claim.

An example: Stuart stands up in a town meeting and calls his neighbor "a mean drunk, an undiscriminating adulterer and a merely adequate embezzler." The neighbor sues Stuart for slander.

Stuart has a homeowners policy, but it is not endorsed to provide personal injury coverage. The homeowners company is not obligated to provide a defense or pay defense costs. But Stuart does have an umbrella policy. This will provide a defense, pay the defense costs and provide drop down personal injury coverage for damages that may be awarded in addition to the defense costs.

> Even if you have umbrella coverage, you need to be careful about defense costs. Many policies do cover defense costs in addition to the limit of liability. But be aware that under the terms of some personal umbrellas, defense costs are included in the policy limit and are not additional coverage—which means every dollar the policy pays to lawyers is one that it won't pay in a final judgment.

DO YOU NEED AN UMBRELLA?

To determine whether you need umbrella coverage, you should first conduct an inventory of your personal assets. This doesn't have to be an extensive physical inventory—it can be a simple list that you make on a single sheet of paper.[1] The purpose is to produce a reasonably close figure that you can compare with the liability limits of your homeowners or renters policy. If the assets total is larger than the liability limits, you need umbrella coverage.

> A note: You want to compare the value of your assets to the personal liability limits of your policies. This is a little unusual, since most of your belongings would be actually covered by the personal property section of a homeowners or renters policy against disasters, damage or theft. But that direct coverage isn't what you're looking for in this exercise.

[1] The Silver Lake Editors' book *The Insurance Buying Guide* (1999) includes a detailed form for calculating the value of your household assets and other tools for measuring your insurable net worth.

Before your personal liability policy goes into effect, your insurer will typically require that all known major exposures be covered by any underlying policies that you may have and that each major exposure is declared in the umbrella policy with a premium shown. So, if you own a boat and you forget to declare it, there will be no umbrella coverage for a boat exposure even if it is covered by an underlying boatowners policy.

Many liability coverages are written as a *combined single limit*, or CSL. This means that the single dollar limit is made available for any type of injury or damage for which you are found liable as a result of a covered accident, occurrence or event. A good personal umbrella policy provides coverage in this manner.

Another variation is known as *split limits of coverage*. As we have seen, auto policies commonly provide split limits. When an umbrella policy provides coverage above split limits, it will begin to provide excess coverage above each of the stated underlying sublimits.

Types of Liability Per Occurrence	Deductible Amounts
Auto	$300,000
Personal	100,000
Recreational Motor Vehicles	100,000
Watercraft	100,000
Business Property	100,000
Business Pursuits	100,000
Employers Liability (where Workers' Compensation is required by law)	100,000
Loss Assessment	50,000

A variation provided by some insurers is an umbrella with what is called a *smoothed limit*. Under this approach, the umbrella limit is the total amount of coverage that will be provided. Instead of providing coverage in addition to that provided by an underlying policy, the smoothed limit policy only provides total coverage up to its limit.

The limits listed on the previous page are the minimums for various required coverages. Automobiles must usually be insured for a single limit of at least $300,000 per occurrence (split limits are also permitted). Most other exposures must be insured for a limit of at least $100,000.

The umbrella policy only pays amounts in excess of these limits—even if the underlying company becomes bankrupt or insolvent. For example, if you are held liable for $350,000 in damages resulting from an automobile accident and the auto insurance company becomes bankrupt, the umbrella policy will only cover $50,000 of the loss (the amount in excess of the deductible).

A special $1,000 deductible applies to losses which are covered by the umbrella policy but are not covered by the underlying insurance for some reason. For example, you're using your car and utility trailer to haul two large and valuable pieces of furniture for a friend. An accident occurs, the furniture is destroyed, and the friend sues for damages. Your auto policy excludes coverage for property being transported by you, but there is no such exclusion in the umbrella policy. This loss would be covered by the umbrella and the $1,000 deductible would apply.

Typically, personal umbrella coverage comes in increments of $1 million, starting at $1 million and going up to $5 million. (It is possible to get higher limits; there are companies that write $10 million policies.)

If you are thinking of purchasing an umbrella policy, it's smart to place it with the same insurance company that writes your home and auto coverage. You're likely to get a discount for having multiple policies with the same company, but even more likely to avoid gaps in coverage if one company is handling all your overlapping insurance needs. In addition, most companies tailor their excess liability policy provisions around their auto and homeowners policies.

PERSONAL INJURY LIABILITY

An umbrella policy also covers your liability for personal injury, including: bodily injury, sickness, disease, disability, shock, mental anguish and mental injury. The definition can also be extended to include: false arrest and imprisonment, wrongful entry or eviction, malicious prosecution or humiliation, libel, slander, defamation of character or invasion of privacy and assault and battery not intentionally committed.

If you commit any of the actions specified in this section, it could lead to someone filing a *personal injury* claim (notice that this term does not have the same meaning as *bodily injury*) against you.

As we discussed in Chapter 2, under an umbrella policy, the term *occurrence* means an accident, but

it also includes continuous or repeated exposure to the same conditions. However, under personal injury coverage (libel, slander, etc.) the term occurrence means an offense or series of related offenses.

An example: Libeling the same tenant in front of others on various occasions would be treated as a single occurrence if that tenant were to file a claim for personal injury. Since the offenses were related, the limit of insurance would not apply separately to each offense.

False arrest claims usually involve damage to a person's reputation when a suspected wrongdoer has been arrested without proper cause. False arrest results from mistaken identity or an error in judgment. False detention or imprisonment restrict a person's freedom of movement, and can also lead to a claim for damages. Malicious prosecution generally occurs when a person brings charges against another without a probable cause to believe that the charges can be sustained, and there is a malicious intent in bringing the charges.

Defamation is the holding up of another to ridicule, and includes libel and slander. Libel is the defaming of another by writings, pictures or other publication injurious to the person's reputation. Slander is oral defamation of others which is injurious to their reputation.

Invasion of privacy is the publicizing of another's private affairs for which there is no legitimate public purpose, or the invasion into another's private activities which causes shame or humiliation

to that person. Wrongful eviction is depriving a tenant of land or rental property by unjust, reckless or unfair means. Wrongful entry is the resumption of possession (repossession of real estate) by an owner or landlord of real property by unjust, reckless or unfair means.

LIBEL AND DEFAMATION

Umbrella policies include some interesting disputes, because as excess insurance they only cover the biggest risks. The 1990 New York Appeals Court case *Robert Brandstetter v. USAA Casualty Insurance Co.*, et al. involved heavily-contested defamation claims.

Brandstetter filed the lawsuit against USAA and Physicians' Reciprocal Insurers, seeking a declaration that they were obligated to defend and indemnify him in an underlying lawsuit alleging libel and defamation against him. The conduct alleged in that lawsuit was done maliciously, wrongfully and with the willful intent to injure.

Barbara Kraus was the Vice President of Nursing Services for the New Rochelle Hospital Medical Center. In October 1987, she reported to the Director of Medicine that she had been told by nurses who worked in the Intensive Care Unit that Brandstetter had failed to perform bronchoscopies on four patients, that he had reported in the patients' charts that he had performed the bronchoscopies, and that he had forged patient forms.

While the hospital's Law Committee found that Kraus's actions in reporting Brandstetter had been

proper, the hospital subsequently exonerated Brandstetter with regard to any alleged misconduct. Kraus was fired in June 1988.

Kraus sued, alleging that Brandstetter defamed her on two separate occasions. First, she alleged that Brandstetter, in the presence of members of the nursing staff, stated, "You nurses will receive your Christmas bonus early, your boss is going to get fired." Second, she alleged that a publication of the Medical Board's newsletter was disseminated to no less than 300 people throughout the hospital and the medical community at large, containing the following statement:

> ...this Medical Board is unanimous [sic] in a vote of no confidence in the Vice President of Nursing Services, Mrs. Barbara Kraus.

In addition to these claims, Kraus alleged intentional infliction of emotional distress, conspiracy to defame, and loss of consortium on behalf of her husband against Brandstetter and others.

The trial court ruled for Kraus on two of her charges. The appeals court upheld both charges, writing:

> ...Kraus stated a legally sufficient cause of action sounding in libel per se. The reasonable interpretation of the statement in the newsletter was that Kraus was incompetent in her professional capacity.

USAA had issued two policies to Brandstetter, one a general liability homeowners insurance policy

and the other an umbrella liability policy. Physicians had issued him a professional liability policy.

Both of USAA's policies had exclusionary clauses which stated that the policy didn't insure liability arising from injury or damage that was expected or intended by the insured.

The trial court effectively dismissed both of Brandstetter's claims. But there was some difference between the two. The appeals court noted:

> Since [Brandstetter] seeks coverage from USAA for actions that are allegedly intentional, the exclusionary clauses apply as to both of USAA's policies...and USAA owes no duty to defend or indemnify [him] in the underlying action.

On the other hand, Physicians' professional liability insurance policy contained no such exclusionary clause. Rather, Physicians' policy agreed to "defend every CLAIM against the INSURED."

A "claim" was subsequently defined to include any "suit...that alleges DAMAGES to an injured party from an INCIDENT." An "incident," in turn, included "any...act or omission to act or series of related...acts or omissions to act resulting" in damages.

But the insurance policy issued by Physicians contained an endorsement which expressly excluded claims or suits arising from services rendered in the course of Brandstetter's employment at the New Rochelle Hospital Medical Center.

The appeals court concluded:

> Contrary to [Brandstetter's] arguments...,
> we find, as a matter of law, that the un-
> derlying lawsuit arose from services ren-
> dered in the course of his employment at
> that facility and, therefore, falls within the
> express exclusion of the endorsement.
> Accordingly, we conclude that Physicians
> is not obligated to provide a defense...al-
> beit for a reason different from that ex-
> pressed by the [lower court].

Applying the general principle that any ambigu-
ities in an insurance policy should be construed
against the insurance company, the court came to
the conclusion that the allegations of the lawsuit
against Brandstetter fell within the coverage pro-
visions of the Physicians' policy.

PROPERTY DAMAGE LIABILITY

Property damage means physical injury to, destruc-
tion of or loss of use of tangible property.

Property damage includes loss of use. If you dam-
age your neighbor's home, your neighbor might
have to live somewhere else while the home is
being repaired. The extra expenses for loss of use
(rent, meals, transportation, etc.) could be claimed
in addition to the actual damages to the home.

Under a property damage liability policy, your
insurance company pays for personal injury or
property damage for which you are legally liable
and which exceeds the retained limit.

A *retained limit* can be either:

- the total applicable limits of all required underlying policies and any other insurance available to you, or

- the self-insured retention if the loss is not covered by any underlying insurance.

MEDICAL PAYMENTS TO OTHERS

Under a personal umbrella policy, your insurance company typically pays the necessary medical expenses that are incurred or medically ascertained within three years from the date of an accident causing bodily injury. Medical expenses means reasonable charges for medical, surgical, x-ray, dental, ambulance, hospital, professional nursing, prosthetic devices and funeral services.

Medical payments coverage is provided "for others," meaning not to any insured or regular residents of the household except residence employees. Medical expenses can be paid for a period of up to three years as a result of bodily injury. Coverage is provided for any person on the insured premises with your permission.

Coverage applies away from the premises if caused by: 1) a condition on the insured location; 2) your activities, such as engaging in sports; 3) a resident employee in the course of employment; and 4) an animal owned or in your custody.

The minimum limit of insurance for medical payments coverage is usually $1,000.

> *Remember:* A policy typically does not state that the insurance company will pay for accidents only for which you are legally liable. This type of coverage often benefits all parties concerned: the injured person does not have to sue or prove negligence in order to collect; you may avoid a lawsuit; and the insurance company may be spared the expense of defending a court case.

WHO IS AN INSURED?

An umbrella policy will cover you on an excess basis while using a non-owned auto, only if the use of that auto is covered by underlying insurance. For example, you work for the ABC Company, which provides you with a car for use in your sales work. As long as your employer's policy provides at least $300,000 of coverage for your use of the company-owned car, your umbrella policy will provide additional coverage.

Family members are insured for their use of owned autos, or autos furnished for their regular use, only if their use of such autos is covered by the required underlying insurance.

For autos or boats owned or in your care, any other person using such items, or any person or organization responsible for the acts of someone using such items, would be insured. So, if your

daughter lets a friend drive the family Winnebago, the friend would be considered an insured. If you allowed your neighbor to use your Winnebago to cart members of his daughter's soccer team to this Saturday's scrimmage, the team would also be considered an insured person.

For animals owned by any family member, any other person or organization responsible for the animals is insured. If, while on vacation, you leave your pot-bellied pig with a neighbor who has agreed to take care of it and the pig breaks loose and ambushes another neighbors' infant, the umbrella policy would cover pigsitter as an insured person if she is sued for the injury.

The following are not considered an insured under an umbrella policy:

- the owner or lessor of an auto, recreational motor vehicle or watercraft loaned to or hired for use by an insured or on an insured's behalf;

- a person or organization having custody of animals owned by an insured in the course of any business or without the consent of an insured.

So, if you rent a boat for fishing, the boat rental company is not considered an insured person under the policy (it should have its own liability coverage). Or, if your daughter owns a horse which is boarded at Sunset Stables for a fee, the stable is not considered an insured person under this policy (it should have its own liability coverage).

UMBRELLA EXCLUSIONS

The exclusions and limitations of an umbrella often follow the underlying policies. However, the umbrella will usually have fewer exclusions than the primary coverage, less restrictive exclusions and a broader insuring agreement.

INTENTIONAL ACTS

Coverage under an umbrella policy is excluded for an act committed by or at the direction of an insured with intent to cause bodily injury or property damage. This does not apply to bodily injury or property damage resulting from an act committed to protect persons or property, or to prevent danger in the operation of an auto or boat.

Insurance is designed to cover accidental and unexpected losses, so intentional acts are not covered. But a few exceptions are made—mostly for situations in which an insured person acts with the intent of protecting persons, property or preventing a greater loss.

If you shoot a criminal who has broken into your home to steal from you, you will be covered. Another example: If your car's brakes fail and you purposely drive into a building in order to avoid hitting children crossing the street, the damage to the building would be covered.

The 1991 California Appeals Court decision *National Union Fire Insurance Co. v. Lynette C.* dealt with a disturbing—but disturbingly common—liability claim: sexual molestation.

In August 1980, when Lynette was 10 years old, she was placed by Colusa County as a foster child with Debra and Duane Lopes. Beginning in October or November 1980, and continuing until Lynette was removed from the Lopes home in May 1983, Duane sexually molested her.

As a result of the molestation, Duane pleaded guilty in November 1984 to committing lewd or lascivious acts upon a child.

In August 1987, following three years of mental health treatment arising from the molestations, Lynette sued Duane and Debra. In regard to Debra, Lynette alleged she had been negligent in allowing Lynette's placement in the foster home because she knew that Duane had a propensity to sexually molest children.

In February 1988, National sued for a declaration that neither Duane nor Debra was covered under the National insurance policy for the allegations.

The National policy had been issued to the Colusa County Department of Social Welfare and covered foster parents, like Duane and Debra, designated by the county.

Lynette conceded that Duane's sexual molestations were not covered under the National policy. But she didn't concede the same point about Debra.

Lynette's lawsuit was tried before a judge as an uncontested matter in September 1988. Judgment was rendered against Duane and Debra, jointly and severally, in the amount of $1.25 million. The trial court found that Debra's failure to use reasonable care to prevent Lynette's molestation "was, along with [Duane's] batteries, a concurring legal cause of harm" to Lynette.

The trial court granted summary judgment for National, denying any liability for the actions of either Duane or Debra.

Lynette appealed. The only issue on appeal was whether the liability insurance policy issued by National covered Debra.

There were three provisions of the National insurance policy relevant to the case. The first was the basic coverage clause, which provided:

> To pay on behalf of the Insured all sums which the Insured shall become legally obligated to pay as damages because of any act, error or omission of the Insured and arising out of the Insured's activities as a Foster Parent occurring while the foster child is in the care and custody of the Foster Parent. Such coverage hereunder shall include, but not be limited to, bodily injury, property damage or personal injury for which the Insured is held legally liable.

The other two relevant provisions were:

- Exclusion (b) specified that the policy didn't apply "to any dishonest, fraudu-

lent, criminal or malicious act, error or omission of an Insured."

- Exclusion (1) stated the policy was inapplicable "to licentious, immoral, or sexual behavior intended to lead to or culminating in any sexual act." However, this exclusion was qualified when one insured accused another insured of excluded behavior.

According to the appeals court:

> When that interpretation [of an insurance contract] does not depend upon the credibility of extrinsic evidence—and that is the case here—an appellate court may independently determine the policy's meaning regardless of what the trial court may have concluded.

The appeals court went on to write:

> Coverage provisions are construed broadly in favor of the insured, while exclusion provisions are construed strictly against the insurer. However, strict construction does not mean strained construction; under the guise of strict construction, we may not rewrite a policy to bind the insurer to a risk that it did not contemplate and for which it has not been paid.

Lynette argued the exception applied to her situation. One foster parent—Duane—molested a foster child, while the other foster parent—Debra—was at most simply negligent in failing to prevent the molestation.

Since there was no sexual act in this case that was not criminal, the second situation was the only conceivable application—and, therefore, Debra was covered.

Therefore, the appeals court reversed the lower court's judgment. National had to cover Debra's share of the judgment under the liability policy.

ADDITIONAL EXCLUSIONS

Personal injury losses resulting from an insured person breaking the law are excluded. The intent of this provision is similar to that of the exclusion of intentional acts.

Business exposures are usually excluded; but exceptions are made for exposures stemming from activities which may not be business related.

> **An example:** While playing golf with a client, an insured salesman hits a long drive and the ball hits another golfer on an adjacent fairway and causes injury. This accident would not be excluded because playing golf is a "non-business" type of activity.

No liability coverage is provided for a person who uses your vehicle or boat without *reasonable authority* to do so. For example, if a person steals your boat and causes an accident, the thief would not be covered by your's umbrella policy if sued for damages (you would still be covered if sued as the owner).

Another example: If a neighbor has used your boat on numerous occasions, and has been told that it may be used whenever it is not being used by a family member, the neighbor would be insured for use of the boat. This is true even if an accident occurs at a time when you have no knowledge that the boat is being used.

There is no coverage for property owned by you, or by an association of owners of which you are a member (such as the common property jointly owned by a condominium association). Coverage is also excluded for damage to property that is rented, used or occupied by you or in your care, but only to the extent that you have agreed to insure the property in a written agreement.

So, if you rent a new dining set and agree—in a rental contract—to insure the furniture for a stipulated amount, your umbrella policy will not provide coverage for that amount (it might provide some additional excess coverage). The property would be covered if you had not agreed to insure the property by written agreement (but the umbrella deductible will still apply).

A personal umbrella policy includes loss assessment coverage for owners of condominium units. When bodily injury, property damage or personal injury occurs on the "common" premises (not within any owner's unit), a claim for damages may be made against the association. If the loss is not covered by or exceeds the limits of the association's liability policy, it would be necessary for the association to assess the individual owners for a proportionate amount of the loss. For this coverage,

the term occurrence has the same meaning as it does for other liability coverages, except that it also includes acts of directors, officers, or trustees of the association.

> Note: If you are serving as an officer of a corporation or member of a board of directors, your acts are generally excluded from coverage because this is a professional liability exposure. But coverage is provided if you're acting for a nonprofit organization and receive no pay for services.

While the policy will cover some loss assessments made by organizations such as condominium associations, it will not cover assessments made by a governmental body against you or the association, nor will it cover an assessment made by the association to pay for a deductible which applies to an underlying policy.

FAMILY COVERAGE ISSUES

Liability insurance is designed to pay damages suffered by others when you are responsible. For this reason, injuries suffered by you or family members are not covered.

Before the family exclusion was added to the policy, family members were, in some courts, permitted to sue other family members and collect damages.

In the 1993 Arizona decision Christopher *Broadbent v. Laura Broadbent*, Northbrook Indemnity Co., et al., the appeals court considered just such a case—of parental liability.

In April 1984, Christopher Broadbent was playing in and around the swimming pool at the Broadbent home while his mother, Laura Broadbent, watched him. No one else was home.

At that time, Christopher was two years old and didn't know how to swim. While he was in the water, he wore inflatable vinyl rings on his upper arms to help him stay afloat.

The telephone inside the house rang and Laura went inside to answer it. She left Christopher unattended beside the pool. He removed the flotation rings.

Laura talked on the telephone for five to 10 minutes. While standing and talking on the telephone, she could not see the pool area unless she stretched the telephone cord to its limit and stretched her body. She had also removed her contact lenses and couldn't see the outside area clearly.

After being on the telephone for at least five minutes, Laura stretched the telephone cord to check on Christopher but couldn't see him. She dropped the telephone, ran to the pool and saw Christopher floating in the deep end of the pool.

Christopher was revived, but suffered severe brain damage.

In February 1990, a lawsuit in the name of Christopher Broadbent was filed against his mother, alleging that her negligence caused his injuries. State Farm Fire and Casualty Company, the Broadbents' insurer under a homeowners policy, subsequently filed an independent action against Phillip, Laura and Christopher Broadbent seeking a declaration that Christopher's claim was not covered under its policy.

The trial court consolidated the two cases. State Farm moved for dismissal of the Broadbents' charges, arguing that the household exclusion in the homeowners policy precluded coverage of Christopher's claim. It also argued that under Arizona's parental immunity doctrine, Laura could not be legally liable for her child's injuries.

The Broadbents argued that the parental immunity doctrine didn't bar Christopher's claim because, rather than only a parental duty to Christopher, Laura had a general duty to not allow unsupervised young children access to the family's swimming pool.

They also argued that the doctrine of reasonable expectation precluded application of the household exclusion.

The trial court issued decisions for both State Farm and the Broadbents. Both sides appealed. The appeals court permitted Northbrook Indemnity Company, which provided personal umbrella liability insurance coverage on the date of the accident at issue, to appear in the appeal as a real party in interest and on behalf of Laura.

A key element to the appeal was the parental immunity doctrine, which State Farm wanted to enforce so that it wouldn't be liable under the umbrella policy it issued to the Broadbents. The parental immunity doctrine was a common law creation that originated from a Mississippi Supreme Court decision which held that, in the interest of fostering peace and tranquility in families, children were not permitted to sue their parents.

The applicability or nonapplicability of parental immunity was determined on the basis of whether, by the act that caused the injury, the parent breached a duty owed to the world at large or a duty owed to a child within the family sphere. Thus, while the pool was an instrumentality in the control of Laura, the duty of supervision she breached was to Christopher alone. Laura could not supervise the pool in the sense that other parents could supervise their dog.

"This argument on behalf of the child fails because the present appeal presents a case of negligent supervision, rather than failure to control the instrumentality that caused the harm," the appeals court wrote.

It was argued that Christopher's mother's duty to him arose out of her obligation as a property owner. Christopher's attorney argued that Laura had a nonparental duty—to the world at large—to exercise reasonable care to protect all children from the danger posed by the pool.

The court ruled:

> A pool is like many other things that could be dangerous to a child, such as a hot stove burner, a cigarette lighter or even paint thinner. The situation where a parent allows a child to be unattended around items that could be dangerous falls into the category of negligent parental supervision, which does not evoke a duty to the world at large.

In summary, the appeals court concluded that Laura, under the parental immunity doctrine, was immune from liability for her negligent supervision of Christopher. It affirmed the trial court's grant of summary judgment.

Certain exclusions—which apply only to medical payments coverage—are also intended to prevent umbrella policies from becoming health insurance. Medical payments coverage is not available for:

- A residence employee who is injured while off the insured location and not in the course of the employment. Example: An employee is doing grocery shopping for the employer and slips in the store and breaks an arm; there is coverage. If a residence employee is shopping for personal reasons when injured, there is no coverage.

- If any insured person is entitled to workers' comp benefits, either voluntary or under any kind of law, there is no coverage for medical payments.

- Any nuclear or radioactive contamination whether controled or uncontroled.

- Anyone who is a regular resident at an insured location (other than a residence employee).

A FINAL EXCLUSION

Professional liability, or the rendering of or failure to render professional services, is not covered under a personal umbrella policy.

If you're a doctor, lawyer, accountant or other professional, you should purchase separate malpractice insurance, errors and omissions coverage or a separate professional liability policy that is designed to cover these exposures.

OTHER COVERAGES

A personal liability policy covers you for personal liability exposures, and provides no coverage for damages required to be paid under any workers' compensation, unemployment compensation, disability benefits or similar laws.

There is no coverage for liability for which you are also an insured (or would be, except for the exhaustion of limits) under any nuclear energy liability policy. A nuclear energy liability policy is one issued by: American Nuclear Insurers; Mutual Atomic Energy Liability Underwriters;

Nuclear Insurance Association of Canada; or any of their successors.

The personal umbrella policy provides liability coverage over and above your personal auto liability policy. Generally, this means bodily injury and property damage liability coverage. So, umbrella policies do not provide uninsured motorists coverage, underinsured motorists coverage or any similar coverage unless modified to do so.

In most cases, loss assessment coverage is a separate coverage under a liability policy. The liability coverage agreement and the provisions for defense coverage do not apply to loss assessments.

LANDLORD LIABILITIES

Liabilities that arise out of your duties as a landlord to property other than the residence premises are not covered under a personal umbrella policy. Whether you're renting from others or to others, the rental of small residences and condominium units is considered to be more of a residential exposure and not a business exposure, so it is not excluded. If, however, you own a large apartment building with more than four units, it would be a business exposure and would be excluded.

An exception is made for the occasional rental of the residence premises for use as a residence. So, if you go on vacation, you can rent out your principal residence and it will be covered.

Part of a residence (such as the second unit in a duplex or a room in your house) may be rented

to others. But there is a limit in each single-family unit of two roomers or boarders who are unrelated to the occupying family.

You can also rent out part of your property for use as a studio, office, school or private garage.

GETTING YOUR CLAIM PAID

Payment of a liability claim is not an admission of liability by you or the insurance company.

In addition, medical payments are voluntary and are not to be construed as admitting liability should the injured party bring suit at a later date.

> If a dispute arises over payment of a claim, you may not bring suit against the insurance company until you've complied with all of the policy provisions.

The insurance company can't be named as a code-fendant in a lawsuit against you. Furthermore, the company has no obligation to make any payment from a liability (though it does have to pay for your legal defense) until a final judgment against you has been rendered or the insurance company has agreed to settlement of the claim.

If you become bankrupt or insolvent, the company remains obliged to provide coverage and respond to the terms and conditions of the policy.

UNDERLYING POLICY CONFLICTS

An often-cited 1992 Massachusetts Supreme Court case dealt with the conflicts that can occur between umbrellas and underlying policies.

Following an automobile accident in which his daughter was killed while riding as a passenger in someone else's car, Chester McLaughlin sought coverage from Liberty Mutual Insurance under his auto policy for compulsory uninsured or optional underinsured motorists coverage. (McLaughlin had also purchased automobile insurance from Liberty for his two sons. He sought to collect benefits under these policies as well.)

Liberty Mutual insured two of McLaughlin's cars for uninsured motorists coverage up to limits of $100,000 per person and $300,000 per accident. Under an umbrella policy, McLaughlin was insured for liability to third parties in excess of the limits of liability coverage under an automobile insurance policy and a homeowners policy.

As a result of negotiations between McLaughlin and Liberty Mutual, a settlement was reached and McLaughlin collected the full amount of uninsured motorists coverage available under the policies.

McLaughlin then contended, that his personal catastrophe liability (umbrella) policy constituted a motor vehicle liability policy under Massachusetts law. He also claimed it provided him with uninsured motorists coverage up to the umbrella policy limit of $2 million.

Liberty disagreed and sued to get a court ruling against umbrella coverage. The trial court supported Liberty's motion and entered a judgment declaring that McLaughlin's umbrella policy did not contain uninsured motorists coverage.

McLaughlin appealed. The state supreme court agreed to hear the case.

The question it considered: whether an umbrella policy constituted a "motor vehicle liability policy" within the meaning of Massachusetts's uninsured motorists coverage statute.

Its answer was a resounding *no*.

"There is nothing in the language of either Massachusetts state law or McLaughlin's umbrella policy which would require Liberty to provide uninsured motorists coverage to McLaughlin under his umbrella policy," the court wrote.

The state law which required all vehicle liability policies to insure for uninsured motorists coverage, did not require umbrella policies to provide the same coverage. It applied only to the underlying auto insurance policy, and not to excess policies such as McLaughlin's umbrella policy.

The statute stated, in relevant part, that:

> [n]o policy shall be issued or delivered in the commonwealth with respect to a motor vehicle...registered in this state unless such policy provides coverage in amounts or limits prescribed for bodily injury or

death for a liability policy under this chapter...for the protection of persons insured thereunder who are legally entitled to recover damages from owners or operators of uninsured motor vehicles.

The clear language of McLaughlin's umbrella policy indicated that it protected solely against the risk of a judgment against an insured in excess of the coverage for *liability* provided by the underlying auto and homeowners insurance policies. It didn't provide uninsured motorists coverage.

The policy read, in relevant part:

[t]he company will pay on behalf of the insured all sums in excess of the retained limit which the insured shall become legally obligated to pay as damages, direct or consequential, because of personal injury or property damage with respect to which this policy applies....

The Massachusetts court concluded that the most persuasive decisions from other states held that umbrella policies were not auto liability insurance policies under relevant uninsured motorist statutes. In fact, Florida and Kansas had recently amended their uninsured motorists statutes explicitly to provide that umbrella policies were not included.

"We hold that an umbrella policy is not a motor vehicle liability policy and does not provide [uninsured motorists] coverage," the court concluded.

CONCLUSION

Your auto and homeowner's policies have at least some liability insurance that would be used to settle legal claims. But what if a settlement (or judgment, if it goes to court) is $800,000 and you only have $300,000 of liability insurance? The insurer would pay its $300,000, but where are you going to get the other $500,000?

Virtually everything you own would be fair game to pay off the debt. The only good news is that some states protect certain assets (like your home) from seizure.

Worried? You should be. With America's love affair with lawsuits, you can't afford to not have umbrella liability insurance.

As we mentioned earlier, umbrella liability insurance pays $1 million, $2 million and sometimes even $5 million or more of a claim—on top of what your basic policies will pay. You're usually able to set the amount.

For the protection you get, umbrella liability coverage is not very expensive. Premiums are usually $200 to $300 a year for $1 million worth of coverage. The cost depends on such criteria as the amount of coverage, the insurance company issuing the policy and your own "personal risk factors" (such as the number of traffic tickets you've gotten in the past and, possibly, your credit report).

When people do buy umbrella coverage, they often don't buy enough. For example, you may have

assets worth $1 million, figure that you need enough coverage to protect your assets, and therefore buy a $1 million policy. But what if a judgment of $2 million is handed down?

If you're portrayed as a millionaire and lose a personal liability lawsuit, you can lose all of your assets and still owe money. Your future income, if you have to make settlement payments over time, can be jeopardized. The same goes for any inheritance you may receive, not to mention any inheritance you may want to leave your children.

How much you own is a start—but not always the whole story—when deciding how much coverage to buy. Do you live in a wealthy part of town? Do you travel a lot? Do you entertain a lot? Do you operate a home-based business and have employees or clients coming to your home on a regular basis? These things can make you a target.

It's depressing to think of all the liability risks you take, any of which can decimate your net worth. It's fine to take calculated risks—for example, if you don't drive your car every day and you infrequently have people on your property, you may decide that instead of spending money on umbrella premiums you'd rather take the risk that you will never be hit with a liability lawsuit. This strategy is called "self insurance." And many people self-insure—by not buying insurance—without realizing what they're doing.

The goal of umbrella liability insurance is to provide affordable, comprehensive coverage in case

of a catastrophic loss, incidental exposure, or gaps in coverage.

If nothing else, umbrella coverage offers psychological comfort. You'll know that if your neighbor falls on your front steps or you rear-end the car in front of you that you're protected.

But one last reminder: Umbrella coverage isn't a cure-all. It doesn't protect you from every risk in the world—it is excess insurance for whatever primary liability policies you have.

6

WHEN YOU'VE GOT
A SMALL BUSINESS
TO PROTECT

So, you've decided to start a candy company using your grandmother's famous recipe for boysenberry fudge. Good luck. And watch out. It's hard enough to get the stuff into Bloomingdale's for the Christmas rush.

Once you're making money, more troubles—*liability* troubles—can crop up.

The U.S. Bureau of Labor Statistics estimates that there are more than 18 million home-based businesses in the United States. More than 60 percent of those businesses are inadequately insured, according to a survey by the Independent Insurance Agents of America (IIAA).

Whether you spend two hours or 62 hours a week on your home-based business, you face many of the same the risks that corporate giants do. About half of new businesses succeed past two years, becoming assets that need to be protected.

So why do so many home-based business owners neglect to purchase adequate insurance for their

new enterprise? They don't think about business policies when they're padding around in terrycloth robes between their desks and kitchens. They think of themselves as small and struggling, rather than established players that need coverage.

Dozens of likely scenarios can peril the home-based business: a neighborhood punk breaks into your house and steals your computers or the clumsy FedEx guy falls in your foyer while waiting for you to sign the delivery log. When he sues you for pain, suffering, loss of wages—and his wife sues you for loss of consortium—you'll be sorry you didn't buy a business policy.

This kind of accident can wipe out years of hard-won value. And, rather than printing invoices, you'll be sending out résumés.

Another reason that home-based businesses are so often uninsured is that the owners believe—wrongly—that their business activities are covered by their renter's or homeowners insurance. These types of policies don't provide coverage for businesses, though.

Even the most basic small business insurance policy (usually called a *business owners policy* or BOP) can cover loss of income, business personal property, personal and advertising injury, on-premise liability, off-premise liability, professional errors-and-omissions, separate business structures and other assets. It's a broad kind of coverage.

Looking more closely at the numbers, liability is an even bigger issue than it might first seem. Ac-

cording to the IIAA, nearly 70 percent of home-based business owners are between the ages of 55 and 64. Since many of these entrepreneurs are retired or close to retirement age, they have personal assets (nearly paid-off mortgages, sizeable retirement accounts, etc.) that need protection.

LIMITS OF OTHER INSURANCE

One thing can't be reiterated enough: Standard personal insurance doesn't cover business risks. And, not matter how small a business might be, it will count as a business when you have to make a claim. Consider how standard policies deal with business risks:

- Automobile Coverage. If you are using your automobile for business activities—transporting supplies or products or visiting customers—you need to make certain that your automobile insurance protects you from accidents that occur while on business.

> If you have a personal vehicle that you sometimes use for business or if your home-based business is the owner of one or more vehicles, you may need to buy a Commercial Automobile Policy.

- Homeowners Coverage. If you rely on your homeowners policy as your only means of insurance protection, you may find your home-based busi-

ness underinsured or uninsured in the event of a loss.

Homeowners policies were never intended to cover business exposures. Consequently, coverage for the items you use in your business such as computers, fax machines, filing cabinets, tools and inventory are limited to $2,500 in your home and $250 away from home under most policies. And your homeowners coverage provides no liability insurance for your home-based business.

If you're working at home, review your existing coverage. Your homeowners insurance probably doesn't cover your business. You also need coverage for things like liability and business interruption.

TWO KINDS OF COVERAGE

First, let's take a look at what coverage you may need. Insurance coverage generally falls into two categories. This is true of homeowners, auto and most business policies. Those two categories in business terms are:

- Property Coverage—Your business structures and possessions are covered against loss or damage caused by certain covered risks such as fire and theft.

- Liability Coverage—This means that if you become legally obligated to pay money to another person for bodily injury or property damage caused by

your business, your insurance com-
pany will cover those costs (up to the
maximum indicated in your policy),
including the costs of defending your
business in the lawsuit. This coverage
extends to medical payments for in-
jured parties.

Of course, every business has its own special re-
quirements. There are many specific insurance
coverages available to address the needs of your
home-based business.

SEVERAL OPTIONS

To insure your business, you have three main op-
tions—endorsements to your existing homeowners
policy, an in-home business policy or a small
businessowners package policy.

1) Endorsements. Depending on the type
 of business you operate, you may be
 able to add an endorsement to your
 existing homeowners policy. For as
 little as $14 a year, you can double
 your standard homeowners policy lim-
 its for business equipment from $2,500
 to $5,000. Some companies offer en-
 dorsements that include property and
 limited business liability coverage.
 Endorsements are typically only avail-
 able for businesses that generate $5,000
 or less in annual receipts. They are
 available in most states.

2) In-Home Business Policy. The insur-
 ance industry has responded to the

growing number of home-based businesses by creating in-home business insurance policies that combine homeowners and business owners coverage into a single policy. For about $200 per year you can insure your business property for $10,000. General liability coverage is also included in the policy. A business owner can purchase anywhere from $300,000 to $1 million worth of liability coverage. The cost of the liability coverage depends on the amount purchased. If your business is unable to operate because of damage to your house, your in-home business policy covers lost income and ongoing expenses such as payroll for up to one year. The policy also provides limited coverage for loss of valuable papers and records, accounts receivable, off-site business property and use of equipment. These policies provide both business coverage such as business liability and replacement of lost income, and homeowners coverages such as fire, theft and personal liability. In some cases, the companies that offer these policies require that you buy your homeowners and auto policies from them, too.

3) Business Owners Package Policy (BOP). Created specifically for small businesses, this policy is an excellent solution if your home-based business operates in more than one location or

manufactures products outside the workplace. A BOP, like the in-home business policy, covers business property and equipment, loss of income and extra expenses, and liability. However, these coverages are on a much broader scale than the in-home business policy.

UP CLOSE WITH BOPS

A BOP is a self-contained, complete package policy that provides broad coverages for small and medium-sized apartment buildings, offices and retail stores. Each policy includes mandatory property and liability coverages and offers optional coverages. As with any policy, many standard conditions and exclusions apply.

The standard BOP form is modeled after the commercial package policy program that big companies buy. The same wording, organization of coverages and design are followed.

Then, the standard BOP adds coverages that are similar to commercial *property* coverage and commercial *general liability* coverage, along with optional crime and boiler and machinery coverages.

The types of business eligible for a BOP include:

- apartment buildings which do not exceed six stories in height and do not have more than 60 dwelling units (incidental mercantile, service or process-

ing risks which do not exceed 15,000 square feet, and incidental offices are permitted);

- office buildings which do not exceed six stories in height and do not exceed 100,000 square feet in total area (incidental mercantile, service or processing risks which do not exceed 15,000 square feet, and apartments within the office building are permitted);

- mercantile risks which do not exceed 15,000 square feet and do not have annual sales in excess of $1 million;

- service or processing risks which do not exceed 15,000 square feet and do not have annual gross sales in excess of $1 million, provided that no more than 25 percent of their gross sales is derived from off-premises operations; and

- building owners and business operators who are tenants, residential condominium associations and office condominium associations. Service and processing risks are newly eligible for coverage (previously, mercantile risks involving retail sales of merchandise were eligible, but risks involving service or processing were not eligible).

The businessowners program is designed to provide coverage to those with moderate insurance exposures. It excludes those with risks that do not fit the intended exposure pattern. These include: bars, restaurants, automobile dealers and all types

of automotive repair and service operations, banks and all types of financial institutions, places of amusement, contractors and wholesalers.

Companies in these fields must be insured outside of the businessowners program.

COMPONENTS OF A BOP

Each BOP is a complete contract and must include the following parts:

- the policy declarations,
- the common policy conditions,
- a standard or special property coverage form (one or the other),
- the businessowners liability coverage form, and
- endorsements as required.

The policy declarations show the policy number, name of the insurance company, name of producer, name and address of the named insured and the policy period. Spaces are provided for a description of the business, the form of business, locations of described premises, and name and address of any mortgage holder.

There are 11 common policy conditions attached to every BOP. Some of these conditions relate to basic things like cancellation, fraud and what happens when the policyholder dies; others involve more specific things like how the insurance company determines premiums (i.e. they have a right to audit, inspect, survey, report, etc.).

Both the in-home business policies and the standard BOP forms offer the same optional coverage for *employee dishonesty*. Coverage applies to loss of business personal property, including money and securities, resulting from dishonest acts of employees. Losses that result from any criminal or dishonest acts of the named insured or any partners, however, are not covered.

This coverage carries a *discovery period* of one year after the policy expiration date, and losses discovered after that time are not covered.

LIABILITY COVERAGE

The standard BOP provides the following two major liability coverages:

- business liability, and
- medical payments.

The business liability insurance covers your legal liability for damages because of bodily injury or property damage, and it also covers personal injury and advertising injury.

The insurance company provides defense costs and the standard set of supplementary payments found on liability policies (i.e., cost of bail bonds, settlement expenses, loss of earnings, prejudgment and postjudgment interest on amounts awarded).

The medical expense insurance covers expenses for bodily injury caused by an accident on premises you own or rent, including the ways next to such premises, or an accident because of your opera-

tions. Medical expenses incurred within one year of the accident date are covered, and payments are made without regard to fault or negligence.

The businessowners liability form includes a long list of exclusions. In total these are similar to the combined exclusions applicable to bodily injury and property damage liability, personal injury, advertising injury and medical payment coverages found on commercial general liability forms.

You should be aware of the types of exclusions applicable to these coverages. Some of the exclusions are complex and very detailed. Some are exotic, like the clause that excludes damages caused by war or nuclear materials. The following is a brief glance at a few of these exclusions:

- bodily injury or property damage expected or intended by you;

- liquor liability;

- obligations under workers compensation, disability, unemployment, etc.;

- bodily injury to any employee arising out of and in the course of employment by you;

- pollution liability;

- bodily injury or property damage arising out of any aircraft, auto or watercraft;

- bodily injury or property damage arising out of the transportation of mobile equipment;

- professional liability;

- property damage (to your work, product or other);

- damages claimed for any loss, cost or expense because of loss of use, withdrawal, recall, repair, removal or disposal of your product, work or impaired property;

- various personal or advertising injuries (slander, libel, defamation, etc.);

- medical expenses for bodily injury to you, an employee or tenant;

- medical expenses for bodily injury to any person if the bodily injury is covered by a workers' compensation or disability benefits law or similar law; and

- medical expenses for bodily injury to any person injured while taking part in athletics.

Again, this list is a mere glance at the exclusions to coverage. Read your BOP carefully and know what is and isn't covered. Think about that boat parked in your driveway; think about a freelance contractor's slip and fall during a visit to your office; and think about your forgetting to include a warning label on a toxic product—assuming that you've moved on from boysenberry fudge.

WHO IS AN INSURED?

If you buy a BOP as an *individual*—rather than as a corporate entity—your spouse is also an insured

with respect to conduct involved with your business. If the named insured is a *partnership* or joint venture, all members and partners and their spouses are insured with respect to their business activities. If the named insured is a *corporation* or organization other than a partnership or joint venture, all officers and directors are insured with respect to their duties as officers and directors; and stockholders are insured with respect to their liability as stockholders.

Employees are insured with respect to their activities as employees, and any person or organization acting as your real estate manager, or having custody of your property, or operating mobile equipment with permission is insured, but only with respect to their exposure in that capacity.

The declarations shows three separate limits of insurance:

1) Liability and medical expenses limit. It is a combined single limit and is the most the insurance company will pay for all bodily injury, property damage and medical expenses arising out of one occurrence, and all personal injury and advertising injury sustained by any one person or organization.

> Note that the bodily injury and property damage coverage is on an "occurrence" basis, while the personal and advertising injury coverage is on a "per person or entity" basis.

2) Per person limit for medical expenses. It is a sublimit that applies within the overall liability per occurrence limit.

3) Fire legal liability limit. It applies on a per fire or explosion basis. This is a separate limit of insurance that applies only to liability for damages to premises rented by you and arising out of a fire or explosion.

While not shown on the declarations, the coverage form defines two aggregate limits that apply:

- The policy period aggregate for all injury and damage under the products/completed operations hazard is the liability and medical expense limit shown.

- The aggregate for all other injury or damage (except fire legal liability) and all medical expenses is twice the limit shown in the policy for liability and medical expenses.

If the policy is written for more than a one-year period, the aggregates applies separately to each annual period.

CONDITIONS AND DEFINITIONS

Businessowners liability coverage is subject to a number of standard policy conditions. Bankruptcy of the named insured does not relieve the insurance company of any obligations. In the event of an occurrence, claim or suit, you must notify the insurance company, provide information, and sub-

mit copies of any demands or legal papers. With respect to any vehicles or mobile equipment subject to a financial responsibility law, the policy provides the minimum coverage required by law. Legal action against the insurance company may not be taken unless all terms of the policy have been fully complied with.

There will be a so-called *separation of insureds*, with respect to rights, duties, claims and suits under the policy. This means that everyone covered by the policy is treated separately except with respect to the limits of insurance.

The policy also includes a number of standard commercial liability definitions, including: *Advertising injury, auto, coverage territory, impaired property, insured contract, mobile equipment, personal injury, your product* and *your work*.

BOP ENDORSEMENTS

Endorsements may be used to alter the coverage or to provide additional coverages.

A *hired auto* and *non-owned auto* liability endorsement may be used to add coverage for either or both of these automobile exposures if you do not have a commercial auto policy. If you have a commercial auto policy, the endorsement is not available for attachment to a BOP.

A *comprehensive business liability exclusion* endorsement may be used to exclude specific operations or locations from coverage. A limitation of coverage to designated premises or project en-

dorsement may be used to exclude coverage except for the premises or projects specifically designated in the declarations.

A variety of endorsements may be used to add additional insured parties to a BOP. Special endorsements exist for managers or lessors, state or political subdivisions, townhouse associations, co-owners of premises, engineers, architects and surveyors, and others.

PROFESSIONAL LIABILITY

In many small businesses, the business owner provides advice or professional services for which customers pay a fee. However, if these services are in some way unsatisfactory, the customer may sue the service provider for professional negligence.

Accountants, attorneys, financial planners or anyone who provides professional services may find themselves as the defendant in a lawsuit. While many of these suits are unsuccessful, legal defense costs and potential settlement awards are ample reason for professional liability coverage.

Professional liability insurance is particularly important for attorneys and psychologists, for example, who work out of the home.

That said, these policies are important for more than just lawyers and doctors. Professional liability policies are available for:

- advertisers, broadcasters and publishers,
- insurance agents and brokers,
- accountants,
- architects and engineers,
- attorneys,
- pension plan fiduciaries,
- stockbrokers, and
- directors and officers of corporations.

Due to the growing frequency of malpractice suits and the sympathies of courts, professional people are held more accountable for their mistakes than ever before. Ever higher sums are being awarded to plaintiffs in malpractice suits. The need for professional liability insurance has grown in direct proportion to these trends.

Professional liability coverage protects you against legal liability resulting from negligence, errors and omissions, and other aspects of rendering or failing to render professional services. It does not cover fraudulent, dishonest or criminal acts.

Many professional liability policies contain exclusions commonly found in general liability poli-

cies, such as liability you assume or obligations that fall under a workers compensation law.

In the medical field, professional liability coverage is often referred to as *malpractice insurance.* In other areas, the coverage is known as *errors and omissions insurance*, particularly where there is no coverage for bodily injury. However, all professional liability is a form of malpractice insurance.

Most professional liability policies today are written on a *claims-made basis*, which obligates the insurance company that has written the policy currently in effect when a claim is made to cover, even if the negligent act or error occurred many years before (provided it did not occur before any retroactive date shown on the policy).

In most cases, errors and omissions insurance excludes coverage for bodily injury and damage to tangible property—forms covering insurance agents, accountants, and attorneys exclude bodily injury and property damage. The negligence, errors and omissions of many professionals will only generate claims for financial damages. But the nature of a profession determines the nature of malpractice claims, and the insuring agreements reflect this fact.

COMMERCIAL GENERAL LIABILITY

At several points in this chapter, we have mentioned commercial general liability (CGL) insurance. This is the kind of liability that larger companies usually carry. Although this book is designed for individuals and smaller business, the

mechanics of CGL insurance are worth considering, because they define many of the terms that apply to people and small firms.

CGL protects a business from a variety of business liability exposures arising out of its premises, operations, products and completed operations. The insurance usually covers legal obligation arising out of injuries or damage suffered by members of the public, customers, tenants and others.

Major changes were made in CGL forms and terminology during the 1980s and 1990s. For one thing, the abbreviation *CGL* had originally stood for "comprehensive general liability" coverage.

> The word "comprehensive" was replaced (with "commercial") because it wrongly suggested that any liability was covered. Many plaintiffs' attorneys attempted to use the term "comprehensive" to extend coverage to absurd lengths.

Older CGL policies had broken coverages down in dozens of separate subsections (each with its own separate insuring agreement). The newer CGL policy is broader and more flexible. It covers most risks—unless it's amended to eliminate a coverage. Endorsements might eliminate coverage for products, advertising injury, personal injury or medical payments. Other endorsements might exclude coverage for liability arising out of scheduled locations only, while preserving the coverage everywhere else.

Separate forms are available for companies that have very limited and specific exposures. There is a form that provides only the products and completed operations insurance. Another form provides owners and contractors protective coverage— it is used when an owner or contractor requires a contractor or subcontractor to provide coverage for a specific job, which can only be done by issuing the coverage as a separate policy.

Separate forms are also available for exposures that are not covered by CGL forms (e.g. pollution coverage, liquor liability, etc.).

In sum, the CGL is designed to assume coverage while still customizable to amend, limit or expand coverages. It allows companies to tailor coverage to fit specific needs and exposures.

OCCURRENCE AND CLAIMS-MADE

Originally, general liability covered accidents— sudden, unexpected events that happened at a specific time and location. Under the newer CGL policies, the concept of *accident* was expanded to include continuous or repeated exposure to conditions that result in bodily injury or property damage that was neither expected nor intended (by the company).

> Basically, the *occurrence form* covers injury or damage that happens during the policy period, while the *claims-made form* responds to claims filed during the policy period.

An occurrence form covers injury or damage that occurs during the policy period, even if the claim is made three, four or five years later.

> An example: Ramjac Corp. had a separate $1 million occurrence policy in each of three years during which its faulty fingerpaints were poisoning toddlers. Lawsuits followed. The court required Ramjac's insurance company to pay $3 million—the $1 million limit for each of the three years of occurrence.

The process of adding that the court did in this example is called *stacking*. In contrast, a claims-made policy doesn't allow this. It covers claims that are first made during the policy period. If you continually renew claims-made coverage with a $1 million limit, a single loss can only be charged to one policy.

Claims that take place after the end of a policy period create an exposure known as a *claims tail*. Tail coverage is automatically built into the insuring agreements of occurrence forms. This is not the case with claims-made forms.

Claims-made CGL forms would be unacceptable if they left policyholders exposed to serious insurance gaps that could not be covered. So, *extended reporting periods* (also called ERPs) were created to solve the problems of claims tails and transitions back to occurrence coverage. Proper use of ERPs allows a policyholder to change from an occurrence CGL policy to a claims-made CGL

policy without any situations in which a loss is covered by two policies or is not covered at all.

Most policy provisions under the two types of CGL policy are identical. The insuring agreements differ slightly, because the coverage trigger is different under claims-made coverage. There are a few differences in the claims-made conditions, and the claims-made form has an additional section concerning extended reporting periods.

In the declarations page, the insurance company "declares" the facts of the policy (name of insured, policy number, etc.). The declarations page may also show a retroactive date, before which no coverage applies.

Although a retroactive date is not required, it defines when coverage begins and is useful for creating a clean line between occurrence and claims-made coverage.

When claims-made coverage is written without a retroactive date, duplicate coverage may exist. In that case, the claims-made coverage would apply as excess over earlier occurrence policies.

BUSINESS UMBRELLA POLICIES

Just like individuals, businesses sometimes need umbrella liability coverage. However, there are no standard commercial umbrella policies. So, making general comments is difficult.

Some business umbrellas are written to "follow form," which means they do not provide broader coverage than the primary insurance. Others are more like personal umbrellas, providing coverages not included in the underlying insurance.

For many businesses, an umbrella policy protects business assets that could be threatened by multimillion dollar liability lawsuits. Usually, commercial umbrella forms provide a minimum of $1 million of insurance, but they are frequently written with limits of $10 million to $100 million. The policies may include occurrence or claims-made terms.

Commercial umbrellas also help to fill two types of insurance gaps—those created by oversights, and those resulting from exposures that may not be fully insurable under traditional policies. Where no primary insurance exists, the required self-insured retention will usually be $25,000 or more. For particularly risky exposures, the insurer may require a retention of $50,000 or $100,000—and as much as $1 million.

Business umbrellas usually cover advertising and related liabilities. They also usually provide worldwide coverage for products liability, which is an important coverage for any firm selling to international markets. Blanket contractual liability coverage, for both oral and written contracts, may be included.

Frequently, business umbrellas also provide liability insurance for incidental malpractice, non-owned aircraft and non-owned watercraft exposures. It is

not uncommon for umbrellas to provide employees liability coverage, by making employees part of the definition of "named insured." Employees could be sued as individuals for acts or omissions related to their employment.

Finally, business umbrellas may be written to provide liquor law liability and many other liability coverages not covered by BOPs or CGL policies. But these additional coverages get expensive.

WORKERS' COMPENSATION

If you hire employees, you need to have workers' compensation insurance (also called employer's liability coverage). This insurance—different than a BOP—pays medical expenses, rehabilitation costs and lost wages to any employee injured on the job (technically, "in the course of employment," which includes business trips, running errands for the company and other out-of-the-office activities).

The coverage also insures against psychiatric or chronic disabilities—namely, job-related stress and slow-to-develop problems like carpal tunnel syndrome. These subtle claims can be as devastaing...or more so...to a small business than the classic lifting injury or broken bones that most people equate with the term *workers' comp*.

Workers' comp coverage is mandatory—much like auto liability coverage is for anyone who owns a car. For most small businesses, the best way to buy workers' comp insurance is through state-administered insurance funds.[1]

[1] The details of workers' comp are too complex for us to discuss completely in this book. For more information, see Silver Lake's book *Workers' Comp for Employers* (1994).

As with auto liability, some people try to get around carrying it. This is a very bad idea. State employee and labor departments examine payroll taxes and other records to find businesses that don't carry the workers' comp coverage. The fines and penalties that can follow are often enough to put a small business out of business.

WHY BOPS ARE IMPORTANT

There's no better way to demonstrate the necessity of a business policy than to give you a real-life scenario. In the 2000 Vermont Supreme Court case *Luneau v. Peerless Insurance Co., et al.*, an ambitious lad's business pursuit went sour from one accident that his homeowners policy didn't cover. It all began one September night in Swanton, Vermont...at the Champlain Country Club.

Robert Wagner worked for Green Mountain Coffee Roasters, but for a number of years he had been conducting his own business on the side as a disk jockey. His business cards read, "Music Unlimited," and he had deducted income on his tax returns from his disc jockey activities, including $5,000 for 1994. Related expenses had also been deducted as business expenses.

On September 4th, 1994, he was paid $300 to serve as the disk jockey at a wedding reception. When he set up his equipment, he stacked his loudspeakers next to the dance floor. During the reception he drank several alcoholic beverages, and at one point he became involved in a scuffle with an intoxicated guest who was upset because Wagner had forgotten to play his requested song.

During the scuffle, one of Wagner's speakers became dislodged and struck a bystander in the head. The bystander, a woman named Judy Luneau, was hurt badly. The impact caused bleeding, bruising, swelling and a concussion. After the incident, she suffered from neck, back and shoulder pain. She incurred medical expenses and also lost approximately $5,600.00 in wages for the work she missed due to her injuries.

On February 9th of the following year, Luneau filed a lawsuit against Wagner alleging that, while he had been "employed as a disc jockey" during the September 4th reception, he had been negligent (1) in "the placement, use and supervision of the stereo equipment," and (2) in his "physical conduct," resulting in her injury.

Luneau and Wagner subsequently stipulated to a judgment that Wagner was liable to her in the amount of $60,000, which the court entered. Of course, as in many cases, the loser (Wagner) didn't have sixty grand. So he transferred to her any rights to being indemnified by his insurance company. This meant Luneau had to go after the insurance company for her settlement. And, on February 7th, 1997, she filed a complaint against Peerless Insurance.

However, the court determined that since Wagner was negligent both in his placement of the speakers and in becoming involved in the shoving match (the result of which caused injury to Luneau), his acts of negligence fell within the business pursuits exclusion of the homeowners policy. Wagner didn't have a business policy; so, Peerless Insur-

ance Company had no duty to indemnify Wagner
(and pay Luneau).

Although the policy included personal liability
coverage, it included a business pursuits exclusion
clause that read:

> Coverage E—Personal liability and Cov-
> erage F—Medical Payments to Others do
> not apply to "bodily injury"...[a]rising out
> of "business" pursuits of an "insured."

This exclusion, common to homeowners policies,
does not apply to activities that are usual to non-
"business" pursuits.

Thus, the court determined that when the acci-
dent took place, Wagner's activities were "entirely
related to his business pursuit at that time."

Whether or not a particular activity falls within
the business pursuits exclusion is a question of fact
to be decided on a case-by-case basis.

After the *Luneau* court determined that Wagner
was plainly engaged in the business of being a disk
jockey at the wedding, it had to decide whether
Wagner's activities at the wedding (which directly
resulted in the injury) were "usual to non-business
pursuits." If so, his homeowners would have to
cover.

The court relied on previous case law, specifically
the 1967 decision *Gulf Ins. Co. v. Tilley*. In that
earlier case, a child was injured when she pulled a
coffee pot down on herself. Her family sued the
home day-care provider, who had used the pot to

prepare coffee for herself and a friend. Although the day-care provider's homeowners insurance carrier denied coverage under the business pursuits exclusion, the court found the case fit within the exception for activities that are usual to non-business pursuits. It reasoned that "preparation of hot coffee is an activity that is not ordinarily associated with a babysitter's functions."

However, since the *Tilley* decision, most courts have moved away from that narrow notion of liability. The *Luneau* court wrote that a homeowners policy is:

> designed to insure primarily within the personal sphere of the policyholder's life and to exclude coverage for hazards associated with regular income-producing activities...[which] involve different legal duties and a greater risk of injury or property damage to third parties than personal pursuits.

Wagner had legal duties while conducting his business. When he failed to take the proper precautions, he became negligent—all within the course of his business activity.

The court thought it was particularly significant that the injury to Judy Luneau resulted from a "scuffle" between the disc jockey and a wedding guest. If the scuffling guest had sued Wagner, things might have been different. The exception for "activities which are usual to non-business pursuits" might have applied. Even though the disc jockey was on duty and playing music, engaging in a physical fight is a non-business activity.

So, when all was said and done, Luneau—the victim—lost. Despite a court ruling that made Wagner liable for his negligence in his business pursuit, she could not seek damages from his insurance company. She would have to try to collect from Wagner.

And how would someone like Wagner pay? He didn't have the cash. Either he'd have to work out some scheduled payments to Luneau or a court could force him to liquidate his assets (the very ones that allow him to conduct business) in order to pay.

CONCLUSION

Bottom line: Business people can obtain business liability insurance, and should—if they want things covered when the business generates trouble as well as cash.

Coughing up sixty grand in a small, one-man business isn't an easy thing to do. And it's far more expensive than buying a policy.

There are many more liability issues that face businesses—even small ones. The purpose of this chapter has been to consider the risks that often apply to start-up or home-based businesses. Clearly, the standard business owners policy...or BOP...is the best tool for handling these. BOPs are not terribly expensive and protect you against the basic problems that a home-based business can cause.

7

ODDBALL LIABILITIES: SLIPS, FALLS, DOG BITES & FAMILY TROUBLES

Crazy things happen in everyday life. In fact, personal liability issues often turn on situations that sound absurd...at first. In other words, oddball liabilities aren't really so oddball after all. As the legal maxim goes: Things happen according to the ordinary course of nature and ordinary habits of life. There is no such thing as a *safe haven*. But there are such things as insurance and an ability to understand how we can protect ourselves.

We've seen how personal liability insurance pays claims made against you that you are found legally liable for under a homeowners policy. Personal liability also pays legal defense costs if a suit or claim made against you is groundless, false or fraudulent. This is important as attorneys (even the 1-800 ones) may charge as much as $300 an hour to defend you against a claim even if you are not responsible for another person's damages.

Standard insurance policies do not cover liabilities created by business activities and intentional or criminal actions. And your insurance company may try to push a liability claim into one of these

categories if it has doubts. So, when a strange situation happens—your straight-A son sets the barn on fire—be prepared to take it seriously.

SWIMMING POOL LIABILITIES

Just when you think you've created a safe haven in your sprawling backyard for holidays and work-free weekends—rose bushes, a gas grill and tulips lining your black-bottom pool—you realize that it's not so safe. Or a lawsuit brought against you and your family makes you realize that your yard isn't safe for everyone.

The main item in most backyards that causes liability problems is a swimming pool. But some swimming pool lawsuits are so poorly thought-out that they don't work in even the current litigious atmosphere. And you—as a swimming pool owner—have a few arguments on your side.

In *Joseph J. O'Sullivan v. Norman Shaw*, the Massachusetts Supreme Court considered two important liability terms: *open and obvious* and *duty to warn*. In this case, an adult dived head-first into the shallow end of a swimming pool. At night. He hit his head, broke his neck and blamed the homeowners—who weren't there at the time. A typical case of someone trying to lay his own negligence onto someone else.

The details went something like this: Joseph O'Sullivan was a friend of the Shaws' granddaughter, and had used their pool at least once prior to the night of the accident—during daylight hours. He had observed various swimmers dive into the

pool's deep end from the divingboard and into the shallow end by performing a flat or "racing dive." O'Sullivan himself had previously dived into the deep end from the diving board two or three times, and had made one dive into the shallow end. Although he did not know the exact dimensions of the pool, he was aware of approximately where the shallow part ended. Moreover, he was aware of the shallow end's approximate depth, having observed other swimmers standing in that part of the pool and having subsequently stood next to these people outside the pool.

On the evening of July 16, 1996, 21-year-old O'Sullivan was a guest at the Shaws' home. The Shaws were out of town, but their granddaughter had permission to be on the premises and to use the swimming pool. Sometime between 9 and 9:30 p.m., O'Sullivan suffered injuries to his neck and back when he dived into the shallow end of the pool. At the time, he was attempting, in racing dive fashion, to clear the 10-foot expanse of the shallow end and surface in the deep end, but he entered the water at too steep an angle and struck his head on the pool bottom, resulting in a fracture of his cervical vertebrae.

By his own admission, O'Sullivan knew that he could be injured if he were to hit his head on the bottom of the pool, and his purpose in trying to clear the shallow end was to avoid the sort of accident that occurred. His injury caused immediate paralysis in his lower extremities and required a two-day stay in the hospital, but the paralysis was not permanent.

O'Sullivan sought to recover damages for his injuries. Superior Court Judge Howard J. Whitehead entered summary judgment in favor of the homeowners, and O'Sullivan appealed. Appeals court Judge Lynch held that under open and obvious rule, homeowners had no duty as matter of law to warn guests of the danger of diving head-first into the shallow end of a residential pool.

One of the pivotal questions was whether a defendant has a duty of care to the plaintiff in the given circumstances. And, it followed that:

- The duty is determined by reference to existing social values and customs and appropriate social policy.

- An owner or possessor of land owes a duty of reasonable care to all persons lawfully on the premises. This includes an obligation to maintain property in a reasonably safe condition in view of all the circumstances, including the likelihood of injury to others, the seriousness of the injury and the burden of avoiding the risk.

- Landowner's duty to protect lawful visitors does not extend to dangers that would be obvious to persons of average intelligence.

- Open and obvious danger doctrine presumes a plaintiff's exercising reasonable care for his own safety.

- Open and obvious danger rule concerns the existence of a defendant's

duty of care, which the plaintiff must establish as part of his prima facie case before any comparative analysis of fault may be performed.

Of key importance in this case was the so-called "open and obvious danger rule." According to the 1995 decision *Davis v. Westwood Group,* argued in a Massachusetts court, a legal duty owed by the landowner to any visitor (claims of negligence had to assume a breach of this duty) includes an obligation to maintain property in a reasonably safe condition; it also includes a duty to warn visitors about any "unreasonable dangers of which the landowner is aware or reasonably should be aware."

However, the same precedent held that a landowner is "not obliged to supply a place of maximum safety, but only one which would be safe to a person who exercises such minimum care as the circumstances reasonably indicate." And the various duties defined by *Davis* and other decisions did not extend to dangers that would be obvious to persons of average intelligence.

In fact, the court said:

> Landowners are relieved of the duty to warn of open and obvious dangers on their premises because it is not reasonably foreseeable that a visitor exercising (as the law presumes) reasonable care for his own safety would suffer injury from such blatant hazards.

In other words, where a danger would be obvious to a person of ordinary perception and judgment,

a landowner may reasonably assume that a visitor has knowledge of it and, therefore, any further warning would not necessarily reduce the likelihood of harm.

The reasoning (and deciding) of this case was rather simple. In applying the open and obvious rule, and thus the question of duty to warn, the court noted:

> It would be obvious to a person of average intelligence that a swimming pool must have a bottom. We have no doubt that an ordinarily intelligent adult in our society would be aware that the bottom of a swimming pool is a hard surface, liable to cause injury if one were to strike it with one's head. Moreover, the design and layout of the Shaws' pool would have indicated to a person of average intelligence that the end into which the plaintiff dived was not intended for this activity: the diving board was affixed to the opposite end of the pool, making it apparent that the pool's deepest water was located at that end and that diving was intended to take place there.

The court concluded that a person of average intelligence would clearly have recognized that diving head first into shallow water posed a risk of injury by striking the bottom of the pool. And because the danger of diving into the shallow end of a swimming pool—at night—is open and obvious to a person of average intelligence, the Shaws had no duty to warn O'Sullivan. Therefore, they could not be found liable for his injuries.

Surprised by the outcome? Basically, open and obvious can cancel a duty to warn—especially when it comes to the risky, stupid acts of seemingly competent adults. You may wonder how a court decides whether an adult is competent or not; and that, of course, is also determined on a case-by-case basis. Just remember, you can't always blame someone else for your flagrant negligence.

WHOOPS, THERE GOES ANOTHER LITIGIOUS GUEST

Slip-and-fall claims are some of the most bogus liability issues in the American legal system. From New York judges who sue the state as a kind of additional pension benefit to California insurance scammers who fabricate claims against friends and family, slip-and-fall claims often involve absurd circumstances.

Insurance companies know that these claims are often shady—and they will often investigate slip-and-fall liabilities carefully. This can make problems for you, if you are the policyholder facing a lawsuit. The best strategic approach to take if you're facing a slip-and-fall claim may be to follow the practice of the insurance companies: Don't dole out any money until you've fully investigated the merits of the claim.

And, generally, the courts give property owners some good tools for battling iffy claims.

The September 2000 Ohio Appeals Court decision *Daisy Lee, et al. v. Joseph Grant, et al.* consid-

ered some of the basic mechanics of a weak slip-and-fall liability case.

On March 9, 1996, Daisy Lee attended a baby shower at the home of Marsha Hayes. Hayes and her husband were renting the home from its owners, Joseph and Hanna Grant. Lee arrived at the house at about 4:30 p.m.; she parked her car on the street and walked up the driveway to the house. As she walked up the inclined driveway, she noticed several areas of snow and ice. Lee and several other shower guests held on to each other.

Lee left the shower at approximately 7:30 p.m. but decided that she did not want to go back down the driveway. She noticed that the front walkway leading to the street appeared to be clearer than the driveway and decided to return to her car via the front walkway. As she walked down the walkway, Lee's left foot slipped causing her to fall backwards. Lee noticed that her heels were on a piece of ice. As a result of the fall, Lee suffered injuries to her left wrist, hand and arm.

On March 9, 1998—just inside the legal time limits—Lee filed a lawsuit against Joseph and Hanna Grant. Lee alleged that the Grants negligently failed to maintain the property, failed to give notice of a dangerous condition, and failed to properly remove the accumulation of ice and snow. Lee alleged that she fell on an unnatural accumulation of ice and snow that was negligently allowed to remain on the path of exit intended for use by invitees. To make the a case a nearly perfect example of legal abuse, Lee's husband added a loss of consortium claim.

The Grants filed a motion to dismiss the case. Citing the Ohio state court decision *Brinkman v. Ross*, they argued that, because Lee fell on a natural accumulation of snow and ice, they could not be held liable for her injuries. They also argued that, under another state decision, landlords who have "neither possession nor control of rented property cannot be held liable for damages resulting from the condition of the property." The Grants attached excerpts Daisy Lee's deposition, in which she clarified the situation:

> When she arrived at the baby shower at around 4:30 p.m., the weather was sunny and cold. As she walked up the driveway toward the house, she noticed patches of ice and snow in her path, some of which appeared to have been partially cleaned. As she left the house, she decided to use the front walkway, which appeared to have been cleaned more than the driveway. Lee stated that she was watching where she was going and that she was looking down at the time she fell. She stated that she saw some snow on the walkway but did not see the ice. She admitted knowing that snow can be slippery if it freezes.

Joseph Grant also testified that he never cleaned the driveway or the front walkway of the home at any time since the tenants had occupied the property. He also stated that the tenants had complete, unrestricted access to the property.

Daisy Lee insisted that unnatural accumulations of ice and snow caused her to fall. She also argued that, upon leaving the party, she chose the side-

walk of the dwelling where snow and ice had been rearranged so as to prevent her from recognizing the full danger involved. Finally, she claimed that when she'd first entered the house for the party, she'd told Marsha Hayes about the condition of the driveway. Hayes said the driveway had not been completely cleaned by the Grants.

In September 1999, the trial court granted the Grants' motion for summary judgment, ruling that the Lees failed to present any case law to dispute the Grants' legal arguments and case law. The Lees appeals. That loss of consortium must have been weighing heavily on them.

The Lees argued the trial court had erred in granting summary judgment in favor of the Grants. Specifically, they argued, a landlord who does not retain the right to admit or exclude people from leased property does not reserve the possession or control necessary to impose liability upon him for injuries caused by the condition of the premises. But the appeals court didn't buy this argument. It wrote:

> In this case, Grant stated that the tenants had complete, unrestricted access to the property and that Grant never cleaned the driveway or the front walkway of the home at any time since the tenants occupied the property. This testimony constitutes evidence that Grant did not retain any control over the property so as to support an imposition of liability upon him for injuries caused by the property's condition.

The appeals court also rejected the Lees' argument that Daisy Lee's affidavit raised an issue of fact about whether the snow and ice had been rearranged by the landlord, Grant. Her affidavit, in which she claimed that Hayes had told her that Grant had failed to clean the driveway, wasn't enough to create an issue of fact for trial. Anything Hayes said about the ice in the driveway was hearsay—and not admissable evidence.

The appeals court concluded:

> Lee did not meet her burden of establishing a material issue of fact for trial. Consequently, the trial court properly granted Grant's motion for summary judgment.

Another, similarly weak slip-and-fall claim put the issue in an even clearer context...and plainer terms. The 1993 Supreme Court of Ohio decision *Brinkman, et al. v. Ross, et al.* included the perspective of the state's trial lawyers—which reflected their usual selfish interest; but it also included some common sense from the state's high court.

Richard and Nadine Ross invited Carol and Charles Brinkman to visit them at their home as social guests. The Brinkmans accepted the invitation for the evening of February 4, 1989. Before the Brinkmans were due to arrive, the private sidewalk situated between Rosses' driveway and residence became hazardous to walk on due to a natural accumulation of ice and snow. The Rosses knew of the hazardous condition, but they took no steps to alleviate the condition or to warn the Brinkmans of its existence.

The Brinkmans and their daughter arrived and parked in the driveway. While walking on the sidewalk between the driveway and house, Carol Brinkman slipped on the snow-covered ice and fell, sustaining serious injuries. The fall was caused solely by the natural accumulation of ice on the sidewalk, which ice had been concealed from view by a natural accumulation of snow. Immediately prior to the fall, Carol Brinkman had warned her daughter of the slippery condition of the sidewalk.

The Brinkmans filed suit against the Rosses, alleging that the Rosses had been negligent in maintaining "an ice-covered sidewalk concealed by a blanket of snow leading to the entranceway of [their] residence." The Rosses asked the court for a summary judgment dismissing the claims. The trial court agreed with the Rosses, dismissing the lawsuit because under "long-standing Ohio law there is no liability for failure to remove natural accumulations of ice and snow from sidewalks."

The Brinkmans appealed. The court of appeals, in a divided vote, reversed the judgment of the trial court. Its majority held that, when a homeowner knows of a hazardous condition on his premises caused by a natural accumulation of ice and snow and expressly invites a social guest to visit the premises at an appointed time, the homeowner owes a duty to the guest "to take reasonable steps to remove the hazard and to warn the guest of the dangerous condition."

The Rosses pressed that decision up to the state supreme court, which agreed to consider the case.

The state supreme court called the appeals court's decision a "radical extension of homeowner liability with regard to natural accumulations of ice and snow." In Ohio, it is well established that an owner of land ordinarily owes no duty to business invitees to remove natural accumulations of ice and snow from the private sidewalks on the premises, or to warn the invitee of the dangers associated with such natural accumulations of ice and snow. In the 1968 decision *Sidle v. Humphrey*, the court had ruled that:

> The dangers from natural accumulations of ice and snow are ordinarily so obvious and apparent that an occupier of premises may reasonably expect that a business invitee on his premises will discover those dangers and protect himself against them.

The underlying rationale in *Sidle* was that everyone is assumed to appreciate the risks associated with natural accumulations of ice and snow and, therefore, everyone is responsible to protect himself or herself against the inherent risks presented by natural accumulations of ice and snow.

Of course, there was a slight difference in the *Brinkman* case. It involved the duty of a homeowner to a social guest, rather than a business to a customer. But the Ohio supreme court didn't think there was much of a distinction in that difference. It ruled:

> [T]here is no reason why we should now hold that a homeowner owes a duty to his or her social guest to remove natural

accumulations of ice and snow from side-walks and walkways, or that the home-owner must warn the guest of the natural hazard, when a similar duty has not been imposed upon owners or occupiers of land with respect to business invitees.

That said, the court acknowledged that the case involved a very narrow issue of a homeowner's liability to a social guest with respect to injuries occasioned by a slip and fall caused by a natural accumulation of ice and snow. If the claims had involved other issues, the court admitted that it might have found the Rosses liable.

The Ohio Academy of Trial Lawyers had filed a friend-of-the-court brief asking the state's high court to abolish all distinctions in Ohio regarding the duties owed by landowners to "social guests," as opposed to those classified as "business invitees." The lawyers expected that this would allow more lawsuits against businesses. The state supreme court's decision had the opposite effect. It ruled that there didn't need to be a decision on the dif-ference between the two sorts of visitor, since nei-ther could sue, anyway:

> ...[W]e determine there is no distinction between the duties of a homeowner to a social guest on the one hand and to a busi-ness invitee on the other hand concerning natural accumulations of ice and snow on sidewalks or walkways on the homeowner's premises. Whatever the clas-sification of the entrant upon the premises, there exists no duty for the homeowner

to remove or make less hazardous natural accumulations of ice and snow.

Finally, the Ohio Supreme Court summed up the problem with the Brinkmans' claims—and made a statement that can apply to most slip-and-fall claims:

> Living in Ohio during the winter has its inherent dangers. ...It is unfortunate that Carol Brinkman slipped and fell on [the Rosses] sidewalk. However...we are unwilling to extend homeowner liability to cover slip-and-fall occurrences caused entirely by natural accumulations of ice and snow. To hold otherwise would subject Ohio homeowners to the perpetual threat of (seasonal) civil liability any time a visitor sets foot on the premises, whether the visitor is a friend, a door-to-door salesman or politician, or the local welcome wagon.

That sums up slip-and-fall claims. Most states assume that people should be smart enough to deal with obvious risks—and that homeowners can't anticipate every possible thing that can go wrong on their property. Legitimate slip-and-fall claims usually need to find some sort of negligence or greater responsibility on the part of visitors.

And most insurance companies treat shaky slip-and-fall claims with the skepticism they deserve. If you're of "average intelligence" and you see an "open and obvious" danger, be wary—don't be suit-happy. Dive into deep ends. And go for the galoshes when Mother Nature makes life a little more trying.

FIDO BITES THE NEIGHBOR'S KID

It might sound like a cliché, but dog bites are a major source of personal liability claims. If you have pets, you are responsible for any harm they do to people. According to the Centers for Disease Control and Prevention, there are approximately 4.7 million dog bites per year. These bites cost over $1 billion with the property/casualty insurance industry paying roughly $250 million of that in homeowners liability.

You may be thinking, "My dog isn't vicious. I keep him safely confined. He loves children. Nothing could ever happen." Or, you may think you're safe because you put up a precautionary sign that reads "Beware of Dog" in the front of your house. But trouble can still come.

You're running late some morning and don't quite get the gate latch closed all the way. Your dog gets out, wanders the neighborhood and finds some kids playing street hockey. The stick and hockey puck look like great fun so he decides to join them.

High in prey drive from watching all the activity, Fido runs toward the kids, barking like crazy. A frightened child runs, waving her hockey stick in the air. Fido goes for the stick but misses it and accidentally bites the child on the hand.

The little girl's mother comes outside to see a screaming eight-year-old cradling a bloody hand and your dog crouching defensively nearby. The little girl is alternately crying about her hand and

insisting the she didn't do anything to provoke the vicious attack. The mother, not a calm sort, calls an ambulance and the police. The little girl's father has been out of work for a while—so, when he shows up in the ER, he's worried about his daughter and how he's going to pay the hospital bills. And how he's going to pay the mortgage and his next car payment. He figures he'd better call a lawyer.

Your whole life has just been turned upside down—and you're sitting through a boring staff meeting thinking about all the e-mails you have to return on the Schnitzelhausen project.

Dog owner liability is determined by the state law where the bite occurred. In most states, you, as the dog owner, are financially responsible for damages caused by your dog. Many states impose strict liability if your dog bites someone if it is loose or if the person bitten was in a public place or permitted on your property. For example: Washington state law says:

> The owner of any dog which shall bite any person while such person is in or on a public place or lawfully in or on a private place including the property of the owner of such dog, shall be liable for such damages as may be suffered by the person bitten, regardless of the former viciousness of such dog or the owner's knowledge of such viciousness.

The three most common bases of dog-bite lawsuits are: a specific dog bite statute, common law

rule and ordinary negligence. Each affect liability:

1) Dog Bite Statutes. Laws in numerous states impose "strict liability"; that means you, the owner, are held responsible regardless of whether you were at fault. The effect of these statutes, however, may be mitigated by the conduct of the victim-i.e., if they were trespassing, or teasing, tormenting or provoking the animal.

2) Common Law Rule. In addition to statutes, the courts have developed a system of rules called the "common law." The common law imposes liability on you if you knew the dog was inclined to be dangerous and knew it had a tendency to cause the type of injury that was, in fact, suffered.

3) Negligence. Under the negligence theory, the victim must prove that your careless behavior in handling or controling your dog directly caused the injury. Also, that the incident occurred when the victim used reasonable care to prevent the injury. Unlike strict liability, which does not consider your conduct as it does in negligence, strict liability requires proof of your knowledge of your pooch's dangerous propensity.

In most personal injury lawsuits, the victim may be compensated for medical bills and, if relevant, for lost wages as well as damage to property. If your conduct was outrageous or your dog had

injured someone previously, you may be liable for punitive damages. Damages for pain and suffering, although more difficult to assess, may also be recovered. However, the extent and value of the damages must be proven by the bite victim.

As a dog owner, you may have some defenses, which also vary from state to state. You may successfully defend such a lawsuit if you can prove that: the bite victim was trespassing; the victim's own negligence contributed to his injures; the victim provoked the dog into attacking; or the victim knew there was a risk of being injured by the dog, had an opportunity to avoid the injury and did not do so.

WHO COVERS A DOG IN A TRUCK?

Let's take a closer look at two cases and see how typical dog bark liability scenarios played out in real courts. This first one not only deals with a biting dog—but it also hashes out which of two different insurance policies would cover the damages.

Specifically, in the 1997 decision *Richard D. Diehl v. Cumberland Mutual Fire Insurance Co.*, the Superior Court of New Jersey had to decide whether a dog-bite injury in a car would be covered by an auto policy or a homeowners policy.

On December 26, 1989, Richard Diehl was driving away from his home when he saw his brother George approaching in a pickup truck. Richard pulled over and got out of his car. As he walked around the rear of the pickup truck, he was bitten

in the face by George's dog, which was in the open cargo area.

The truck was owned by Theresa Brown and insured by the New Jersey Automobile Full Insurance Underwriting Association through its servicing carrier, CSC Insurance Services (CSC). At the time of the incident, George lived with his mother who had homeowner's insurance with Cumberland Mutual Fire Insurance Company.

A few weeks after the bite, Richard's attorney gave Cumberland—the homeowners insurance company—the notice of a claim. Following an investigation, Cumberland denied coverage.

Richard then filed a lawsuit against George alleging negligence as a result of the dog bite. And, on August 1, 1991, unrelated to Richard's complaint, Cumberland gave CSC—the auto insurance company—notice of the denied claim, alleging that CSC's insured's vehicle was used in the incident. CSC wrote back to Cumberland claiming that it would investigate to "determine coverage."

George was served with Richard's lawsuit on August 15, 1991. Richard's lawyers sent a copy of the complaint to Cumberland. More than six months later, in April 1992, Cumberland wrote to George's mother and informed her that it was denying coverage.

In August 1992, a year after the lawsuit started, the court entered judgment in favor of Richard and against George in the total amount of $55,085.72. In a normal legal move, George and

his mother assigned to Richard all of their claims against Cumberland for refusal to defend and indemnify them for the dog bite complaint and judgment. Richard then filed a lawsuit against Cumberland for damages and for the refusal to defend. Cumberland argued that the claim did not arise from any covered loss.

A few months later, Richard's lawyers wrote to CSC, describing the accident and enclosing a copy of the complaint. CSC did not reply. So, Richard's lawyers amended the lawsuit to add CSC as a defendant. CSC made various defenses, including lack of coverage.

Complex legal maneuvering followed. CSC and Cumberland each filed a motion for summary judgment based on lack of insurance coverage. After argument, the judge granted CSC's motion and dismissed all claims against it. The judge concluded that, because an injury caused by a dog sitting in the back of a vehicle did not arise out of a "use of the automobile," it did not trigger coverage under an automobile policy. Thus, Cumberland's homeowners policy had to provide coverage.

Almost four years after Richard's lawsuit was first filed, the trial court entered judgment against Cumberland in the amount of $55,275.16, prejudgment interest in the amount of $5,861.79 and legal fees and costs (for Richard's lawyers) of $2,590.

Cumberland appealed, insisting that Richard's injuries were excluded from coverage under the

homeowners policy because they were covered under the automobile policy. (The homeowners policy excluded coverage for bodily injury arising out of the "maintenance, operation, ownership, or use...of any...motor vehicle...owned or operated by...any insured.")

The appeals court cited some general principles in earlier case law. According to *Westchester Fire Ins. Co. v. Continental Ins. Co.*, there had to be a "substantial nexus between the injury and the use of the vehicle in order for the obligation to provide coverage to arise." Westchester dealt with the liability issues arising from an injury to a person who was struck by a stick thrown from an insured's car.

Under the *substantial nexus* test, auto coverage applies if the negligent act, which caused the injury (although not foreseen or expected), was a natural and reasonable consequence of the use of the automobile. In other words, a clear connection must exist between the legitimate use of a car and an incident arising out of that legitimate use.

Another case, *Lindstrom v. Hanover Ins. Co.*, dealt with a similar issue. In *Lindstrom*, the New Jersey Supreme Court concluded that the drive-by shooting of a person that caused gunshot injuries was an accident within the contemplation of the insurance coverage. The high court explained:

> In our view the automobile did more than provide a setting or an enhanced opportunity for the assault. In addition to allowing the assailant to be at the place of

attack, it furnished the assailant with what he must have assumed would be both anonymity and a means of escape. The assailant would not likely have committed such an act of apparently random violence without the use of a car.

Back to the dog in the pickup. The *Diehl* appeals court acknowledged that other states have reached different conclusions in determining whether, for the purpose of extending automobile liability insurance, a dog bite can arise out of the use of a vehicle. However, consistent with Lindstrom, it held that automobile liability insurance should cover the injury caused by a dog bite to the face occurring while the dog was in the open cargo area of a pickup truck because it arose out of the use of the vehicle to transport the dog.

Moreover, the *Diehl* court contended:

> ...[T]he bite incident was facilitated by the height and open design of the deck. In our view the act was a natural and foreseeable consequence of the use of the vehicle, and there was a substantial nexus between the dog bite and the use of the vehicle at the time the dog bit the plaintiff.

Looking for a bottom line to this case? Two conclusions: 1) the dog owner was indisputably liable for his pet's behavior, and 2) his auto policy had to cover for the damages. We won't guess what happened between the two brothers on a personal level.

WHO'S DOG IS IT, ANYWAY?

Another important insurance issue: Who is an insured? Though it might seem like an easy distinction—that is, who is covered as an insured under a specific policy, such as homeowners—surprisingly, it is not always so clear.

Consider the 1991 Louisiana Appeals Court case *Laura Cain, et al. v. Richard A. Parent, et al.*, a suit brought on behalf of a minor child for a dog bite injury. The case also involved the dog owner's filing a third-party petition, asking the court to declare her insured under her mother's homeowners policy. This brought the court to focus on the definition of *resident*, another important insurance term.

In August 1987, Laura Cain was bitten by an American Staffordshire Terrier owned by Tianne Siener. When the bite occurred, the dog was being walked by Siener's brother, Michael Siener. The whole thing took place in Lafayette, Louisiana near a townhouse occupied by Tianne and owned by her mother, Eileen Parent.

Following the incident, Al Cain and Carmen Cain, Laura's parents, filed suit against Tianne, Michael, their mother Eileen, her husband and Allstate Insurance Company—their homeowners liability insurers. Subsequently, Tianne filed a third-party petition for declaratory judgment, seeking a declaration that she was an insured person under her mother's Allstate homeowners policy and that Allstate therefore had a duty to defend.

A trial court found that Tianne and her brother were insured persons under the Allstate policy issued to their mother. Allstate appealed. The issue on appeal: For the sake of this dog bite lawsuit, were Tianne Siener and Eileen Parent mother and daughter...or landlord and tenant?

According to Allstate, Eileen Parent's policy did not cover the accident because the dog was not owned by her, the only named insured on the policy. Further, Allstate contended that Tianne was not an insured under the policy since she was not a resident of the named insured's household at the time of the occurrence.

According to Section II of the Family Liability and Guest Medical Protection policy issued by Allstate to Eileen Parent:

> Allstate will pay all sums arising from an accidental loss which an insured person becomes legally obligated to pay as damages because of bodily injury or property damage covered by this part of the policy.

In addition, the policy clearly defined the insureds:

> Insured person—means you and, if a resident of your household:
>
> a) any relative; and
>
> b) any dependent person in your care.

Allstate's argument: If Tianne were a member of her mother's household at the time of the dog bite, the policy provided liability coverage because she was Parent's daughter. However, if Tianne

were not a member of her mother's household, the policy did not provide coverage. And she wasn't a member of her mother's household.

The court considered existing case law that summarized what it means to be a resident of the same household. Unfortunately, however, these cases didn't offer much concrete help.

When the U.S. Supreme Court considered the question, it ruled that, when construing "resident of the same household" in the context of a legally separated wife, for example, the determination did not depend solely on whether a couple was living under the same roof. The high court placed emphasis on membership in a group rather than attachment to a building and noted it was a matter of intention and choice rather than location.

From this framework, the appeals court decided that Eileen Parent and her daughter, Tianne, maintained separate households. Each represented an independent family unit. Tianne was not a member of her mother's household and thus, she wasn't an insured under Allstate's policy.

Tianne also argued that if the appeals court were to reverse the trial court's decision, the Allstate policy would cover no one against any loss. The court disagreed, specifically because Tianne was not the policyholder. "If there should be any merit to this assertion," said the court, "the matter is between [Tianne's] mother and Allstate."

In some ways, this was a loss for Laura Cain—the woman who'd been bitten by Tianne's dog. With-

out the insurance company's resources, she would have to get her money from Tianne—who didn't have very deep pockets. This proves the old legal maxim that winning a judgment is easy, collecting one is hard.

In other words, it doesn't always matter who's at fault as much as it matters how much the at-fault person can afford to pay.

PARENTAL LIABILITY

The *Cain* decision raises the important issue of how liability issues affect family members. If your brother or uncle or third-cousin does something awful, can you be held liable?

In the real world, this question usually focuses on another family tie: If your child does something awful, can you be held liable? In *Cain*, the answer was no. But, in that case, the daughter was a legal adult living on her own. If your child is still a child, liability issues usually go differently.

In civil cases, the concept of vicarious liability holds that parents must pay for damages caused by their minor children. Often, homeowners insurance covers at least some of the damage under a standard liability clause, with varying deductibles. Beyond this, a good umbrella liability policy can cover parents and their kids, whether they are living at home or are away at school.

All states now hold parents responsible for at least some of the damage their children cause. This is

in large part as a result of some high-profile cases—like the Columbine, Colorado, high school shootings—and an overall increase in violent acts by juveniles.

A side note: Despite the parental liability claims following the Columbine tragedy, the parents of gunman Dylan Klebold filed court papers blaming authorities for failing to prevent their teen's murderous rampage. The Klebolds threatened to sue the Jefferson County sheriff's department and school district. In a bizarre twist, the Klebolds argued that if investigators had told them about their son's Internet rantings and his friend's violent tendencies, they would have kept the two boys apart and prevented the mass murder.

Sound ludicrous? Well, it's merely a product of the human condition. As evidenced by other cases, when something bad happens, people jump to hold someone else liable—before taking a good look at themselves and acknowledging their own negligence. This is when the courts step in.

Parental liability laws are cropping up in every state. These laws generally require parents to pay for damages done by their children—whether it's damage to property or a person. However, the specifics vary by state; some states hold parents liable for property damage and bodily injury caused by a child—in others, parents are only liable for the criminal acts of their children. Typically, parents are sued in civil court. However, in some states (for example Oregon), parents can be charged criminally with a class A misdemeanor for their children's actions.

A caveat: intentional or criminal acts are, as usual, excluded from insurance coverage. So, if your kid gets involved in some kind of mischief—even of the prankish sort—you are going to have to settle legal claims out of your grocery money (Or, as in the Klebold case, you can try to blame other authorities in your child's life. Good luck.)

Parental negligence is a more serious charge. In these instances, a court decides a parent (or even a teacher or counselor) should have known of the damage a child was about to inflict. Juries have found parents guilty of civil negligence and ordered them to pay up to $500,000 because of bad, destructive things their children have done.

As in the *Cain* case, it's often difficult to collect civil damages in cases seeking to prove parental negligence. Though state law may allow the claims, juries are often split on what constitutes appropriate behavior on the part of the parents. And, even when a plaintiff wins in court, it can be very difficult to collect from the at-fault family, who is often a struggling middle-class type. Lawyers say these cases are used to make a point, not money.

In March 2000, the Alaska Supreme Court considered the case of an insurance company's refusal to defend the parents of a grown man who physically and sexually assaulted a child. Note: a grown man. This was more than a simple case of a son's misbehavior; this case called into question parental liability because the incident occurred in the parents' home.

Harold Lancaster, the grown man in question, lived with his parents, Eleanor and Dolan Lancaster, and his daughter. On the night of November 11, 1995, his daughter invited an 11-year-old friend to spend the night. The elder Lancasters were away that evening, a fact unbeknownst to the friend's parents. Harold sexually and physically assaulted his daughter's friend. Following the incident, the victim's parents brought a suit against the Lancasters for the criminal wrongdoings of their son. They alleged that the elder Lancasters were negligent in failing to disclose Harold's presence or his alleged propensity to assault children and in failing to watch over their daughter.

The Lancasters' insurance company, Allstate, invoked exclusions for intentional and criminal acts. Again, we see here an insurer's refusal to cover damages based on specific exclusions contained in the policy. However, this case got tricky.

The parents of the assaulted child settled with the Lancasters in exchange for an assignment of rights that allowed them to sue Allstate. When an Alaska district court asked the state supreme court to answer three questions concerning potential tort duties of adjustors and the insurer's coverage obligations under state law, the Supreme Court of Alaska held that:

1) Allstate's salaried adjustor owed the policyholders a duty of care, enforceable in a tort action against the adjustor personally, to exercise reasonable care in connection with any investigation of the case;

2) bodily injuries sustained by the child arose from an "accident";

3) the policy's criminal and intentional act exclusions did not exclude coverage; and

4) the policy's joint obligations clause was irrelevant to either intentional or criminal acts exclusions.

To make a long story short, the court determined that the incident did constitute an "accident" for purposes of the homeowners policy. Thus, Allstate had to cover for the damages suffered by the victim while visiting in the Lancasters' home. Why?

According to the family liability coverage part of Allstate's policy, "Subject to the terms, limitations and conditions of this policy, Allstate will pay damages which an insured person becomes legally obligated to pay because of bodily injury or property damage arising from an accident and covered by this part of the policy."

The policy did not, however, define "accident." Nor did it specify whether a court should apply the term subjectively—from the perspective of either the policyholder claiming coverage or the victim—or objectively. Without specific policy language, the court's practice of enforcing the policyholder's reasonable expectations required it to determine whether the loss was the result of an accident from the perspective of the policyholders claiming coverage.

The court ruled:

> From the standpoint of the elder Lancasters, it was not unreasonable that their interpretation of the policy focused on the acts the victim attributed to them, as distinct from the acts she attributed to Harold. They were sued for their conduct, not Harold's. The victim did not attempt to make them vicariously liable for Harold's acts. Rather, her complaint alleged that the elder Lancasters' negligence legally caused injury to her.

With respect to the victim, the elder Lancasters' alleged conduct was allegedly negligent, and therefore neither intentional nor criminal. It thus triggered neither exclusion. So, the Lancasters' homeowners policy had to pay the victim.

Sometimes a criminal act is an insurer's way out of covering an insured, especially when that act is intentional; however, as seen in this case, that exclusion does not always hold.

LIABILITY AND MINOR CHILDREN

If you think about parent/child cases at all, you're probably looking for a more typical parental liability case involving a genuine, minor child and his liable or negligent parents. Here's one for the ages: A 14-year-old boy drives the family lawn mower on a public road to the church and collides with and injures another boy on a bicycle.

The court hearing the resulting lawsuit offered a list of the five points[1] that explain when parents may be held liable for the torts of their children:

1) where the relationship of master and servant exists and the child acts within the scope of his authority accorded by the parent;

2) where a parent is negligent in entrusting to the child an instrument which, because of its nature and purpose, is so dangerous as to constitute, in the child's hands, an unreasonable risk;

3) where a parent is negligent in entrusting to a child an instrumentality which, though not necessarily a dangerous thing of itself, is likely to be put to a dangerous use because of the known propensities of the child;

4) where the parent's negligence consists entirely of his failure to reasonably restrain the child from vicious conduct imperiling others, when the parent has knowledge of the child's propensity toward such conduct; and

5) where the parent participates in the child's act by consenting to it or by ratifying it and accepting the fruits.

The facts of this case—called *Stronger v. Riggs*—were simple, and so was the outcome. On May 14, 1998, Daniel Riggs left his home on a riding lawn mower en route to the local church where

[1] Although these points are based on Missouri law, you'll find similar definitions in most jurisdictions.

his father was the pastor. He was to mow the church lawn and, at the request of his mother, Daniel drove on a public road.

Although his mother followed him in her car for part of the two-mile trip, she eventually went on ahead. During this time, one of three boys riding his bike began taunting Daniel. This led Daniel to go as fast as possible on the mower, which resulted in a collision. The taunting boy sustained numerous injuries—bruises, abrasions and emotional distress. Emotional distress? The boy's parents let their lawyer craft the case.

Among the arguments made at trial, and in reference to the five rules of liability, the court stated:

> [A]lthough a motor vehicle is not a dangerous instrumentality per se, it becomes a dangerous instrument when it is entrusted to an immature, incompetent or reckless minor.

Though Daniel Riggs was by all accounts a mature, good-natured boy with good intentions, the court noted that the law held that any child under 16 does not possess the requisite care and judgment to operate a motor vehicle on the public highways. Thus, the mother breached her duty to protect the public when she permitted her child to operate the vehicle on the public roads.

It should be stated, however, that the court of appeals made these statements and delineations. Originally, the circuit court had granted summary judgment for the Riggs. When the parents of the injured bully appealed, the appeals court reversed.

The pastor and his wife could be held liable for the bicycle/lawnmower wreck. If they didn't have a homeowners policy or a personal liability umbrella, they'd have to write the check themselves. (As it turned out, the case eventually died in a procedural bog after it was sent back for trial.)

Clearly, parents *can* be held liable for their children's wrongdoings. However, in many jurisdictions, parents are not liable in damages for the torts of their minor children merely because of their status as parents. An exception to this rule exists where the parents have knowledge about their child's dangerous propensities but still fail to act reasonably to restrain the child from injuring others.

A KID WHO'S SIMPLY BAD

Perhaps the hardest part about parental liability is that a situation may arise for which any law cannot compensate. As we've seen, many laws that govern a parent's liability have caps for damages. Is there any way around such a cap if your son is killed by another boy for no apparent reason?

This is exactly what happened in the sad case of *Lavin v. Jordon*. On June 29, 1995, Troy Lavin delivered pizza to the Nashville home of Ross and Susan Jordan. Shortly after his arrival at the home, Sean Jordan, the Jordan's son, killed Troy by shooting him multiple times with a .22 caliber rifle. Sean Jordan, who later pled guilty to second-degree murder, didn't even know Troy Lavin.

Lavin's parents filed a lawsuit alleging that the Jordans failed to control and police their son despite their knowledge of his weapons possession. According to the record, Sean Jordan had a "history of assaultive, violent, anti-social criminal behavior." This was evidenced by his delinquent status, having assaulted at least one other minor and raped a schoolmate. The Lavins sought compensatory and punitive damages in the amount of $2 million.

The trial court held that, pursuant to the parental liability statute, damages were capped at $10,000. In an attempt to void the cap, the Lavins appealed. The appeals court ruled that the cap didn't apply, stating: "the common-law cause of action for the same tort [is] unaffected by the statute and [permits] the parents to seek full recovery."

The Jordans, facing a possible million-dollar judgment and bankruptcy, appealed *that* ruling. The state supreme reversed the reverse, holding that the statutory cap on damages did apply.

Despite the obvious great loss of life suffered by the Lavins, they could not seek full compensation as they would for an adult murderer. (Though at least one judge dissented—and would have waived the cap.)

CONCLUSION

There isn't much you can do once an oddball situation turns ugly. The best way to prevent this kind of trouble is to be careful and pay attention to

detail. Don't ask a teenager to watch your house or, at least, warn him not to use the pool.

Remember, liability coverages in insurance policies exclude protection in cases of permitted use. If you don't give permission, the insurance company will have a harder time denying a claim.

And what about kids who are simply bad? A tougher issue. Try not to kid yourself that a troublemaker isn't one; get him the best care you can...and keep him away from situations that will fuel his destructive impulses.

Liability insurance does extend to family members (so it may be an even better idea if you have a trouble-prone kid). Unfortunately, it doesn't do anything to help the family member himself.

8

DEFAMATION, EMOTIONAL DISTRESS & INTELLECTUAL PROPERTY CLAIMS

The personal injury liability portion of a standard homeowners or umbrella liability policy covers your liability for personal injury. Personal injury includes bodily injury, sickness, disease, disability, shock, mental anguish and mental injury. The definition also extends to include libel, slander, defamation of character and invasion of privacy.

If you commit any of the actions specified in this section, it could lead to a *personal injury* claim (notice that this term does not have the same meaning as bodily injury).

Defamation, sometimes called "defamation of character," is spoken or written words that falsely and negatively reflect on a living person's reputation. Defamation is the holding up of another to ridicule, and includes libel and slander.

Slander is a spoken defamation.

Libel is a written defamation. (Generally, radio and television broadcasts that are defamatory are considered to be libel, rather than slander.)

For personal injury coverage, the term *occurrence* means an offense or series of related offenses. Libeling the same tenant in front of others on various occasions would be treated as a single occurrence if a personal injury claim were made. Since the offenses were related, the limit of insurance would not apply separately to each offense.

Invasion of privacy is the publicizing of another's private affairs for which there is no legitimate public purpose, or the invasion into another's private activities which causes shame or humiliation to that person.

Defamation is often included within the scope of umbrella coverage. Claims like sexual harassment are probably beyond the scope of coverage.

Claims with a mixture of covered and noncovered claims are, in many states, considered sufficient to trigger a company's duty to defend. The company may reserve its right to deny coverage. In some states, the company may even reserve its rights to recover the costs expended to defend a claim that is not covered.

But subject to these reservations, the insurance company generally must provide a defense.

Courts impose severe penalties on companies that are found to have breached their defense obligation. Policyholders may be awarded punitive damages. Companies may be held liable for judgments above limits. Defense determinations must be made carefully and under state laws, based upon the allegations of the complaint.

In order to prove defamation, a person has to prove that what was said or written about him was false. If the information is true, or if he consented to publication of the material, he does not have a case. However, he may bring a defamatory action if the comments are so reprehensible and false that they affect his reputation in the community or cast aspersions on him.

There are three main defenses to a libel claim (other than asserting that it never happened or that you were never involved):

1) Claiming, and proving, that the statement was privileged (and thus not public). Only certain professions (doctors, lawyers, psychologists), or individuals (chiefly your spouse) can maintain that privilege; and if any non-privileged third party was part of the communication, the privilege is broken. (Employees of a professional are only partially covered, to the extent that you need to use them to contact the professional. Don't expect to tell your deepest, darkest secret to your attorney's secretary and maintain that privilege.)

2) Claiming, and proving, that the statement is true, for "truth is an absolute defense."

3) Claiming, and proving, that the statement was an opinion, not an assertion of a fact. Since this last defense is only as good as the weakest or worst, but

still reasonable, misinterpretation, it's not one you want to rely on. There's a world of difference between saying "I think he's a crook," and "he's a crook." Especially if a third party might inadvertently leave out the first two words when passing your message on.

Establishing the truth is the single most effective defense that can be offered. If the remark is truthful and it hurts, is embarrassing or subjects him to ridicule, there is little he can do. Unless the remark is false, he has no recourse.

If you have been defamed, you may seek both actual damages, to recover the harm that you have suffered, and punitive damages to punish the person who made the remark (and serve as an example to deter others).

If the defamation improperly accused you of a crime or reflected on your profession, the court or jury assesses the damages. For other types of defamation you must prove some actual damage to be able to recover.

If the statement is made about a public official—for example, a police officer, mayor, school superintendent—or a public figure who is a generally prominent person or a person who is actively involved in a public controversy, then it must be proven that the statement was made with knowledge that it was false or with reckless disregard for whether the statement was true or false. In other words, the fact that the statement was false is not enough to recover for defamation. On the other hand, if the statement was made about a private

person, then it must be proven that the false statement was made without reasonable care as to whether the statement was true or false.

Whether a statement is deemed an expression of opinion as opposed to a statement of fact is not always an easy question to answer. For example, the mere fact that a statement is found in an editorial is not enough to qualify for the opinion privilege if the particular statement contained in the editorial is factual in nature.

There is also a privilege known as neutral reporting. For example, if a newspaper reports on newsworthy statements made about someone, the newspaper is generally protected if it makes a disinterested report of those statements. In some cases, the fact that the statements were made is newsworthy and the newspaper will not be held responsible for the truth of what is actually said.

There are other privileges as well. For example, where a person, such as a former employer, has a duty to make reports to other people and makes a report in good faith without any malicious intent, that report is protected even though it may not be totally accurate.

Another example of a privilege is a report on a judicial proceeding. News organizations and others reporting on activities that take place in a courtroom are protected from defamation actions if they have accurately reported what took place.

If you think you have been defamed by a newspaper, magazine, radio or television station, you

must make a demand for retraction before a lawsuit can be filed. If the newspaper, magazine, etc. publishes a retraction, you can still file suit, but you can only recover your actual damages. No punitive damages can be assessed.

Libel and slander cases are often very complicated. Before you decide to take any action in a libel or slander case, you should consult with an attorney. An attorney can help you decide whether you have a case and advise you regarding the time and expense involved in bringing this type of action.

A CLASSIC CASE

The 1999 10th Circuit Appeals Court decision *Dome Corp., et al. v. Compton Kennard* dealt with a classic slander and libel case—and one man's efforts to get his insurance companies to cover the cost of his defense against the claims.

The lawsuit was the product of an oil and gas deal gone bad. In 1993, Gary Hermann, the owner and operator of a Florida hardware store, purchased a working interest in several oil and gas wells operated by Dome Corporation and Neodyne Drilling. In 1995, Hermann became unhappy with Dome's handling of the venture. So, he contacted a number of other investors and discussed investigating Dome management's operation of the wells. Hermann then hired Compton Kennard to evaluate management's operation of the venture.

Kennard investigated Dome's operations and prepared a written report detailing deficiencies he perceived in the manner of operation. The report

was mailed to other investors participating in the venture. As a result, Hermann and the other investors filed suit seeking to oust Dome as operators of the wells. Dome management defaulted and the investors replaced them. Dome management then filed a lawsuit in federal district court contending that the report and other statements made by Hermann constituted libel and slander.

Hermann sought coverage under four separate insurance policies: 1) a homeowners policy issued by Auto-Owners Insurance Company; 2) a personal liability umbrella policy issued by The Cincinnati Insurance Company; 3) a businessowners policy issued by Cincinnati; and 4) a commercial umbrella policy issued by Cincinnati. The insurance companies all denied coverage.

Cincinnati filed a third-party complaint seeking a declaration that it had no duty to defend or indemnify Hermann. Cincinnati further sought a determination of whether the homeowners policy provided by Auto-Owners provided coverage. Consequently, Auto-Owners entered the fray seeking a determination of coverage.

The trial court held that, under the four policies, the companies had no duty to defend and indemnify Hermann. Hermann appealed.

The issue before the appeals court was whether the alleged injuries resulting from Hermann's participation in the oil and gas venture unambiguously fell within the business exclusion to the Auto-Owners policy.

For various reasons, the court determined that Michigan law governed the interpretation of the Auto-Owners policy. In it, the policy excluded coverage for injuries occurring "in connection with any business, occupation, trade or profession." The policy defined "business" as any "full or part time trade, profession or occupation." Auto-Owners reasonably argued that Hermann's participation in the oil and gas venture fell within this language because the venture was continuous and profit motivated. Hermann, on the other hand, argued that by defining "business" as a "trade, profession or occupation," Auto-Owners limited the exclusion to injuries occurring in connection with the insured person's principal or primary business.

The record demonstrated that Hermann invested in oil and gas ventures only as a sideline and that his principal business was hardware sales. Thus, the court found his interpretation "reasonable."

Auto-Owners argued that a finding of coverage would effectively read the word "any" out of and insert the phrase "the insured's principal" into the policy language. The court found this a thin distinction:

> If true, such a result is the product of the company's own creation. Instead of using a "business pursuits" exclusion, which has been broadly construed under Michigan law to exclude a wide array of profit motivated activities, Auto-Owners chose to use narrower language excluding injuries in connection with any "business, occupation, trade or profession." The company

further defined business as a "full or part time trade, profession or occupation." After choosing to narrowly define "business," Auto-Owners may not now complain about the ambiguity which arises when its narrow definition is read in conjunction with the expansive term "any."

Auto-Owners argued that the language was unambiguous because of the phrase "in connection with." The court didn't buy this argument, either:

Under the facts of this case, the phrase "any business, occupation, trade or profession" may reasonably be interpreted as either including or excluding the activity giving rise to Hermann's claim. The words "in connection with" do little to clear up the meaning of trade, occupation or profession. Indeed, although no Michigan court has squarely addressed the issue, at least one court has found ambiguity in a policy containing nearly identical language. The present language is subject to more than one reasonable interpretation. Where two reasonable interpretations exist, the policy must be construed in favor of coverage.

Auto-Owners essentially argued that the court should construe the "business" exclusion in this case as a "business pursuits" exclusion. The court declined to do so.

Michigan law clearly distinguished between "business" and "business pursuits" exclusions at the time Auto-Owners issued the disputed policy. In fact, Auto-Owners chose to use the "business pursuits"

language in the portion of the policy covering property damage and bodily injury. Arguably, Auto-Owners believed that the breadth of the "business pursuits" exclusion would impact its ability to market its homeowners policies if the company included such a clause in the portion of the policy covering personal injury. Regardless of its reasons for doing so, Auto-Owners chose not to use the established "business pursuits" language in the personal injury section of the policy. In doing so, it created an ambiguity which...must be construed in favor of the insured.

The district court also found that coverage under Cincinnati's umbrella policy was dependent on a finding of coverage under Auto-Owners' homeowners policy. Because the court found that no coverage existed under the homeowners policy, it concluded that no coverage existed under the personal umbrella policy. On appeal, Hermann argued that because the homeowners policy provided coverage, the umbrella policy provided coverage as well. The appeals court agreed:

> The personal umbrella policy provides coverage for personal injuries "arising out of business or business property" if such injuries are covered by an underlying policy. The personal umbrella policy defines business as "[including] but not limited to a trade, occupation, profession or other activity engaged in as a means of livelihood or from which you or a relative intend to derive income (other than farming)." The record demonstrates that Hermann intended to derive income from

the Dome venture. Furthermore, the un-
derlying policy...; Auto-Owners' home-
owners policy, provides coverage. Thus,
coverage exists under Cincinnati's personal
umbrella policy.

Finally, the appeals court had to consider the
businessowners and commercial umbrella policies
issued by Cincinnati. Under Florida law, an
insurer's duty to defend depends upon the facts
and legal theories alleged in the pleadings. The duty
arises when the facts alleged "fairly and potentially
bring the suit within policy coverage." Any ambi-
guities must be construed in favor of the insured.

The district court had assumed that the policies
named Hermann in his individual capacity as an
insured. The district court then analyzed the
policy to determine whether Hermann's claim was
covered. It found that the policy covered an
individual's "business" only where such business
is solely owned by the named individual. The court
determined that because Hermann was not the sole
owner of the oil and gas venture giving rise to the
claims, the policies did not provide coverage.

On appeal, Hermann argued that the district
court's conclusion that the businessowners and
commercial excess policies provided no coverage
was inconsistent with its finding that his oil and
gas activities were "business" activities for purposes
of the homeowners policy. The thrust of this ar-
gument was that the homeowners and business
owners' policies are interrelated—if there is not
coverage under one, there must be coverage un-
der the other. Cincinnati argued that the district

court correctly found no coverage because Hermann was not the sole owner of the oil and gas venture.

Indeed, the policies provided coverage for an insured only "with respect to the conduct of a business of which [he or she is] the sole owner." The record clearly showed that Hermann was not the sole owner of the venture. The venture had numerous working interest owners to whom the persons operating the well were accountable. When Hermann became unsatisfied with the operators, he was unable to replace them without support from the other owners. So, the district court correctly found that the businessowners and commercial umbrella policies provided no coverage.

The appeals court concluded that Hermann was entitled to coverage under the homeowners policy issued and the personal umbrella policy. He was not entitled to coverage under the businessowners or commercial umbrella policies.

EMOTIONAL DISTRESS CLAIMS

Connecticut's March 2000 Supreme Court decision in *Gary C. Moore v. Continental Casualty* is a great example of an emotional distress lawsuit. The initial claim was weak itself—but the resulting attempt to get the insurance company to cover the claim was positively weird.

Gary Moore was the insured under a homeowner's policy issued by Continental. His sister, Gail Standish, filed a suit against Moore, alleging conversion,

fraud, intentional infliction of emotional distress
and negligent infliction of emotional distress.

Standish was the joint owner of property with
her mother, Coral Moore. Standish charged that
her brother had obtained power of attorney from
Coral and herself and, together with Richard
Stapleton (their attorney), had obtained a $150,000
line of credit that was secured by the jointly-owned
property. Standish alleged that, as a result of her
brother's actions, she had suffered financial loss in
the amount of $150,000, and also had suffered
emotional distress, stress and anxiety as a result of
that financial loss.

Four of the seven counts in the complaint filed
by Standish were directed at Moore. Three of those
counts alleged reckless or intentional acts: count
four alleged that Moore used a line of credit in
violation of Connecticut state law; count five al-
leged that Moore, acting as Standish's fiduciary,
wantonly and recklessly or intentionally made
material omissions and misrepresentations regard-
ing her line of equity; and, count six alleged inten-
tional infliction of emotional distress. It was un-
disputed that these three counts did not trigger a
duty to defend under Moore's homeowners policy
because they were excluded under the "expected
or intended" exclusion. Count seven, however,
alleged negligent infliction of emotional harm.

In the final count, Standish specifically charged:

> [Moore and Stapleton] negligently and
> carelessly caused emotional harm to
> [Standish] in one or more of the follow-

ing ways: a) In that they failed to inform [Standish] that they were incurring substantial liabilities on her property...; b) In that they negligently and carelessly failed to inform [Standish] that the Will of [her] mother had been changed and would subject her property to a large encumbrance; c) In that they negligently and carelessly failed to warn [Standish] of the effects of the actions they were taking concerning Coral Moore; d) In that even though they knew, or in the exercise of reasonable care should have known, that the combined effect of their actions would serve to create a severe financial hardship on... Standish, they failed to take any action which would allow her to protect herself from the effect of their actions.

Moore brought a declaratory judgment action against Continental, seeking a ruling that it had a duty to defend him against the lawsuit. Continental answered with a motion of its own—seeking a ruling that it didn't have to defend Moore. The court granted Continental's motion and denied Moore's. Moore appealed. The state appellate court agreed with the lower court's ruling. Moore pressed his case up to the state supreme court.

At this point, the Connecticut Trial Lawyers Association filed a brief supporting Moore's claims. There were huge legal fees to be charged if insurance companies could be forced to pay defense costs in emotional distress cases. The Connecticut ambulance chasers must not have had much respect for logic or clarity in allying with Moore. Some of his arguments were downright strange.

In effect, Moore claimed that Continental had a duty to defend because the policy defined "bodily injury" broadly enough to include emotional distress. The state supreme court didn't agree:

> Applying the appropriate standard of review to the allegations of the complaint and the language of the policy, we conclude that these allegations do not trigger the defendant's duty to defend. An allegation of emotional distress arising out of economic loss, as alleged in this case, does not trigger a duty to defend under the coverage for "'[b]odily [i]njury,'" which is defined in the insurance policy as "bodily harm, sickness or disease...."

There were three types of personal liability coverage in the policy: the first, for personal injury, involved noncorporeal torts but did not cover the tort of negligent infliction of emotional distress; the second, for bodily injury, used the term *bodily* to describe the type of injury covered; and the third, for property damage, used the term *physical* to describe the type of property damage covered. Therefore, the court concluded that, to the extent that nonbodily or noncorporeal torts were covered, they were specified in the personal injury category. (That category explicitly excluded emotional distress claims.) Otherwise, such a claim would require some aspect of bodily harm, as in the case of bodily injury, or physical damage, as in the case of property damage. (And Standish's claims couldn't show either of those predicates.)

Part of Moore's argument for coverage was based on some bizarre definitions of policy terms. As

noted above, the policy defined "'[b]odily [i]njury'" as "bodily harm, sickness or disease." According to Moore, the word *bodily* modified *harm*—but not the words *sickness* or *disease*. So, he argued that the definition of *bodily injury* meant not merely bodily harm, bodily sickness and bodily disease, but also nonbodily sickness and nonbodily disease. The court disagreed:

> We cannot rewrite the insurance policy by adding semicolons any more than we can by adding words. If the policy had referred to "green vehicles," and defined that term as "green cars, trucks or motorcycles," it is unlikely that there would be a reasonable dispute about whether blue trucks and red motorcycles were intended to be included in the definition. We decline to adopt [Moore]'s idiosyncratic grammatical interpretation of the language in the policy.

Moore made one more weird claim. He argued that emotional distress is within the policy's definition of *bodily injury* because "modern medical science teaches that emotional distress is accompanied by some physical manifestations." To support this theory, he pointed to the state supreme court's own rulings in various workers' comp cases. The court didn't like having its own decisions used in this way:

> Although we do not question the modern medical understanding of the interrelatedness of the mind and body, we disagree that such an understanding deter-

mines the meaning of the policy language
in question in the present case. We also
disagree...that our precedents in the areas
of tort and workers' compensation law
appropriately inform the meaning of that
policy language. It is undoubtedly true
that emotional distress ordinarily might
be accompanied by some physical mani-
festations, such as an altered heart rate and
altered blood pressure, and perhaps other
such manifestations as changes in the size
of the pupils, and sleeplessness and head-
aches. That does not mean, however, that
"bodily harm, sickness or disease," as used
in the insurance policy in this case, neces-
sarily includes emotional distress caused
by economic loss.

The judgment of the lower courts was affirmed.
Moore couldn't use his policies to defend his sister's
claims for emotional distress. The Connecticut
trial lawyers must have been crestfallen.

INTELLECTUAL PROPERTY DISPUTES

The most valuable asset for any company is its
intellectual property—copyrights, patents, trade-
marks, trade secrets and brand names. The pro-
tection of intellectual capital, however, is one of
the most overlooked areas of risk management.

Copyright and trademark infringement is a ma-
jor area of concern for New Economy businesses.
Even if the infringement is not intentional, it can
still result in tangible diminishment of the value
of a site or service.

A 1996 amendment made to the 53-year-old Lanham Act, a federal law designed to protect consumers from deception, introduced the legal concept of "dilution." It's the theory that a company's trademark could be "watered down" if used without permission by a person or company.

The Internet has encouraged these claims in two ways. First, it's easier to track infringers, especially if they advertise on the Internet. Second, the Internet has made it easier to bring suit anywhere in the country against a company that runs an active Web site where someone can make a reservation or purchase goods online. Because the site is open to people from all over, the company is vulnerable to lawsuits from every jurisdiction.

Copyrights give ownership to an author's or artist's work, such as a book, pamphlet or musical composition. A trademark is a word, short phrase or symbol that people identify with something specific, like a company, and patents protect inventions, to prohibit someone else from making an item in exactly the same way the inventor did.[1]

Patent litigation is expensive. Even small patent-infringement cases, involving a couple of million dollars in claims, run nearly $750,000 to litigate, according to a survey published by the American Intellectual Property Law Association. If the suit makes it to trial—which most don't—and through the appeals process, the cost could balloon to $3.5 million.

[1] Simple copyright forms are available at: http://lcweb.loc.gov/copyright. Trademark registration forms, a searchable database and tips on searching, are at: www.uspto.gov. Filings are relatively cheap: $30 for a copyright and $325 for most trademarks.

Trademark and copyright litigation costs less but still is expensive—averaging nearly $250,000.

As with most legal problems among businesses, most intellectual-property lawsuits are settled by agreement rather than by judge or jury. Often an infringement case ends in a quick licensing agreement, distribution arrangement or other resolution that allows the previously unauthorized use.

Most intellectual property disputes are resolved with cease-and-desist letters. The owner of the trademarked or copyrighted material will send the letter to the person or group using the material and—if the improper use stops immediately (or, in legal terms, *cured*)—there's not much more to the matter. This is especially true of improper use on Internet Web sites. Sometimes, though, the owner seeks monetary damages from the user.

Even the music band The Grateful Dead—famous for its generous policies toward fans recording live performances—employs lawyers to ensure their music or images aren't improperly used on the Internet. Internet users can trade Dead songs and images only if they do not generate any revenue. The band budgets $5,000 to $7,000 per month to pursue Internet pirates who steal concert videos, sell knockoff T-shirts and make money from digitally-recorded songs. It even sent a cease-and-desist letter to a person who was trading MP3 recordings of Grateful Dead songs for free—but was making money from banner ads on his Web site.

GIANTS V. SMALL FRY

Going after a competitor who has infringed upon intellectual property is unavoidable for many small businesses. If one finds that you—even if *you* are an individual producing a Web site in your basement—have used its material without permission, you can expect some kind of action.

Still, because these lawsuits are costly, the decision to sue is usually a close call for most businesses. That's why companies making infringement claims come on so hard initially; they're hoping to get a quick settlement. So, in part, a major element in defending intellectual property is attitude. That's why you often see corporate giants battling small businesses or individuals over intellectual property. For example:

- Billionaire Richard Branson's Virgin Enterprises sued Virgin Chocolates, a small Colorado company. Branson claimed exclusive rights to the trademark *Virgin* used with consumer goods and wanted to prevent it from being used for a line of adult candy.

- Polo/Ralph Lauren won a trademark infringement suit against Westchester Media Co., the start-up publisher of *Polo Magazine*. A federal judge in Texas ruled that the magazine could cause consumer confusion with the clothing, fragrance and home furnishings designer.

- Chemicals giant Monsanto Corp. dropped its legal resources on a number of small farmers who'd used its genetically engineered seeds without paying proper licensing fees.

That last example makes an interesting case.

Roger Nelson and his sons farm about 8,600 acres of soybeans and wheat in Cass County, North Dakota. Soybeans usually make up about 70 percent of their annual crop.

The Nelsons first used Roundup Ready soybeans—which are a patented, genetically-engineered Monsanto Corp. product—as a relatively small part of their soybean crop in 1998. Because the co-op where they sold the beans didn't pay differently for conventional or engineered soybeans, the Nelsons didn't distinguish between their two kinds of beans.

Then in 1999, the Nelsons raised a much larger crop of Roundup Ready beans. That year, they paid $18,800 in tech fees to Monsanto for using the new technology. But that may not have been enough.

In mid-July 1999, a certified fraud examiner working for a company that contracted with Monsanto to investigate potential violations of the grower contracts arrived at their farm. "He said someone had called Monsanto with a tip that we had taken saved seed from 1998 and planted it in 1999," Rodney Nelson said. The Nelsons cooperated with the examiner.

The examiner called back several days later to report that there had been no irregularities. But in November, the Nelsons received a call from an Indiana firm that represented Monsanto, asking to inspect their fields again. Again, the Nelsons cooperated.

Several months later, in July 2000, a Monsanto attorney wrote the Nelsons a letter with troubling news. The inspectors from Indiana had found Roundup Ready genetics in some of the fields the Nelsons said were conventional, and lab tests proved it. The letter went on to state:

> This has revealed the presence of Roundup Ready gene in several thousands of acres farmed by you.... At present there is a large discrepancy between the number of acres which have tested positive and the number of acres that you could have planted with the quantity of seed that is indicated by sales receipts that we have.

The lawyer wanted a conference with the Nelsons and their attorneys to "evaluate [their] responses." A Monsanto representative would be on hand with "full settlement authority." The Nelsons agreed and asked that an *Agweek* reporter attend. Monsanto refused. But Monsanto did allow the North Dakota State Seed Commissioner and the North Dakota Department of Agriculture to have representatives at the meeting (though, in fact, it didn't have much choice in that matter).

Scott Baucum, Monsanto's U.S. manager of intellectual property rights, described the conference

as a "good meeting" that ended amicably. "There was not even a discussion of settlement," Baucum told a local newspaper. "[We tried] to determine if there was a violation."

After the July 2000 lawyer letter, the Nelsons decided to take no chances in accidental growth of Monsanto product. In early August, they had a third party inspect all of their fields. They invited the Monsanto representatives to cooperate with the new tests—but they declined.

By that point, the corporate giant seemed to be backing away from its initial, harsher position. "We haven't even determined there is a violation," Baucum reiterated to a local reporter. "We've said, look, we see things we didn't understand." He stressed general points, noting that Monsanto's market research indicated that between 6 percent and 9 percent of Roundup Ready soybeans planted in the United States were "pirated in some way." The company had begun to study why spots of their product were cropping up in groups of counties.

"I think, basically, it's an economic issue," he concluded.

And these cases can involve individuals. In 1999, a Massachusetts-based shoe company sued a Colorado programmer for putting up a Web site at earth.com. Mondial Trading Co. claimed that it had an exclusive trademark on the name *Earth* to sell clothing. "The EARTH trademark is famous," the company said in papers filed in federal court in Boston.

But Tony Sanders, the Colorado Springs resident who owned the earth.com domain, said he just used the name for e-mail and his personal Web site—not to hawk clothing that competes with Mondial's.

"I strongly feel that I [did] not [infringe] on their rights in any way," Sanders said in an e-mail.

The lawsuit demanded that Sanders turn over the address to Mondial. He refused—and became a minor celebrity in the Internet community.

The Boston law firm Fausett, Gaeta & Lund agreed to represent him for free, after word of the suit spread online. Less than two weeks after the law firm entered the picture (and three days before a response to the complaint was due), Mondial dropped its suit. The little guy won.

"PROCESS PATENT" CLAIMS

Legal claims brought on the basis of patent infringement—particularly patents issued for a "business method" or "business process"—have become a controversial topic. The patents lock up an idea about how something can be done, rather than a concrete invention like a machine or a chemical. They first gained attention when several Internet players—most notably, amazon.com and Priceline.com—received business process patents for the way they take or fulfill orders...and then promptly threatened competitors with lawsuits.

The controversy was further fueled when an employee of the U.S. Patent Office admitted to one

national newspaper that some process patents had been issued prematurely, due to time pressures and a lack of people who adequately understand the technology sector.

How do process patent disputes work?

In 1997, the Irish computer software company AllFinanz decided to market a life insurance underwriting program in the United States. The small company looked for large players in the American insurance industry with which it could make agreements to distribute its software. After some searching, AllFinanz identified several big insurers as potential partners—one of these was Indiana-based Lincoln National Corp.

AllFinanz's software was pretty good. Traditionally, analyzing life insurance application forms, referencing actuarial tables and calculating risk, took months; the software did all that in minutes.

AllFinanz talked with Lincoln National for almost a year without signing an actual agreement. While these negotiations went on, AllFinanz completed deals with three other big American insurance corporations. Then, in early 2000, Lincoln National surprised everyone by suing AllFinanz.

The lawsuit claimed that AllFinanz—by making, using, offering to sell and selling its suite of software systems and components—infringed upon Lincoln National's risk assessment patent. The Lincoln National patent, "Method and Apparatus for Evaluating a Potentially Insurable Risk," was issued in December 1990. The patent covered,

among other things, Lincoln National's "knowl-edge-based automated life insurance underwriting software products, i.e., the Lincoln Underwriting System and the LincUs(™) suite of underwriting system products."

Jim Maher, head of the Irish company, said Lincoln National was suing precisely because AllFinanz was having some success. "If we were somewhat on the periphery, not closing deals, we would never have been touched," Maher told one newspaper.

According to Lawrence Rowland, president and chief executive officer of Lincoln National:

> Lincoln [National] was granted this patent because we were the first to recognize the power of technology in delivering mortality risk management knowledge and tools to our customers. Our ability to do this through software using our own intellectual property is key to our success. That is how we are able to contribute to our clients' success.

AllFinanz argued two points. First, its software didn't violate anyone else's patent; second, Lincoln National's patent was invalid because another party had documented the same process before Lincoln National's 1990 application.

Maher expected that the companies would settle out of court, before a drawn-out trial. "I think it makes no sense for either business to engage in high-profile, very expensive, resource-consuming litigation," he said. "If it's possible to resolve this

commercially and legally, the chief executives of both businesses have an obligation to their boards and shareholders to sit down and resolve this."

INSURANCE FOR IP LIABILITIES

During the late 1990s, the insurance industry began to offer new coverages designed to protect people and small businesses from Internet-related intellectual property liabilities. The key risks in this market included some thorny issues: copyrights, libel and liability for advertising and links to other pages.

The fact that it takes brainpower to make a Web site work is a major challenge for insurance companies that prefer to look at the world in terms of hard assets and direct losses. Still, most realize they have to move into the intellectual property risk market.

Most e-commerce intellectual property policies are based on older multimedia liability policies, which were originally intended to cover the liability faced by publishing or advertising across different forms of media. However, unless the policy language specified coverage for infringement of a patent, copyright, trademark or other intellectual property, this kind of insurance was usually not enough.

Many law firms won't take a patent infringement case on a full contingency-fee basis because patent litigation is so expensive, even for them. *Patent enforcement insurance* is meant to address that problem. It is one of essentially two kinds of patent insurance. The other is called *defensive insurance*.

Enforcement insurance covers the costs of enforcing your patent against those who infringe. An insurer may or may not cover preexisting infringement. Defensive insurance, on the other hand, pays the legal costs of defending against a charge of infringement. Some defensive policies also cover damages incurred as a result of infringement.

In 1999, Chubb Corp. launched a policy to cover small businesses against claims for libel or misrepresentation that could arise from Web sites, e-mail and other online communications.

"As more companies disseminate information to the public via Web sites and other media...commercial businesses now have the same liability exposures once reserved only for book publishers, broadcasters and advertising agencies," said Leib Dodell, media and intellectual property underwriting manager at Chubb.

Dodell said that the policy offers "all-risks" coverage for Internet activity, avoiding the approach some insurers had chosen of adopting coverage for specific perils. This approach is better, "given the uncertainty of the legal rules governing the Internet and the types of legal claims that will be generated by Internet activity," said Dodell.

Chubb's new product is built upon the Multimedia Liability Insurance policy the insurer introduced several years earlier. It increases the available liability limits to $25 million (from $10 million), includes liabilities assumed under insured contracts and allows the insured to choose its own lawyers in the event of a claim.

In addition, the policy provides:

- Insurance for the cost to defend injunctive relief actions as well as demands for damages;

- Insurance for plagiarism and unauthorized use of titles, slogans, formats, ideas, characters, plots, performances or performers; and

- Advertising injury/personal injury protection broader than that available in a standard commercial general liability contract, for both publishing and non-publishing activities.

And the claims can come from unexpected sources. In 1999, New Jersey-based Dendrite International sued four anonymous people who posted what Dendrite considered libel and trade secrets on a Yahoo! message; the suit put California-based Yahoo! in the middle of a legal action.

In early 2000, a Florida judge ruled that a Fort Lauderdale man had the right to know who was posting anonymous messages about him through Yahoo! and America Online.

CONCLUSION

This chapter has dealt with some liability issues that might seem far-fetched to you now. But these are fairly sure to become common personal liability problems.

In an information age, concepts like defamation and copyright infringement are bound to move

from business contexts to personal contexts. And, judging from the number of lawyers who have taken to focusing on intellectual property as their speciality, there are going to be plenty of experts helping make that move.

So, consider these small-business matters inching into the personal liability arena. You'll want to be careful of that move.

9

HOLD HARMLESS
AGREEMENTS &
BANKRUPTCY

This book has talked a lot about insurance. That only makes sense, since insurance is the tool that most people use to handle personal liability issues. But it's not the only tool. This chapter considers two common alternatives.

The first is a *hold harmless agreement*—a legal contract that limits or transfers liabilities between two parties. Like insurance, you usually have to make a hold harmless agreement before a liability occurs. We'll look at the mechanics of these agreements and the best strategies for using them.

The second of these alternatives is filing for *bankruptcy*. Oftentimes, people or companies use bankruptcy as a tool for avoiding financial responsibilities. And, just about any person or company can use bankruptcy in this way. In this chapter, we'll examine when—and how—you can do so.

HOLD HARMLESS AGREEMENTS

Every insurance policy is a contract. But there are other contracts you can use to protect yourself

from personal liabilities. The most common of these is a contract between people or corporations stating that one side will not make or pass on legal claims or judgments to another. This is known generally as a hold harmless agreement.

Few people think about hold harmless agreements in the daily routine of their lives. Asking the manager of the grocery store, your visiting college friends and the people at your work to sign legal documents promising not to sue you is unrealistic. However, you can focus on a few activities or situations...work-related or not...that pose risks to your financial well-being and press for such agreements there. For example, an independent management consultant might ask clients to sign such agreements before she works with them. (Many standard consulting contracts have this language.)

Another example: A hot-shot advertising executive who wants to coach his son's Little League team may ask the local Little League chapter to sign a hold harmless agreement protecting him from any complaints (the legal kind) related to how he manages the team.

Be very careful before signing any hold harmless agreement. Make sure you understand—clearly– the following key points:

- the names and identities of all of the parties (people or companies) covered in the agreement;

- the intended goal of the agreement (who's being protected and who's doing the protecting);

- the specific activities or affiliations covered by the agreement;

- the circumstances, situations or events in which the activities take place;

- the terms (locations and/or time limits) that apply to the agreement; and

- the specific exclusions and exceptions that apply to the agreement.

If you're thinking of signing—or drafting—a hold harmless agreement to protect yourself against liabilities related to a personal or business activity, you should check with any existing insurance policies you have. Insurance policies will sometimes have conflicts with hold harmless agreements.

In many cases, a policy will specifically exclude coverage for liabilities that you assume in a hold harmless agreement. So, if you plan to extend your coverage to someone else, it may not work.

Even if a policy covers a liability assumed under a hold harmless agreement, it will usually count any settlements against its normal limits. Make sure those limits are high enough to absorb any claims you inherit through the hold harmless agreement.

Although they can take any sort of exotic shape, most hold harmless agreements fall into one of four categories:

- someone else holds you harmless for things he or she does;

- someone else holds you harmless for things you do;

- you hold someone else harmless for things you do; or

- you hold someone else harmless for things he or she does.

A rule of thumb: The first two categories are agreements you want to sign. The third is one you want to sign only after examining the agreement carefully. The fourth is one you don't want to sign.

EXAMPLES OF AGREEMENTS

Although a well-drafted hold harmless agreement is as effective a means of protection against liability claims as insurance, individuals tend not to think of the things when they get involved in risky situations. Hold harmless agreements tend to be favored by people who think about insurance and risk for a living. For example, they are a popular tool among local governments. Some specific cases chosen randomly from the last few years:

- The city of Carlsbad, California, asked a subdivision developer to draft a hold harmless agreement, relieving the city of any liability if an earthquake or landslide were to hit a development built over a dormant seismic fault. The developer also had to make a disclosure statement, which described the fault and several ancient landslides. Such documents protect contractors from lawsuits.

- The village of Hanover Park (near Chicago) modified its village ordinance to allow residents to have brick mailboxes

without holding the village liable for accidents. When the village had prohibited brick mailboxes in 1995, trustees allowed nine existing masonry boxes to remain as long as the owners signed a hold harmless agreement. The new ordinance extended that arrangement to all residents. Typically, 40 to 50 mailboxes out of 11,000 in the community were damaged each year, mostly by village snowplows.

- School districts near Seattle had to keep their high school swim teams out of the pool for several weeks. Those districts hadn't signed new hold harmless agreements that shielded the county from liability if an athlete were injured severely. The county council forced the matter after a multimillion-dollar jury award to a high school swimmer who was paralyzed in a 1995 accident at a county pool when he hit his head diving into 5-foot-deep water. County pool employees saw swimmers failing to observe the "feet first" safety principle but didn't intervene. The county council passed an emergency ordinance banning teams until their districts returned hold harmless agreements. Some school officials said they were told by their insurance carrier not to sign.

Also, hold harmless agreements have a slight patina of corporate greed, since they are often slipped into larger contracts or business arrangements. As

a result, the agreements frequently surface when some person or group regrets a bad deal.

In late 1999, some 1,000 physicians in the Kansas City area delayed signing new labor contracts they say unfairly restricted their medical practices. Blue Cross and Blue Shield of Kansas City had offered the 3,200 doctors new contracts during the summer; of those, about one-third had not signed by the November deadline.

Among the key issues: who defines when care is medically necessary; how physicians are reimbursed for treating patients; and how much liability insurers owe to a physician's patients. The doctors were especially upset that the hold harmless clauses exempted insurance companies—but not physicians—from liability if an insurer's decision to withhold care resulted in injury to a patient.

The Blue Cross and Blue Shield ended up agreeing to extend more coverage to the doctors.

HOW AGREEMENTS ARE WORDED

You may have already signed hold harmless agreements without realizing what you were doing. If you use the Internet a lot, you have probably clicked "I agree" to a few pages of text that include such language. A March 2000, federal lawsuit between the Internet companies CoStar and LoopNet included an example of this.

CoStar sued LoopNet (a commercial real estate Web site) for improperly using CoStar material on its Web site. However, LoopNet said its users

were the ones posting CoStar's material—and that it was merely what Internet legal types call a "third-party service provider." To prove this point, LoopNet offered an excerpt from the agreement that all users had to accept before using the site:

> The submission of information to the LoopNet Web site is subject to your acceptance of terms and conditions, including without limitation that you agree to (i) provide LoopNet, Inc. with full and unrestricted rights to publish, use and reproduce the information in connection with the LoopNet services without infringement of any third party rights, (ii) guarantee the accuracy of the information, and (iii) indemnify and hold harmless LoopNet, Inc. from any cost, damages or liability arising out of or related to your failure to comply with the foregoing obligations.

That's a hold harmless agreement placed smoothly within what you might dismiss as "boilerplate" language. It was part of the reason LoopNet was able to win a few procedural points in the early rounds of the lawsuit—and ultimately why the two companies settled their differences.

An important point to make about hold harmless agreements: Because they don't follow any particular form, they can be written to do all kinds of things. They can protect you from a liability related to some activity or affiliation—but they can also create exposures that you wouldn't otherwise face.

Here are two examples of hold harmless agreements taken from actual events:

RELEASE AND HOLD HARMLESS AGREEMENT

The undersigned desires to use [COMPANY PRODUCTS] in the [COVERED EVENT], an event sponsored by [SPONSORING PARTIES] and other as yet unnamed sanctioning bodies, or sub-divisions thereof, during the calendar year 200_. The undersigned desires to do so all the while understanding and acknowledging that [ACTIVITY] is potentially dangerous and poses a risk to life and limb.

With this understanding, for himself (or herself), his (her) personal representatives, heirs, and next of kin, the undersigned:

1. Hereby releases and discharges for all time [SPONSORING PARTIES], their officers, directors, agents and/or employees, from all liability to the undersigned, or anyone representing the undersigned, for any loss or damage, on account of injury or damage or loss sustained by the undersigned, including his (her) death as a result of the participation by the undersigned in the [COVERED EVENT], whether caused by the negligence of [SPONSORING PARTIES] and whether on or off [ACTIVITY] premises, while the undersigned is participating in any [COVERED EVENT].

2. Hereby assumes full responsibility for, and risk of, bodily injury, death and/or property damage while participating in any [COVERED EVENT].

3. Hereby waives any claims, and does covenant not to sue [SPONSORING PARTIES], for any claim which he (or she)

may now have or may acquire against said entities or against any of their agents, representatives or employees by reason of any injury or damage or loss sustained by the undersigned, including his (her) death, as a result of the performance of his (her) services hereunder whether on or off activity premises, regardless of the cause thereof.

4. Hereby agrees that this release and hold harmless agreement is intended to be as broad and inclusive as is permitted by the law of the state in which any of its activities are located, and if any portion of it is determined by a court of law to be invalid, the balance shall continue in full force and effect.

5. Hereby understands that Section 1542 of the California Civil Code provides that a general release does not extend to claims which the undersigned does not know or suspect to exist in his favor at the time of signing the release, which if he (she) knew or suspected such claims, would have materially affected his (her) willingness to sign the release.

6. Hereby waives his (her) rights under Section 1542 of the California Civil Code and any similar law of any state, and acknowledges that this waiver is an essential term of this release without which he (she) would not have signed this release.

THE UNDERSIGNED REPRESENTS THAT HE (SHE) HAS READ, UNDERSTANDS, AND IS VOLUNTARILY SIGNING THIS RELEASE AND HOLD HARMLESS AGREEMENT and, further, represents that no verbal statements have been made to the undersigned to induce him (her) to sign this Agreement.

INDEMNIFICATION AND HOLD HARMLESS AGREEMENT

I, the undersigned, hereby certify that my participation in [COVERED EVENT] to be held between the months of _____ 200_ and _____ 200_, sponsored by [SPONSORING PARTY] is entirely voluntary I realize that [EVENT ACTIVITY] involves risk and may result in financial or other losses to participants.

In consideration of the risks mentioned above, I hereby agree to indemnify and hold harmless [SPONSORING PARTY] and its trustees, officers, appointees, agents, and employees (the "indemnified parties"), from any and all losses, costs (including claims based in whole or in part upon allegations of negligent acts or omissions of any of the indemnified parties) by or on behalf of any person, or by or on behalf of me or any of my personal representatives, for any damage to person or property arising out of my participation in [COVERED EVENT] as a result of causes which ordinarily occur before, during or after such activity as well as those which do not ordinarily occur before, during or after such activity.

One note: The terms "hold harmless agreement" and "release" are often used together and sometimes interchangeably. The terms do not mean exactly the same thing. Generally, a hold harmless agreement is more particularly tailored to protecting you from a personal liability.

INTERPRETING THE AGREEMENTS

How enforceable are hold harmless agreements? The July 2000 New York (Western) District Court

decision, *Francis D. and Deborah M. Szlachta v. Norton Company, et al.*, dealt with a complicated hold harmless agreement.

Francis Szlachta alleged that, due to the negligence of Norton Company in keeping its factory entryways and surrounding parking lot in a passable, ice-free condition, he slipped and fell, suffering extensive injuries for which he sought damages in the amount of $4 million. His wife, Deborah Szlachta, sued for loss of consortium.

Szlachta alleged that he was injured February 18, 1997 at about 6:55 a.m. when he slipped and fell in the parking lot of Norton's plant in Wheatfield, N.Y. He claimed to have slipped on a patch of "black ice" on the walkway leading to Door # 35 and fallen backwards onto the trailer hitch of a trailer owned by H.V.E.S. Electrical, Inc.

For many years prior to the accident, Norton had contracted with Haseley Trucking Co. (also a defendant in the case) to plow and salt its Wheatfield plant's parking lot. A facet of that agreement is reflected in the following excerpt from the parties' Hold Harmless Agreement:

> [Haseley] hereby agrees to defend, indemnify and hold [Norton] harmless against any and all suits, actions and proceedings, legal or administrative, public or private, and any and all claims, liabilities, judgments, damages, interest, attorney's fees, costs and expenses of whatsoever kind or nature which are or are alleged to be caused by or as a result of any act, omission, fault

> or negligence, active or passive, of
> [Haseley], its sub-contractors, agents, em-
> ployees, or any other third party acting
> under [Haseley's] direction or control....

As part of their snow-removal duties, Haseley em-
ployees were to plow and salt as close to the
Norton building as possible. They were similarly
responsible for getting as close as possible to any
trailers or vehicles parked near the main building.
At the same time, Norton employees—in particu-
lar, one Thomas Sawyer—were responsible for re-
moving snow from the doorways, including Door
35. On the night before the accident, Haseley
did five hours of plowing and two hours of salt-
ing, all of which was concluded at about midnight.

Haseley argued that, given the scope of its con-
tract with Norton—responsibility for the park-
ing lot, but not the walkways in front of the
doors—Haseley owed no duty to Szlachta. It cited
New York law, which held that a snow-removal
contractor may not be held liable in connection
with a snow-removal related injury unless the con-
tract at issue is sufficiently "comprehensive"—i.e.,
so broad as to displace the landowner's duty to
maintain the property safely. So, Haseley argued,
because its contract with Norton was "limited,"
Haseley owed no duty to Szlachta.

In opposition, Norton argued that there were
genuine issues of material fact both as to whether
Szlachta's alleged fall took place in the parking lot—
which area Haseley was charged to plow—and as
to whether Haseley created or contributed to the
allegedly hazardous condition. If either of those
contentions were true, Haseley would, by virtue

of its agreement with Norton, be required to indemnify Norton, irrespective of whether Haseley owed a duty to Szlachta.

The court ruled:

> Haseley's motion [to dismiss the lawsuit] must be denied because its argument turns on a genuine issue of material fact—to wit, where [Szlachta] fell. Haseley contends that, because [Szlachta] fell—if he fell at all—in a zone for which Haseley had no responsibility, Haseley owed [him] no duty. Haseley's premise is that, because Norton's employees were responsible for clearing snow from the area extending six feet from Door # 35 and [Szlachta] maintains that he fell within two feet of Door # 35, then, regardless of the condition of the walkway, Haseley cannot have done anything wrong and is not, therefore, liable to Norton for indemnification or contribution. The difficulty with this position is that the record as it exists today gives rise to nothing resembling certitude as to the site of [Szlachta]'s alleged fall.

So, the court ruled, the hold harmless agreement meant that Haseley would have to go to trial as a co-defendant and argue its case.

BANKRUPTCY

One good way to avoid personal liabilities is to be "judgment proof"—that means not to have any money or possessions that someone could take if they sue you successfully. But, in the course of a

life, you probably have accumulated some assets worth protecting—a home, some retirement money, some valuables.

If you don't have any or enough insurance to protect these things...and if you are sued and found personally liable for someone else's loss...you may need to use the legal tools available for making yourself judgment proof.

That usually means filing bankruptcy.

Of course, there are other steps that should come first. You should try to negotiate an agreement to resolve a personal liability with the person or company you owe. In many cases, you can negotiate effectively in this way by merely mentioning that you might have to file for bankruptcy protection unless you can negotiate a private settlement.

But, frankly, negotiations don't always work.

Bankruptcy is the final reckoning of bad decisions and faulty planning. It doesn't prevent or avoid problems. And it doesn't mitigate—directly, at least —the financial impact of a personal liability. But it is the mechanism for protecting yourself once someone has established that you owe him money.

Although many people and companies file when they have been found liable for a claim, it's interesting to note that bankruptcy laws were written for the creditors and not the debtors.

Bankruptcy law provides for the development of a plan that allows a debtor, who is unable to pay

his creditors, to resolve his debts through the division of his assets among his creditors. This supervised division also allows the interests of all creditors to be treated with some measure of equality. Certain bankruptcy proceedings allow a debtor to stay in business using revenue that continues to be generated to resolve his debts.

An additional purpose of bankruptcy law is to allow certain debtors to free themselves (to be discharged) of the financial obligations they have accumulated, after their assets are distributed, even if their debts have not been paid in full.

THE TWO MAIN TYPES

There are two basic types of bankruptcy proceedings. A filing under Chapter 7 is called *liquidation*. It is the most common type of bankruptcy proceeding. Liquidation involves the appointment of a trustee who collects the non-exempt property of the debtor, sells it and distributes the proceeds to the creditors. Under Chapters 11, 12 and 13, a bankruptcy proceeding involves the rehabilitation of the debtor to allow him to use his future earnings to pay off his creditors. Under Chapter 7, 12, 13 and some 11 proceedings, a trustee is appointed to supervise the assets of the debtor.

A bankruptcy proceeding can either be entered into voluntarily by a debtor or initiated by his creditors. After a bankruptcy proceeding is filed, creditors may not, in most situations, seek to collect their debts outside of the proceeding.

The debtor is not allowed to transfer property that has been declared part of the estate subject to the proceedings. Furthermore, certain pre-proceeding transfers of property, secured interests and liens may be delayed or invalidated.

Chapter 7 of the United States Bankruptcy Code is sometimes referred to by the legal profession as a "straight bankruptcy." It is used primarily by individuals who wish to free themselves of debt simply and inexpensively, but also may be used by businesses that wish to liquidate and terminate. Under the Bankruptcy Code, the court may dismiss a Chapter 7 case filed by a debtor whose debts are primarily consumer rather than business debts.

A Chapter 7 case begins with the debtor filing a petition with the bankruptcy court. In addition, the debtor is required to file several schedules of assets and liabilities, a schedule of income and expenditures and a statement of financial affairs.

In order to complete the official bankruptcy forms, which make up the petition and schedules, the debtor needs to compile the following:

- a list of all creditors and the amount and nature of their claims;

- the source, amount, and frequency of the debtor's income;

- a list of all the debtor's property; and

- a detailed list of the debtor's monthly living expenses—food, clothing, shelter, utilities, taxes, transportation, medicine.

A "meeting of creditors" is usually held 20 to 40 days after a petition is filed. The debtor must attend this meeting, at which creditors may appear and ask questions regarding the debtor's financial affairs and property. In order to preserve their independent judgment, bankruptcy judges are prohibited from attending the meeting of creditors.

A discharge releases the debtor from personal liability for discharged debts and prevents the creditors owed those debts from taking any action against him or his property to collect the debts.

Bankruptcy law provides that an individual debtor can protect some property from the claims of creditors either because it is exempt under federal bankruptcy or because it is exempt under the laws of the debtor's home state. However, a bankruptcy discharge does not extinguish a lien on property, so mortgages and such things stay in place.

Even though the obligation of making the monthly payment is extinguished in the bankruptcy agreement, the lien for the remaining mortgage balance remains on the title—and the lender can foreclose and force a sale. But a Chapter 7 debtor who is not in default on a loan secured by property may be able to retain that property without reaffirming the debt or redeeming the collateral by continuing to make contract payments.

Usually, household furnishings, household goods, clothing, appliances, books, animals, musical instruments or jewelry that are held primarily for the personal, family or household use of the debtor are exempt from liquidation.

With a Chapter 13 filing, which is more common, the goal is to save the house. The borrower agrees to pay the missed mortgage payments and remain current on future ones. The person remains liable for the entire debt.

BANKRUPTCY AND BENEFITS

Most states fail to provide regular individual retirement accounts and Roth IRAs with the kind of ironclad protection from creditors that is afforded pension benefits and 401(k) plans. In general, the rules change markedly from state to state.

New Hampshire and New Mexico, for example, have no laws specifically protecting IRA savings from creditors. Other states, such as Texas, Arizona and Washington, protect virtually everything inside an IRA from creditors.

So, depending on where you live and how you've saved, you could lose some or all of your retirement money if you are sued or file for bankruptcy.

Some states do shelter money in IRAs and Roth IRAs that is deemed necessary to support the saver and his or her dependents in retirement. Any excess, however, is subject to creditors' claims in a lawsuit or bankruptcy. But exactly how much would be protected is open to a judge's interpretation.

And these protections may not be sufficient for high-earners, big savers and those who hope to pass some of their retirement largess to their children when they die.

Congress has considered bankruptcy-law reforms that could preempt state laws and cap protection for IRA assets to a maximum of $1 million.

If you're close to retirement and considering a move anyway, the size of your IRA assets could be one of the deciding factors in where you move. A state-by-state listing of IRA protections in bankruptcy can be found at the Investment Company Institute Web site at: www.ici.org/retirement/99_state_ira_bnkrptcy.html.

You might consider leaving your 401(k) money in a previous employer's plan or transferring it directly into a new employer's plan rather than rolling the money into an IRA when you change jobs. This assumes that the employers will cooperate; some may want you to take your money when you leave while others won't accept transfers from other plans.

SMALL BUSINESS ISSUES

The lines between personal and business liabilities aren't always clear when an entrepreneur owns a small business. Often, these people will file bankruptcy to protect their personal resources from company problems.

In November 2000, the former owner of a small Wisconsin publishing company filed for bankruptcy protection to protect himself against a number of personal guarantees that he'd made in connection with the business. The filing serves as a good example of the personal liabilities that can follow from owning a small business.

John J.T. Shinners, who owned SPI Communications, Inc. and was a member of the Shinners publishing family, filed for Chapter 7 bankruptcy in U.S. Bankruptcy Court; he listed assets totaling $218,393 and liabilities totaling $8,345,998. Of the liabilities, $7,554 was owed to secured creditors and $8,338,444 to unsecured creditors. The bankruptcy would mostly affect the unsecured creditors—essentially erasing the monies owed them.

Bruce Lanser, Shinners's lawyer, said that a lot of the debt was SPI corporate obligations that Shinners had secured with personal guarantees. The lawyer went on to tell a local newspaper that the bankruptcy was "precipitated by his desire to discharge his personal guarantees" and protect himself from personal liability down the road if SPI's creditors tried to hold him responsible for nonguaranteed company debts. This approach, however, doesn't always work.

The March 1998 U.S. Supreme Court decision *Kawaauhau v. Geiger* dealt with a professional liability issue that led to a bankruptcy filing.

When Margaret Kawaauhau sought treatment for an injured foot, Paul Geiger—a medical doctor—examined and hospitalized her to attend to the risk of infection. Although Geiger knew that intravenous penicillin would have been more effective, he prescribed oral penicillin, because he knew his patient wished to minimize treatment costs.

Geiger then departed on a business trip, leaving Kawaauhau in the care of other physicians, who decided to transfer her to an infectious disease spe-

cialist. When Geiger returned, he canceled the transfer and discontinued all antibiotics because he believed the infection had subsided. Kawaauhau's condition deteriorated, requiring amputation of her leg below the knee and she sued Geiger for malpractice.

After trial, the jury found Geiger liable and awarded Kawaauhau and her husband approximately $355,000 in damages. Geiger, who carried no malpractice insurance, moved to another state. Eventually, the Kawaauhaus found him and garnished his wages. Geiger then filed for bankruptcy.

The Kawaauhaus requested the Bankruptcy Court to hold the malpractice judgment nondischargeable under federal bankruptcy law, which provides that a "discharge [in bankruptcy]...does not discharge an individual debtor from any debt...for willful and malicious injury...to another." Concluding that Geiger's treatment fell far below the appropriate standard of care and therefore ranked as "willful and malicious," that court held the debt nondischargeable. The district court affirmed, but the circuit court reversed, holding that:

> [federal bankruptcy law]'s exemption from discharge is confined to debts for an intentional tort, so that a debt for malpractice remains dischargeable because it is based on negligent or reckless conduct.

So, the Kawaauhaus pressed the case up to the high court, which agreed to consider their arguments.

Ruth Bader Ginsberg wrote the opinion of the Court:

[U.S. Bankruptcy Code]'s words strongly support the Eighth Circuit's reading that only acts done with the actual intent to cause injury fall within the exception's scope. The section's word "willful" modifies the word "injury," indicating that nondischargeability takes a deliberate or intentional injury, not merely, as the Kawaauhaus urge, a deliberate or intentional act that leads to injury.

Ginsberg went on to write that, if Congress had meant to exempt debts resulting from unintentionally inflicted injuries, it might have described instead "willful acts that cause injury" or chosen another word or words—like "reckless" or "negligent"—to modify "injury."

Moreover, the Bankruptcy Code's formulation closely resembled the legal category "intentional torts," which generally require that the at-fault person intended the consequences of an action, not simply proof that the act itself took place.

The Kawaauhaus were seeking an interpretation that could include a wide range of situations in which an act was intentional but the resulting injury was unintended. Ginsberg and the Court didn't agree with that theory:

> A construction so broad would be incompatible with the well-known guide that exceptions to discharge should be confined to those plainly expressed, and would render superfluous the exemptions from discharge set forth in [federal law]. The Kawaauhaus' argument that, as a policy

matter, malpractice judgments should be excepted from discharge, at least when the debtor acted recklessly or carried no malpractice insurance, should be addressed to Congress. Debts arising from reckless or negligently inflicted injuries do not fall within [federal bankruptcy law]'s compass.

USING BANKRUPTCY LAW WITHOUT FILING

Bankruptcy filings have become so commonplace that some people who have sizable liabilities will use bankruptcy tactics without actually filing for protection. A good example of this was provided by O.J. Simpson, the famous football player and actor who was tried and acquitted on charges that he murdered his ex-wife and her friend. After he was acquitted of the criminal charges, his ex-wife's family sued him in civil court for wrongful death.

Simpson lost that case (largely because civil lawsuits have lower standards of proof than criminal cases do). In February 1997, he was ordered to pay the families of his ex-wife and her friend $33.5 million. He didn't have that much cash. So, he began to protect his assets as someone about to file bankruptcy might—even though he didn't actually file bankruptcy.

Among the things he did:

- Move to Miami. Florida law forbids forcing a person out of his residence

if he owns it outright; so, many wealthy people facing money problems dodge debts by converting liquid assets into Sunshine State mansions.

- Transfer most of his remaining liquid assets into legal, domestic havens: two pension and retirement funds. These funds (with millions of dollars in them) could not be touched by outsiders even if Simpson filed for bankruptcy. The pensions were scheduled to begin paying their annuities when Simpson turned 55—in 2002.

- Rely on money he received from the NFL and the Screen Actors Guild pensions to cover his regular expenses. These monies were untouchable, again, because pension laws protect them from legal judgments.

- Transfer half a million dollars into the estate of his children (for expenses and education).

- Liquidate most of the assets that could be seized (he'd actually done this before his criminal trial had begun). He sold real estate in New York and California, property in Mexico; a 50 percent interest in a string of HoneyBaked Ham franchises, his Ferrari Mondial and Ford Bronco. He borrowed $3 million against his Los Angeles home and used a Warhol serigraph of himself as security for a loan he took from his children's estate. (Eventually, his

home went into foreclosure and was
sold at auction.)

- Tap into his homeowners policy to pay
 for his defense in the civil trial.

- Let go of many of his personal posses-
 sions. The items seized by the court
 and sold at auction generated $430,000
 for the families. (His 1968 Heisman
 Trophy went for $255,500.)

After the civil case was concluded and Simpson
lost his Los Angeles home in foreclosure and saw
some of his personal possessions auctioned off, he
was still keeping about $16,000 a month (after taxes)
from various untouchable sources.

Lawyers for the families of his ex-wife and her
friend tried to seize Simpson's pension funds; but
these efforts came to nothing. They were eventu-
ally dropped—the lawyers couldn't establish that
the pension benefits could be used as payment in
the wrongful death suit.

...BUT SHOULD YOU FILE?

The question often arises: Is it ethical to file for
bankruptcy after you've been found liable for
someone else's loss? *Ethical* is a tough word to
define in these circumstances. It probably accom-
plishes more to say that it's legal to file bankruptcy
to discharge a liability. And many people do.

The September 1994 California Appeals Court de-
cision *Main Line Pictures, Inc., v. Kim Basinger*
dealt with a high-profile bankruptcy designed

plainly to avoid a legal liability. And it caused many people—in Hollywood and elsewhere—to question the ethics of a bankruptcy system that allows someone to file explicitly to avoid paying a particular personal liability.

Basinger was a well-known actress, having starred in movies like *Batman* and *9½ Weeks*. In December 1990, Main Line sent her a copy of the screenplay of *Boxing Helena*. Main Line's president, Carl Mazzocone, followed with a letter to Basinger—through her agent—offering $500,000 plus additional deferred compensation to star in the movie.

Basinger was excited about the script and interested in playing the female lead. Barbara Dreyfus, the director of development for Mighty Wind Productions, arranged for Basinger to meet the film's screenwriter and director, Jennifer Lynch. (Mighty Wind Productions was Basinger's "loan-out" corporation, a company through which the actress "loaned" her acting services. Payment for Basinger's services was made to Mighty Wind, which in turn employed and paid Basinger.)

In January 1991, Lynch, Basinger and Dreyfus met at Mighty Wind's office. Basinger expressed an interest in the movie, which she believed would be a tremendous showcase for an actress. She also stated she felt a kinship to the role because it concerned a woman who was obsessed, a situation which was familiar to Basinger.

The screenplay contained some nude scenes. Basinger told Lynch about her concerns regarding the nude scenes. Lynch explained in detail how

she expected to film the scenes, stating there would be no gratuitous sex scenes or frontal nudity below the waist. While the film would be sensual, it would not be explicit. The meeting lasted more than an hour and all issues involving nudity were resolved. Basinger agreed to act in the film as it had been presented to her in the script.

A few weeks later, Basinger met with her agents and agreed to act in *Boxing Helena*. Main Line's attorney, Robert Wyman, discussed the contract's material terms with Basinger's attorneys.

Compensation and credit were discussed at the outset. The parties agreed Basinger would receive her usual fee of $3 million for the picture, consisting of guaranteed compensation of $600,000 plus additional deferred and contingent compensation. Basinger agreed to accept second billing behind Ed Harris, the male lead.

On February 27, 1991, Mazzocone, Wyman and Basinger's attorneys discussed each material term of the contract. Wyman reviewed a checklist of all terms in issue; Basinger's attorneys agreed to review each term as described. Wyman then sent Basinger's attorneys a "deal memo" dated February 27, 1991, setting forth the contractual terms for Basinger's performance in *Boxing Helena*.

The next day, Basinger's attorneys sent an annotated copy of the "deal memo" back to Wyman. The annotations requested certain changes to be included in a formal written document. For example, she wanted to change the number of days Basinger would work in post-production.

As soon as the agreement for Basinger's acting services was reached at the end of February, Main Line received authorization to use Basinger's photo to promote the movie.

Republic Pictures, a foreign distribution company, learned that Basinger had agreed to perform in the film; it began preselling the film in foreign markets with Basinger's name attached. Eventually, foreign presales for the movie with Basinger's name attached totaled $6.8 million. Main Line reasonably expected to receive approximately $3 million in domestic presales. The money obtained from the foreign presales would secure financing for the film.

In April 1991, Main Line began preproduction activities including casting, wardrobe, special effects and model construction.

Because timing is critical, film industry contracts are frequently oral agreements based on unsigned "deal memos." Often, actors authorize their agents or lawyers to bind them. Although the parties may intend their oral agreement to be binding, many subsidiary or ancillary terms may subsequently be agreed upon and incorporated into the written contract. The written contract also enables parties to formalize their understanding in legal language.

The absence of an executed written contract doesn't mean there is no legally binding agreement. Basinger, for example, had entered into executed written contracts for only two of her prior films.

In April 1991, Basinger changed agents; she replaced Intertalent with International Creative Manage-

ment (ICM). After ICM read the screenplay for *Boxing Helena*, it concluded Basinger should not do the film.

On May 6, 1991, Basinger called Lynch and Mazzocone and expressed reservations about the script. Basinger stated she wanted the character to be more sympathetic. Two days later, ICM told Lynch and Mazzocone it had suggested that Basinger not act in the film. Lynch attempted to accommodate Basinger's reservations by modifying the script. Lynch met with Basinger to discuss the proposed changes.

On May 29, 1991, Wyman sent to Basinger's lawyers a final execution draft of the Acting Service Agreement and the Producer's Standard Terms and Conditions. The cover letter stated Wyman was delivering an execution copy of the "Agreement between Main Line Pictures, Inc. and Mighty Wind Productions, Inc. f/s/o [for the services of] Kim Basinger."

The signature line called for execution by "Main Line Pictures, Inc. By Carl Mazzocone" and "Mighty Wind Productions, Inc. by Kim Basinger." There was no place for Basinger to sign as an individual.

The Acting Service Agreement was never executed.

On June 10, 1991, Main Line learned that Basinger was not going to act in *Boxing Helena*. Within two weeks, Main Line filed a lawsuit against Basinger and Mighty Wind, alleging that Basinger and Mighty Wind had breached an oral and a written contract to provide Basinger's acting services.

The Producer's Standard Terms and Conditions provided, among other things, that Main Line was entitled to sue if Basinger breached and that Mighty Wind was to indemnify Main Line if Basinger made any claim for compensation. The company pointed out that, after Basinger bailed out of the movie, its presales fell by more than half.

During trial, Basinger's lawyers focused on a technical argument. They claimed that, because Mighty Wind was a corporation, it was entitled to separate jury instructions. Main Line argued no distinction existed between Basinger and Mighty Wind for purposes of the case.

The trial court refused to instruct the jury as requested by Basinger's lawyers. It concluded that everything done by Mighty Wind was done by Basinger.

The jury concluded that "Basinger and/or Mighty Wind" had entered into both an oral and a written contract, had breached the contract and had caused damages to Main Line in the amount of $7,421,694. It further determined that "Basinger and/or Mighty Wind" had denied in bad faith the existence of the contract, and awarded an additional $1.5 million in damages. Finally, the trial court also awarded Main Line $713,522.05 in attorneys' fees and costs.

Basinger's lawyers appealed, arguing that the actress and her loan-out corporation were distinct entities. The case moved through appeals courts for several years—but, in 1994, Basinger was held liable for the damages Main Line had suffered.

She promptly filed bankruptcy, claiming less than $4 million in assets against the more-than-$8 million judgment. Main Line ended up collecting only about a third of its judgment.

The bankruptcy filing raised all kinds of questions about the role of bankruptcy law. Kim Basinger was a wealthy actress with extensive financial assets—including considerable real estate holdings in California and her native Georgia. Perhaps she didn't have sufficient umbrella insurance (which she probably should have, given her wealth and the nature of her work) or $8 million in cash available to pay the judgment...but shouldn't she have worked out some arrangement with Main Line to make good on her debt?

But the actress's attitude—which seems fairly common these days—was to use the law as aggressively as possible to avoid paying the damages. And U.S. bankruptcy law allows this. Until the laws are reformed to limit filings intended to avoid particular liabilities, people will continue to use the Bankruptcy Code as liability insurance of last resort.

CONCLUSION

In insurance circles, tools like hold harmless agreements and bankruptcy are called "non-insurance transfers of risk." And, generally, insurance companies don't trust them. That's why insurance policies include so much language about what happens in the event of a bankruptcy (the policyholder's, not the insurance company's) and about contractual obligations (a legalistic way to describe things like hold harmless agreements).

This doesn't mean that hold harmless agreements and bankruptcy filings are problems. On the contrary, the distrust probably has something to do with how effective they can be. They may be tools of last resort; but they are tools for handling liabilities.

At the beginning of this book, we said that the goal was to explain the liability mania that is gripping much of the modern world. And to examine the various tools an individual can use to manage personal liability risks.

You can't make a litigious world change overnight. But you can protect yourself and—by protecting yourself—push the world a little closer to a less ridiculous position. In fact, as a well-informed consumer, that's your responsibility. We hope this book helps you meet that challenge.

INDEX